CHINESE CERAMICS

Masahiko Satō

CHINESE CERAMICS

A Short History

WEATHERHILL/HEIBONSHA

New York & Tokyo

199156

Originally published in Japanese by Heibonsha, Tokyo, under the title *Chūgoku tōjishi* (History of Chinese Ceramics), 1978. Translated into English and adapted by KIYOKO HANAOKA and SUSAN BARBERI.

First English edition, 1981

Published jointly by John Weatherhill, Inc., of New York and Tokyo, with editorial offices at 7-6-13 Roppongi, Minato-ku, Tokyo 106; and Heibonsha, Tokyo. Copyright ⓒ 1978, 1981, by Masahiko Satō; all rights reserved. Printed in the Republic of Korea and first published in Japan.

Library of Congress Cataloging in Publication Data: Satō, Masahiko, 1925– / Chinese ceramics: a short history. / Translation of: Chūgoku tōji shi. / Bibliography: p. Includes index. 1. Pottery, Chinese. / 2. Porcelain, Chinese. I. Title. / NK4165.S23313 738'.0951 / 81-4480 AACR2 / ISBN 0-8348-1041-7

Contents

*A map of kiln sites and a chronological chart of Chinese
ceramics appear on a foldout between pages 242 and 243.*

Preface and Acknowledgments

Research on Chinese ceramics has progressed steadily in the twentieth century. There has been constant international interest in the subject, intensified by excavations in China since the 1950s. This book is intended to provide an up-to-date introduction to the history of Chinese ceramics from prehistory through the eighteenth century.

That there are some differences between East and West in scholarly approach and methodology cannot be denied. This volume is offered as a Japanese piece of scholarship appearing in English for the first time and will, I hope, shed new light on the subject.

The history of Chinese ceramics covers an extremely long period, from the Neolithic Age to the present day, and over the centuries innumerable kinds of ware, using various techniques and materials, have been created. It is indeed a difficult task to present such an extensive history concisely and clearly. This introductory history attempts to organize the material around the following points:

Wares are classified according to the materials used, particularly glazes, and historical developments are traced without strictly following a chronological sequence. For example, a succession is described in which white porcelaneous ware derives from northern celadon at the end of the Six Dynasties period, develops into the Xingzhou ware of the mid-Tang dynasty, and further develops into the Ding white porcelaneous ware of the Five Dynasties and Northern Song periods.

Each ware has its own distinct features that are the inevitable consequence of

variations in techniques and materials. For instance, the color of Song official celadon depends not only on the quality of the glaze or the glazing and firing technique, but on the clay body as well.

It is recognized that the potters of certain areas and time periods shared a common aesthetic. In the north between the end of the tenth and the eleventh century, the engraving of motifs was widely accepted as the best decorative method, as is seen in the variety of wares produced by the Ding, Yaozhou, and Cizhou kilns.

This ceramics history is based on existing specimens, and over 370 illustrations have been provided. A map of kiln sites, in accordance with the most recent Chinese findings; a time chart showing the development of wares; and a listing of Chinese characters for proper names and technical terms, with both Wade-Giles and *pinyin* romanizations, are also included.

I have benefited greatly on four successive trips to China from the excavations and research ongoing since the Japanese edition of this book was first published with Heibonsha. Many points have been corrected or added to the English edition in keeping with new material.

I would like to take this opportunity to thank Feng Xianming, a curator at the Palace Museum in Peking, and the many other scholars who have generously shared their knowledge on numerous occasions.

I wish to express my sincere gratitude to Kiyoko Hanaoka for long years of research assistance. To her and Susan Barberi I am further indebted for their devotion to the often difficult task of translation. I am also grateful to Margaret Taylor for her editorial guidance and care in organizing the English version of this volume.

CHRONOLOGY

NEOLITHIC PERIOD
Yangshao, ca. 5000–3000 B.C.
Longshan, ca. 2600–1800 B.C.

SHANG DYNASTY, ca. 1500–1066 B.C.

ZHOU DYNASTY, ca. 1066–221 B.C.
Western Zhou, ca. 1066–770 B.C.
Eastern Zhou, 770–221 B.C.
Spring and Autumn, 722–481 B.C.
Warring States, 481–221 B.C.

QIN DYNASTY, 221–207 B.C.

HAN DYNASTY, 207 B.C.–A.D. 220
Western Han, 207 B.C.–A.D. 9
Eastern Han, A.D. 25–220

SIX DYNASTIES PERIOD, 220–580
Three Kingdoms, 220–65
Western Jin, 265–317
Eastern Jin, 317–420
Northern Dynasties
Sixteen Kingdoms, 317–439
Northern Wei, 386–535
Eastern Wei, 534–50
Western Wei, 535–57
Northern Qi, 550–77
Northern Zhou, 557–80
Southern Dynasties
Liu Song, 420–79
Southern Qi, 479–502
Liang, 502–57
Chen, 557–89

SUI DYNASTY, 581–618

TANG DYNASTY, 618–907
Early Tang, 618–84
High Tang, 684–756
Middle Tang, 756–827
Late Tang, 827–907

FIVE DYNASTIES PERIOD, 907–60

LIAO DYNASTY, 907–1125

SONG DYNASTY, 960–1279
Northern Song, 960–1127
Southern Song, 1127–1279

JIN DYNASTY, 1115–1234

YUAN DYNASTY, 1271–1368

MING DYNASTY, 1368–1644
Hongwu, 1368–98
Jianwen, 1399–1402
Yongle, 1403–24
Xuande, 1426–35
Zhengtong, 1436–49
Jingtai, 1450–56
Tianshun, 1457–64
Chenghua, 1465–87
Hongzhi, 1488–1505
Zhengde, 1506–21
Jiajing, 1522–66
Longqing, 1567–72
Wanli, 1573–1619
Taichang, 1620
Tianqi, 1621–27
Chongzhen, 1628–44

QING DYNASTY, 1644–1912
Shunzhi, 1644–61
Kangxi, 1662–1722
Yongzheng, 1723–35
Qianlong, 1736–95
Jiaqing, 1796–1820
Daoguang, 1821–50
Xianfeng, 1851–61
Tongzhi, 1862–74
Guangxu, 1875–1908
Xuantong, 1909–11

CHINESE CERAMICS

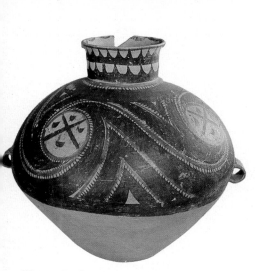

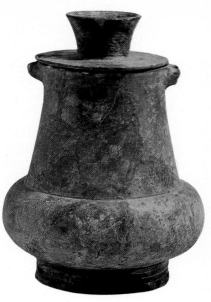

Plate 1. Earthenware jar with spiral design. Painted pottery, Gansu Yangshao culture. H. 39.9 cm. Shanghai Museum.

Plate 2. Earthenware jar with pierced lugs. Black pottery, Liangzhu culture. H. 12 cm. Shanghai Museum.

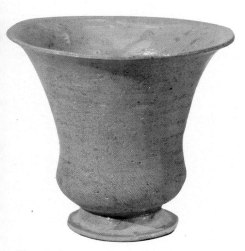

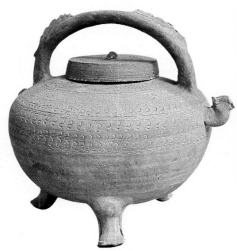

Plate 3. Stoneware *zun*-shaped vase. Ash-glazed ware, Shang dynasty. H. 18 cm. Shanghai Museum.

Plate 4. Stoneware *he*-shaped ewer. Ash-glazed ware, Warring States period. H. 20.6 cm. Shanghai Museum.

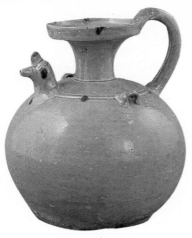

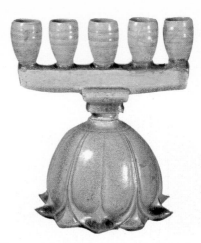

Plate 5. Stoneware chicken-head ewer, ash glaze with iron spots. Yue ware, Eastern Jin period. H 23.5 cm. Private collection.

Plate 6. Ash-glazed candlestick. Hongzhou ware, Southern Dynasties or Sui period. H. 21.3 cm. Idemitsu Art Gallery, Tokyo.

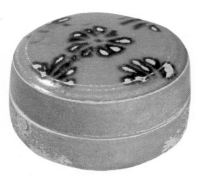

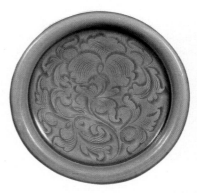

Plate 7. Stoneware covered box, ash glaze with green and brown spots. Tongguan ware, Late Tang period. D. 9.2 cm. Private collection.

Plate 8. Celadon plate with carved peony-scroll design. Yaozhou ware, Northern Song period. D. 19 cm. Private collection.

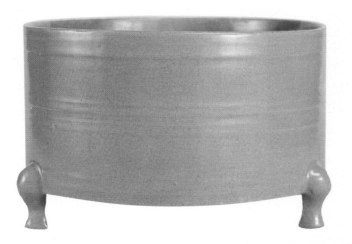

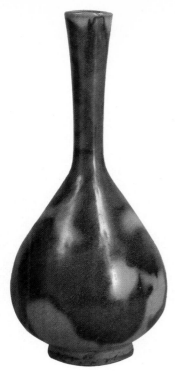

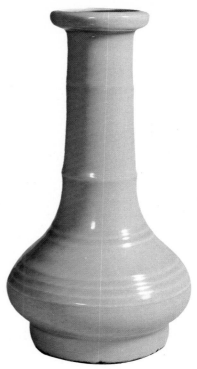

Plate 10. Celadon vase, opaque bluish glaze with purple splashes. Jun ware, Northern Song or Jin dynasty. H. 29.1 cm. Percival David Foundation, London.

Plate 11. Celadon vase. Longquan ware, Southern Song period. H. 29.7 cm. Nezu Art Museum, Tokyo.

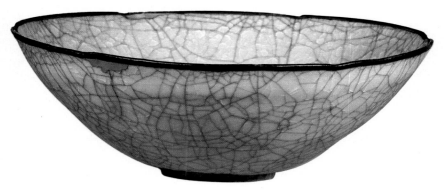

Plate 12. Celadon bowl with foliate rim. Southern Song *guan* ware. D. 25.5 cm. Tokyo National Museum.

Plate 9. Celadon *lian*-shaped censer. Ru *guan* ware, Northern Song period. D. 23.7 cm. Percival David Foundation, London.

Plate 13. High-footed white porcelaneous
bowl. Early Tang period. H. 23 cm.
Palace Museum, Peking.

Plate 14. Small white porcelaneous jar with
carved lotus-petal design. Ding ware,
Northern Song period. H. 9.6 cm. Tokyo
National Museum.

Plate 15. White porcelaneous bowl with molded floral motif. Ding ware, Northern Song
or Jin dynasty. D. 20.3 cm. Private collection.

Plate 16. *Qingbai* bowl with carved lotus-flower design. Jingdezhen ware, Northern Song period. H. 19.5 cm. Idemitsu Art Gallery, Tokyo.

Plate 17. Black glazed stoneware jar with four lugs. Deqing ware, Eastern Jin period. H. 24.9 cm. Shanghai Museum.

Plate 18. High-footed stoneware jar with blue-white mottling. High Tang period. H. 18.1 cm. Idemitsu Art Gallery, Tokyo.

Plate 19. Stoneware bowl with iridescent spots. *Yōhen temmoku*, Jian ware, Southern Song period. D. 12.2 cm. Fujita Art Museum, Osaka.

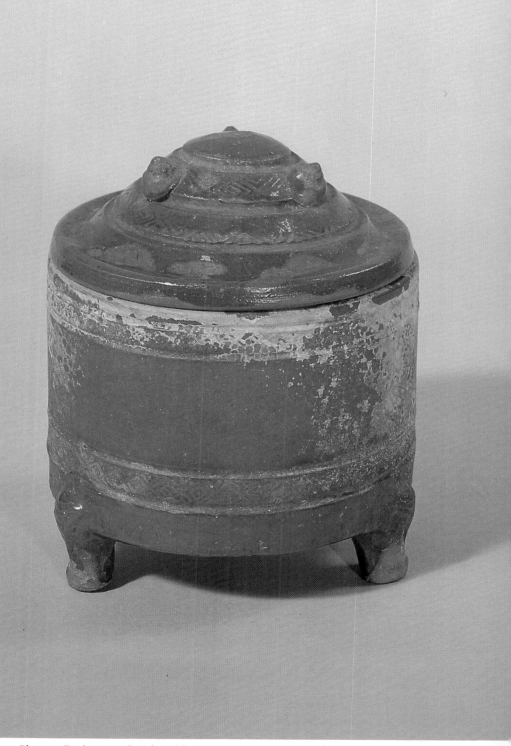

Plate 20. Earthenware *lian*-shaped box with green and brown glazes. Eastern Han period. H. 16 cm. Tenri Sankōkan.

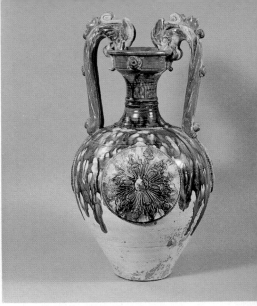

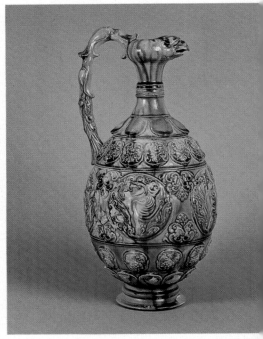

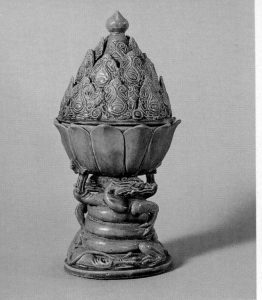

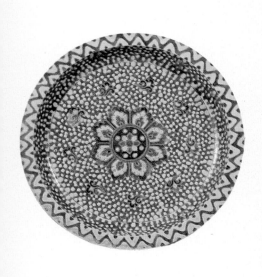

Plate 21. Green glazed earthenware "Bo-shanlu" censer. Sui dynasty. H. 28.3 cm. Private collection.

Plate 22. Three-color earthenware amphora with dragon-head handles. High Tang period. H. 45.6 cm. Tokyo National Museum.

Plate 23. Three-color earthenware tray with three loop feet and stamped floral motif. High Tang period. D. 37.3 cm. Eisei Bunko Foundation, Tokyo.

Plate 24. Three-color earthenware phoenix-head ewer with applied molded decoration. High Tang period. H. 35.5 cm. Hakutsuru Art Museum, Kobe.

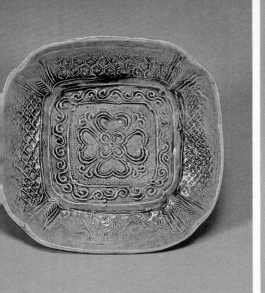

Plate 25. Molded earthenware plate with floral design, green glaze. Tongguan ware, Late Tang period. W. 14.2 cm. Private collection.

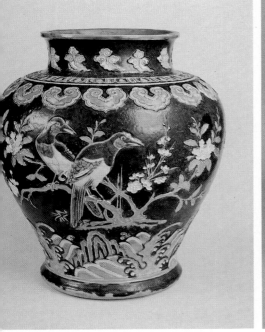

Plate 26. Earthenware *fahua* jar with bird-and-tree design, dark blue and turquoise-blue glazes on biscuit. Ming dynasty. H. 44.4 cm. Ataka Collection, Osaka.

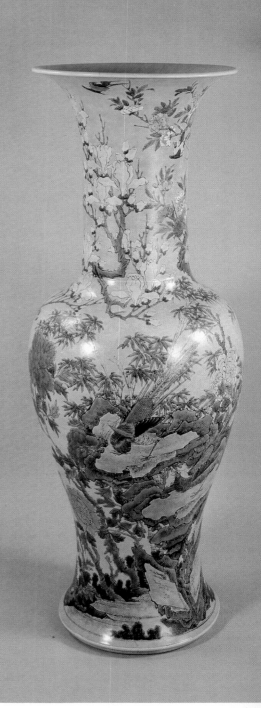

Plate 27. Porcelain vase with flower-and-bird design; enamels on biscuit. Yellow hawthorn type, Kangxi era. H. 77.5 cm. Umezawa Memorial Gallery, Tokyo.

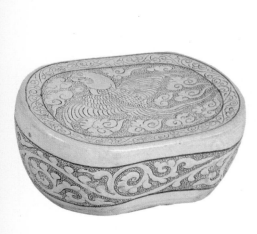

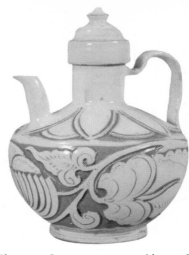

Plate 28. Stoneware pillow with sgraffito decoration, colorless glaze on white slip. Cizhou ware, Northern Song period. L. 22.5 cm. Okayama Art Museum.

Plate 29. Stoneware ewer with sgraffito decoration, colorless glaze on white slip. Cizhou ware, Northern Song period. H. 20.4 cm. Tokyo National Museum.

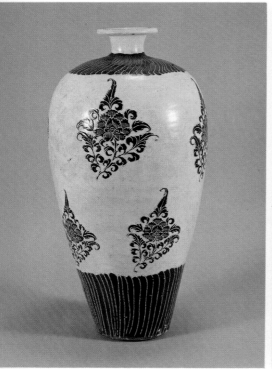

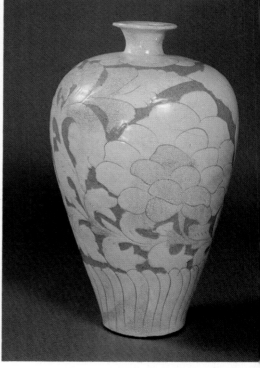

Plate 30. Stoneware *meiping* with sgraffito decoration, white and black slip. Cizhou ware, Northern Song period. H. 40.8 cm. Eisei Bunko Foundation, Tokyo.

Plate 31. Stoneware *meiping* with sgraffito decoration, colorless glaze on white slip. Cizhou ware, Northern Song period. H. 31.6 cm. Private collection.

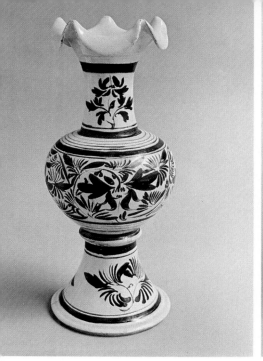

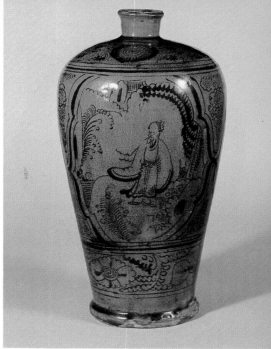

Plate 32. Stoneware vase painted with black floral motif, colorless glaze over white slip. Cizhou ware, Northern Song or Jin dynasty. H. 37.1 cm. Shanghai Museum.

Plate 33. Stoneware *meiping* painted with figure in black, turquoise-blue glaze on white slip. Cizhou ware, Yuan dynasty. H. 27.1 cm. Private collection.

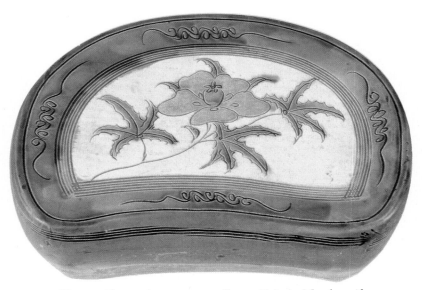

Plate 34. Three-color stoneware pillow with incised floral motif. Cizhou ware, Jin dynasty. L. 33.5 cm. Tokyo National Museum.

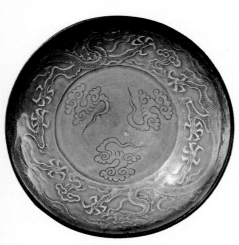

Plate 35. Porcelain dish with molded dragon-and-cloud motif, cobalt-blue glaze. Yuan dynasty. D. 16.2 cm. British Museum.

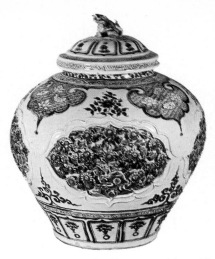

Plate 36. Blue-and-white covered jar with recessed panels, relief in blue and red glazes. Yuan dynasty. H. 42.3 cm. Palace Museum, Peking.

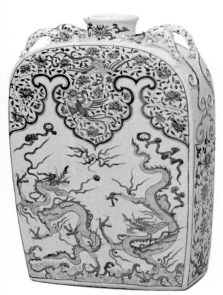

Plate 37. Blue-and-white flask with motif of dragons chasing a pearl. Yuan dynasty. H. 38.9 cm. Idemitsu Art Gallery, Tokyo.

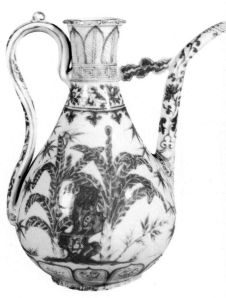

Plate 38. Porcelain ewer painted with banana-tree motif in underglaze red. Hongwu era. H. 32.4 cm. Private collection.

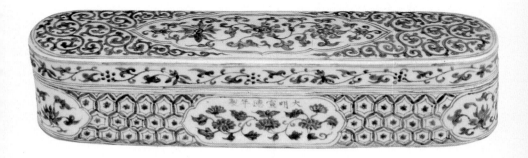

Plate 39. Blue-and-white brush box with floral scroll
motif. Xuande reign mark and era. L. 31.8 cm. Kikusui
Handicraft Museum, Yamagata.

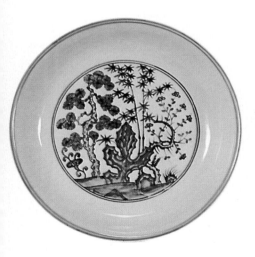

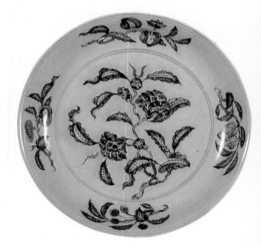

Plate 40. Blue-and-white plate with pine,
bamboo, and plum motif. Chenghua reign
mark and era. D. 20 cm. Private collection.

Plate 41. Blue-and-white plate with yellow
ground, flower-and-fruit motif. Chenghua
reign mark and era. D. 29.8 cm. Private
collection.

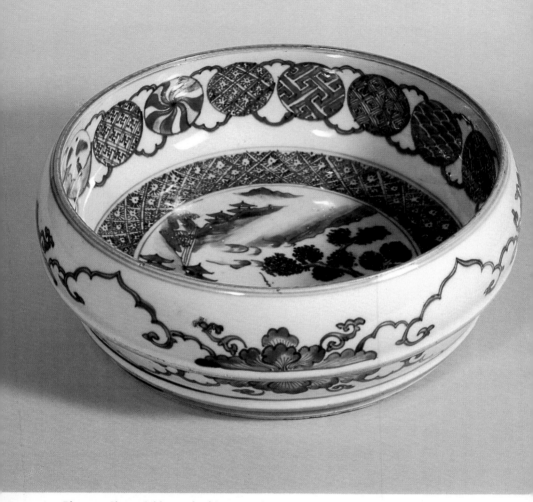

Plate 42. Shonzui blue-and-white water jar. Late Ming dynasty. D. 22 cm. Tekisui Art Museum, Kobe.

Plate 43. Small porcelain *doucai* enameled jar with motif of flowers and butterflies. Cheng- ▶
hua reign mark and era. H. 8 cm. Percival David Foundation, London.

Plate 44. Porcelain *kinran-de* enameled *sensanpin* with motif of birds and flowers. Jiajing era. H. 21.1 cm. Idemitsu Art Gallery, Tokyo.

Plate 45. Porcelain *wucai* enameled vase with dragon motif. Wanli reign mark and era. H. 32 cm. Private collection.

Plate 46. Porcelain *famille rose* enameled plate with plum-blossom motif. Gu Yue Xuan type, Yongzheng reign mark and era. D. 17.3 cm. Tokyo National Museum.

Plate 47. Porcelain *famille verte* enameled covered bowl with motif of flowers and butter-flies. Kangxi era. H. 40.5 cm. Umezawa Memorial Gallery, Tokyo.

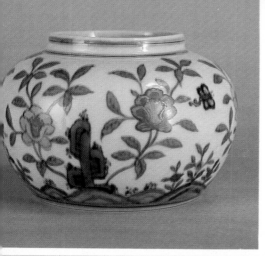

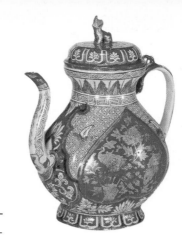

43	44
46	
45 | 47

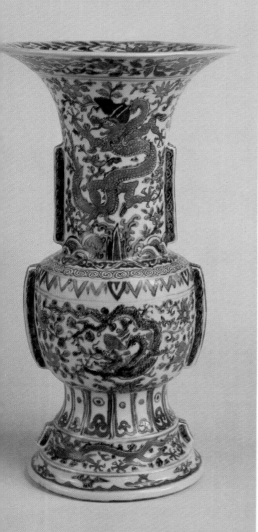

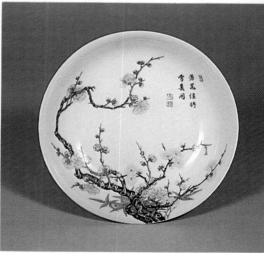

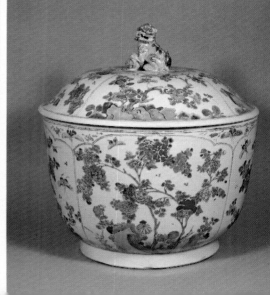

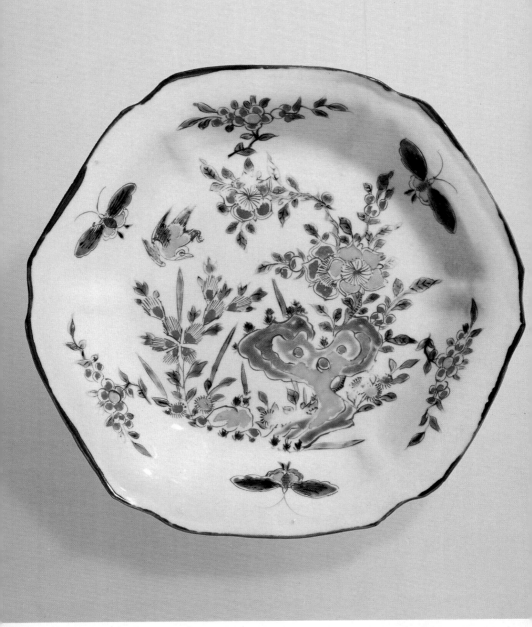

Plate 48. Porcelain Nankin *aka-e* enameled plate with motif of birds and flowers. Early Qing dynasty. D. 20.7 cm. Private collection.

1

Painted Pottery and Black Pottery

All histories of ceramics begin with and extend from the making of earthenware. The history of Chinese ceramics is no exception, and we shall begin this book by taking a look at the development of earthenware in prehistoric China.

The earliest known pottery of China is the unglazed earthenware of a neolithic culture that originated sometime in the fifth millennium B.C. This culture was based on agriculture and thrived in the Yellow River basin. Its people created three different types of earthenware. These were a coarse pottery with a yellowish brown sandy body, a red pottery fashioned out of a fine-grained clay, and painted pottery decorated with motifs painted with an iron-oxide pigment. The excellence of the last has given the name Painted Pottery to this neolithic culture, which is also called the Yangshao culture after the village of that name in Henan where the first discovery of painted pottery was made.

Though the coarse yellowish brown and red utilitarian vessels are important archaeological artifacts, specimens of them outside China are rare. They seem to have played a very minor role in Chinese ceramics history.

Painted Pottery

Layers of loess washed and strained into fine particles by the Yellow River yielded the clay from which painted pottery was made. The pots were coil-built, a technique in which coils of clay were built up from a round base and welded together by hand to create a smooth surface. After being roughly formed in this manner the pot was further compressed and refined by beating it with a small wooden paddle on the exterior while holding a block of wood

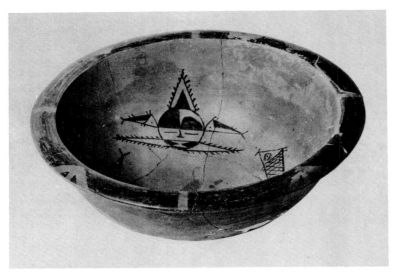

1. Earthenware bowl with human-face motif. Painted pottery, Yangshao culture. H. 18 cm. Banpo Museum.

against the inner wall. In the final step the exterior of the pot was given a fine gloss by vigorous polishing. This beating technique produced very thin walls which, combined with the smooth surface, make these pots much lighter than they appear.

Decorative motifs were painted onto these vessels with an iron-oxide pigment. Firing caused this pigment to change into colors ranging from black to sepia, the variation in color probably due to varying quantities of iron and impurities in the pigment. Two distinct types of decoration are apparent, one done only in black or sepia, the other combining the two colors. Recent excavations in Jiangsu have unearthed unusual examples of another type in which white slip and red pigment have been used in addition to the black and sepia (Fig. 3).

Shapes and painting motifs vary according to the time and place of production. The most commonly found shapes are a wide, shallow bowl (Figs. 1–2) and a short-necked jar with two small loop handles (Pl. 1, Fig. 4), a type that was prevalent in the Gansu region. Motifs often used on the bowls include spirals, curved lines, leaf shapes, diagonal checks, and dotted patterns, and occasionally fish and frog motifs. The jars have repeated patterns of wide spirals embellished with serrated edges and extending in undulating rhythms around the body of the vessel. The original significance of this particular motif is not known, but the excavation of the jars in tombs and their likely connection to funeral rites led J. Gunnar Andersson, the Swedish geologist who first discovered Chinese painted pottery, to name the spirals the "death pattern."

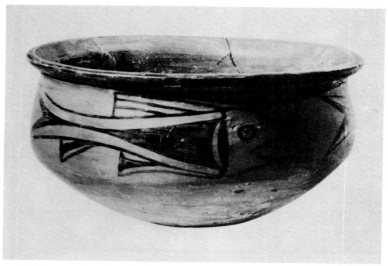

2. Earthenware bowl with fish motif. Painted pottery, Yangshao culture. H. 17 cm. Banpo Museum.

Recent discoveries of pieces decorated with motifs of deer, fish, snakes, and human faces have further complicated attempts to solve the riddle of the meanings of the designs. Abstract designs including the death pattern predominate, and, though the assumption that their symbolism relates only to funeral rites may be wrong, it seems clear that vessels bearing these patterns must have been meant for some special ritual use.

It is not possible to date exactly the duration of painted pottery production, but those pieces discovered at the Yangshao sites: Banpo in Xi'an, Shaanxi, and Miaodigou in Shanxian County, Henan, are considered to have been produced sometime between 5000 and 3000 B.C. This period is not much later than the Jarmo, Hassuna, and Sialk cultures of West Asia (the Middle and Near East), which are known to have been the earliest producers of painted pottery in the world. This dating also helps to verify the theory that Chinese painted pottery evolved under stimulus from West Asia.

As the painted pottery of the Yangshao culture gradually spread throughout surrounding areas, unique local variations developed. Of these offshoots, the painted pottery produced in the valley of the Tao River in Gansu (Pl. 1, Fig. 4) shows the most remarkable independent development. The earthenware vessels of this region were once known as Banshan painted pottery after the site where many samples were discovered. A major portion of Chinese painted pottery now scattered in collections around the world belongs to this group.

Investigations in China since the Communist revolution have made it clear that Banshan pottery is actually a later, peripheral form of Yangshao painted

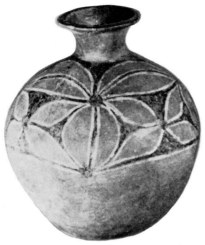

3. Earthenware vase with petal design. Painted pottery, Yangshao culture. H. 19.5 cm. Nanjing Museum.

4. Earthenware jar with spiral design. Painted pottery, Gansu Yangshao culture. H 31 cm. Kyoto University.

pottery. The group as a whole is now usually termed Gansu Yangshao pottery. The major sites where this type of pottery has been discovered are Banshan, Majiayao, Wajiaping, and Lanzhou, all dating around the third and second millenniums B.C.

Black Pottery

Painted pottery was followed by black pottery made of a very fine-grained clay and fired by reduction, a process in which excessive fuel is fed into the kiln to damp the fire and reduce the amount of oxygen in the kiln. This forces the body to absorb carbon particles, which cause the iron in the body to deoxidize and turn black. This earthenware was burnished before firing to a glossy jet-black finish.

The first discovery of black pottery was made at Chengziyai, which lies near the hill called Longshan in northern Shandong; hence this ware is referred to as the pottery of the Longshan culture. The origins of Longshan black pottery and its relationship to the older painted pottery have been widely debated. The presently accepted thesis, based on recent excavations of the many Longshan sites including Miaodigou in Shanxian County, Henan, is that the Longshan culture followed the Yangshao culture sometime in the third millennium B.C., and that the Longshan black pottery evolved from the Yangshao painted pottery.

Two of the distinguishing characteristics of painted pottery, thin construction and a well-polished surface, are retained in the black pottery, but there are also major improvements to be seen in the newer ware. One is evidence

5. Earthenware jug with handle. Black pottery, Longshan culture. H. 19.3 cm. Kyoto University.

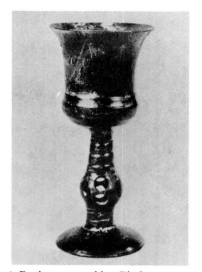

6. Earthenware goblet. Black pottery, Longshan culture. Shangdong Museum.

of the development of the potter's wheel. The black pottery is more precisely formed and has even thinner walls, obtained by the use of a wheel (Fig. 5). The introduction of the wheel also allowed for mass production, which helps to explain the great quantity of black pottery unearthed from Longshan culture sites.

Another progressive characteristic of black pottery is found in the variety of shapes. Painted pottery was confined to simple bowls, cups, jars, vases, and stemmed bowls and trays. Black pottery can be divided into several broad categories of shapes, which can be further subdivided according to subtle variations in design. Opportunities for careful study of these wares are limited since the greater number of specimens are in China. However, some specimens of this type can be found outside China, such as a refined, handled jug with three hollow legs and a goblet (Fig. 6), which testify to the diversity and complexity of form made possible by the potter's wheel and the growth of an advanced culture. The skillful use of the wheel, evident in the patterns of horizontally incised lines and raised linear bands, speaks of a changing consciousness within this new genre toward the art of decoration.

A burnished black pottery, similar to the Longshan ware, was produced from very early times in Mesopotamia, in the Nile River basin, and in the Anatolia plateau region. Whether or not there is any relationship between this pottery and the black pottery of China is still uncertain. It is most likely that some sort of connection did exist, for there are close similarities in shape and decoration.

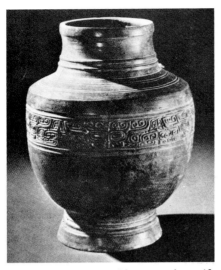 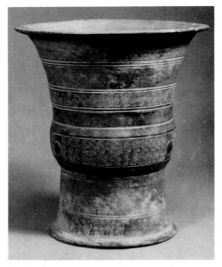

7. Earthenware jar with stamped motif. Black pottery, Shang dynasty. H. 35 cm. Private collection.

8. Earthenware *zun* with stamped pattern. Gray pottery, Shang dynasty. H. 25.3 cm. Private collection.

The Longshan black pottery culture developed in the region centering around Shandong and Henan, its production later spreading to the surrounding areas. It should also be mentioned that prior to and following this Longshan culture, other black pottery cultures developed independently along the Yangtze and Pearl river basins. One of the cultures in the south is called Liangzhu after the site area in Zhejiang (Pl. 2). This culture was contemporary with the Longshan culture, but it may have developed a little earlier. Despite the emerging bronze culture of central China, which caused the pottery culture to decline, black pottery continued to be produced in many places. The Lifan culture in Sichuan is a late example that lasted until the Western Han dynasty (206 B.C.–A.D. 8). Even in central China, black pottery did not wholly disappear but continued for a time to be produced concurrently with the new metalware of the Bronze Age. An example is the black pottery of the latter half of the Shang dynasty (ca. 1500–1066 B.C.), which took on many of the shapes and decorations prevalent in the bronzes of that period (Figs. 7–8). These versions of black pottery were once thought to have been the forerunners of the bronze vessels, but it is now known that the bronzes and earthenware coexisted and that the pottery borrowed its designs from the bronzes.

2

From Black Pottery to Gray Pottery

The Beginning of Gray Pottery

Much of the black pottery of the Shang dynasty is actually more gray than it is black. These gray earthenware vessels were fired in the same type of reduction kiln as the black pottery. The gray pottery, however, was fired at a higher temperature for a longer period of time and was not forced to absorb a great amount of carbon. As the iron in the clay deoxidized, the clay turned gray. Most clays contain some iron, and, in an oxidation firing where the fire is kept burning with a sufficient oxygen supply, this iron oxidizes, causing a vessel to turn red; painted pottery and red pottery are good examples of this.

The drab, gray pottery is not as aesthetically pleasing as the bright and colorful red and painted potteries. But the gray ware tradition is extensive, beginning in the latter half of the Shang dynasty and continuing for over a thousand years. The reduction process undergone by gray pottery in firing caused the clay body to become more cohesive and to contract more tightly than clay fired by oxidation. Its durability insured gray pottery a place of importance in Chinese ceramics history.

A kind of gray pottery has been unearthed in Henan from the sites of Erligang in Zhengzhou, Shaogou in Luoyang, and the last Shang-dynasty capital of Anyang and in Shaanxi at Puducun, Xi'an. Major shapes include *zun* and *zhong* (wine vessels), *li* (hollow-legged tripod vessels), *jue* (tripod goblets), *yi* (water utensils), *gui* (high-footed bowls), *dou* (tripod vessels), and *ding* (stemmed bowls)—all representative bronze-vessel designs (Figs. 8–9, 12).

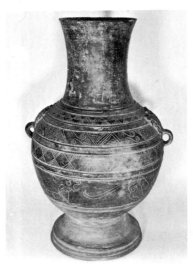

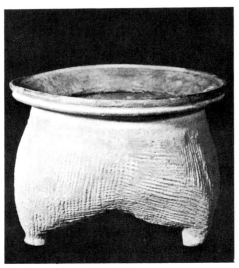

9. Earthenware *zhong*. Gray pottery, Warring States period. H. 45.5 cm. Ōhara Art Museum, Okayama.

10. Earthenware *li* with matt pattern. Gray pottery, Shang dynasty. H. 11.6 cm. Osaka Municipal Museum of Fine Art.

It is probable that these wares were made as substitutes for the more costly bronzes and that some of them were used as funerary vessels.

Decorative Techniques

The gray vessels discussed above are not the only gray pottery known to have existed. Coarser gray earthenware, coil-built and beaten, used as everyday eating and cooking vessels, was also widely produced (Fig. 10). This utilitarian ware is rarely decorated, with the exception of impressions left by a corded beater. The finer gray ware fashioned after the bronze vessels, however, is often elaborately decorated. Many of these decorative techniques were also used on black pottery. One technique used was to incise designs of trellises and zigzag lines into the surface of the vessels with a tool similar to a spatula. Another technique that evolved from this was to make impressions in the clay with stamps carved in simple geometric patterns, including trellis and key-fret designs. A more complex incised design, consisting of a series of horizontal or vertical lines, developed early in the Eastern Zhou period (770–221 B.C.).

One distinguishing method of decoration was to polish the patterned surface areas, such as bands and animal motifs, on a half-dried clay vessel so that portions of the vessel would acquire a glossy finish after firing. The resulting lustrous jet black was a pleasing contrast to the dark-gray matte surface of the unpolished portions (Fig. 11). *Hu* (jars), *ding,* and *dou,* unearthed from the Miaodigou site in Luoyang, have very delicate polished patterns of this type. Other examples of gray and black pottery bearing such burnished

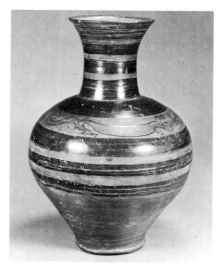

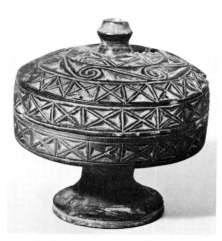

11. Earthenware vase with polished peco-ration. Black pottery, Western Han period. H. 39 cm. Private collection.

12. Earthenware censer. Gray pottery, Western Han period. H. 14.5 cm. Tenri Sankōkan.

decoration are to be found in Persian, Etruscan, and Asia Minor pottery, as well as in the Yayoi ware of Japan. This particular method of decoration was probably a natural result of attempts to give variation to the drabness of the somber ware.

Painted Gray Pottery

A more direct method of decoration than those mentioned above is that of painting a vessel's surface after it has been fired. The painted gray pottery of China (Figs. 13, 15) was decorated with pigments applied by a brush, which allowed for greater freedom in design and color. These wares are bright and quite beautiful. Production of painted gray earthenware was initiated in the Western Zhou period (1066–770 B.C.) and continued for over a thousand years, but the excellence of the decoration was plagued by one serious defect. Because the painted motifs were not baked on, they easily peeled off and faded.

The transient nature of this decoration makes its application seem almost pointless. Because they were to be used only as *mingqi,* or funerary vessels, however, this sort of decoration was all that was necessary. Their beauty was more important than their durability, for they were meant to be sealed within airless tombs. Pigments of white, red, purple, green, blue, and yellow were used to create scenes evocative of the legendary Isles of the Immortals in the Eastern Sea—scenes, for example, of floating clouds and animals prancing in the mountains. Occasionally, simpler designs of quatrefoils, fish, and hunters on horseback were also depicted.

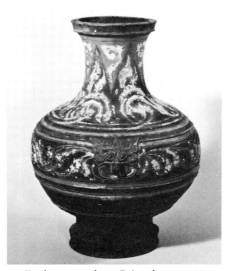 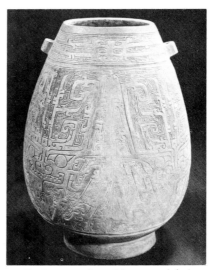

13. Earthenware *zhong*. Painted gray pottery, Western Han period. H. 52.6 cm. Private collection.

14. Earthenware jar with stamped design. White pottery, Shang dynasty. H. 21 cm. Private collection.

Gray pottery production, including painted gray pottery, seems to have been most active in the period during the Warring States (481–221 B.C.), the Han dynasty (207 B.C.–A.D. 220), and the Three Kingdoms period (220–65). Most of the examples available for study are *mingqi* and other vessels adapted for funeral use. Most of the utilitarian vessels have not survived. At this time, there was also a gradual development of high-fired ash-glazed and low-fired lead-glazed wares, which will be discussed later. These wares did not achieve the universality of the gray pottery, and it is likely that they belong to a very special group of wares of limited production.

The gray pottery of the Han and Three Kingdoms periods nearly always resembles the dominant bronze vessels, but certain exceptions have been discovered, such as the *bianhu* (pilgrim flask) with two feet, the jar with cocoon-shaped body, the vessel consisting of two or more bottles joined together, and the bird-shaped *yi*. That such unusual shapes are mainly found south of the Yangtze River basin reflects the relative independence of that area.

The largest number of gray pottery pieces consists of various kinds of figurines and miniature objects meant for burial. A discussion of these objects would entail a digression from the mainstream of Chinese ceramics history, and the reader is advised to refer to other publications for more detailed information.

White Pottery

There is a certain type of white pottery that was produced at the same time as the gray and black pottery of the Shang period. Specimens have been excavated

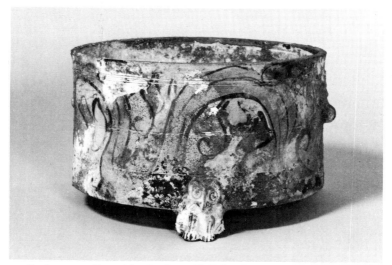

15. Earthenware *lian* with cloud motif. Painted gray pottery, Eastern Han period. H. 17.5 cm. Private collection.

from the site of the last Shang-dyansty capital of Anyang in Henan (Fig. 14). The close resemblance of these wares to contemporary bronze vessels formerly caused them to be mistaken for molds used in bronze casting. It is now clear that this white ware, known as Shang white pottery, is in fact a white pottery made from almost pure kaolin-type clay. Common shapes are the *lei* (large jars), *gui*, and *hu*, decorated with stamped imprints of key-frets, coiling dragons, and other motifs that are more simplified than those found on the equivalent bronzes. This white ware was specially made as a substitute for the bronzes and is extremely rare compared to the gray and black wares.

3

The Beginning of Ash-Glazed Stoneware

The Development of High-Fired Glaze

One of the most important discoveries made in the excavations conducted at the Shang capital of Anyang in Henan is a quantity of stoneware shards covered with a dark tawny glaze. Stoneware is fired at higher temperatures than earthenware producing a more tightly contracted, nonporous ware. These shards bear fine patterns that appear to be impressions left from beating.

This discovery points to two notable factors in the history of Chinese ceramics. One is that ash glazes, requiring a firing temperature of more than 1100°C, were already in use in the Shang period around the second millennium B.C. (Fig. 16). The second factor is that, though in West Asia the more easily handled low-fired glazes preceded the use of high-fired ash glazes, in China the process was reversed. The more difficult, high-fired ash glazes seem to have been developed first.

Chinese ceramics are often described as being impressive and mysterious. These may not always seem to be the most appropriate adjectives, but their source can be traced to the use of high-fired ash glazes. The ash glazes produced somber colors of olive green, bluish green, white, brown, and black, which form a strong contrast to the bright and colorful low-fired glazes of Persian and Turkish pottery and the majolica pottery of Southern Europe.

It is certain that Chinese ash-glazed pottery made its first appearance sometime in the Shang period. The very first of these wares were probably accidentally produced. Wood ash in a closed kiln would have settled on

16. Stoneware jar with matt pattern. Ash-glazed ware, Shang dynasty. Henan Museum.

red-hot vessels and mingled with the feldspar in the clay to create a natural ash glaze Later this accidental effect was improved upon by deliberately mixing wood ash with a solution of clay and water and applying this to the pots before firing. It should be noted here that the ash of wood and of many grasses contains a small amount of iron that will turn yellow when fired in an oxidation kiln and a grayish olive green, or basic celadon glaze, when fired in a reduction kiln.

It appears that ash-glazed stoneware should not have been so difficult to produce, and it seems plausible that such wares must have been produced in West Asia very early on. In actual fact, however, high-fired ash-glazed wares were not produced in West Asia and Europe until the eighteenth century. This great gap between the development of pottery in China and in the West may be attributed to differences in kiln construction and firing methods. The Chinese invented a more efficient kiln and reduction firing, both of which helped to bring about superior glazing techniques as well. The benefits of these inventions extended into Korea, Japan, and Southeast Asia.

Having once developed high-fired glazing techniques, it is unlikely that the Chinese would have shown much interest in any low-fired glazing techniques that may have come in from West Asia. This will be discussed further in the chapters on low-fired, green and brown glazed wares and three-color ware. It is to be emphasized here that high-fired ash-glazed wares were central to Chinese ceramics.

High-fired ash-glazed wares of the Shang period were unearthed in small

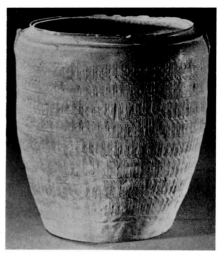

17. Stoneware *zun*. Ash-glazed ware, Western Zhou period. H. 18.5 cm. Anhui Museum.

18. Stoneware jar. Stamped ware, Spring and Autumn period. H. 29.7 cm. Chinese government.

quantities from the early sites of Zhengzhou in Henan and the site of Yidu in Shandong (Pl. 3). Other such vessels of *lei, zun,* and *dou* types, belonging to the Western Zhou period, were discovered at the excavation sites of Dantu and Zhenjiang in Jiangsu, Tunqi in Anhui (Fig. 17), and Luoyang in Henan. The wares of the Shang period unearthed at Zhengzhou and Anyang were originally thought to have been produced in those areas where they were found. Recent studies in China, however, indicate that they must actually have come from Jiangnan, the extensive area south of the Yangtze River, including southern Jiangsu and northern Zhejiang. These pieces, though they were excavated in central China, were probably brought from the south as trade goods.

This conclusion is drawn from the evidence of the great quantity of ash-glazed wares discovered south of the Yangtze River basin and from the results of chemical analysis of these wares. It may further be concluded that ash-glazed pottery originated in the south, unlike the gray and black wares, and continued its development there until the sixth century.

High-Fired Stamped Ware

A stoneware closely related to the ash-glazed wares discussed above is a high-fired ware with stamped patterning, developed along the southeast coast of China (Fig. 18). This ware evolved from the low-fired stamped earthenware produced in the same region beginning in the Shang period. The high-fired stamped ware resembles gray pottery, differing in that the clay body is more

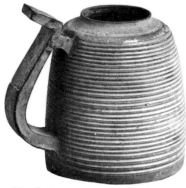

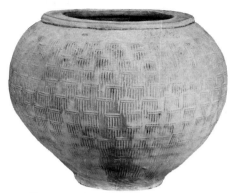

19. Handled stoneware jug with grooves. Ash-glazed ware, Warring States period. H. 11.2 cm. Shanghai Museum.

20. Stoneware jar. Stamped ware, Warring States or Han dynasty. H. 12.1 cm. Keiō University.

firmly contracted and is covered with stamped geometric patterns such as trellis, squared spiral, and stepped line designs. The characteristic stamped decoration evolved naturally from the process of beating coil-built vessels with wooden paddles, which improved the rather irregular shapes of these wares. No doubt the impressions that remained from the beating process pleased the potters, who began carving paddles with designs to stamp the finished vessels with geometric patterns.

High-fired stamped ware was produced from the Spring and Autumn period (722–481 B.C.) all the way through the Han dynasty. Most of the examples of this type are jars with low, bellied sides, some of which are coated here and there with a natural ash glaze (Fig. 20). A late example of this ware has a stamped coin pattern (Fig. 21). A slightly different group of jars were fashioned on the potter's wheel in the same shape, but are marked with rows of grooves. A few have a thin coating of ash glaze. One example is the handled jug, noted for its exceptional shape, unearthed from Yizheng in Jiangsu (Fig. 19). These vessels were produced in the region of the Huai and Yangtze river basins, which includes Jiangsu and the northern part of Zhejiang.

Both of these wares are quite different from the Shang and Western Zhou ash-glazed wares. Though the wares produced in the centuries during the Spring and Autumn period and the Han period were fired in high-temperature kilns, they were not glazed intentionally and were not copies of bronze shapes. Despite these major differences, both the ash-glazed ware and the unglazed, high-fired stamped ware were produced in the same region: south of the

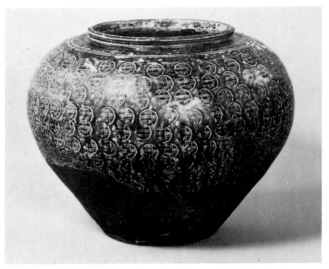

21. Stoneware jar with stamped coin motif. Ash-glazed ware, Western Jin period. H. 31.5 cm. Private collection.

Yangtze River basin. Kiln sites of the Western Zhou period, discovered in the district of Jinhua in Zhejiang, verify that there was a time when both wares were fired together in the same kilns. For some unknown reason, ash-glazed pottery production declined in the Spring and Autumn period to be replaced by the unglazed stamped wares, which, though unglazed, flourished as utilitarian vessels for daily use. What caused this change and why ash glazing did not develop further at this time are questions that require more study.

4

Proto-Porcelain

Many examples of pottery produced before the Warring States period are currently accessible only in China, with the exception of Gansu Yangshao painted pottery. And the research concerning these rare specimens is still at a relatively immature stage. Our knowledge of Han pottery, however, is very broad. The numerous artifacts of the Han period, especially the ash-glazed stoneware, have helped to provide detailed information on the development of ceramics at that time.

Han ash-glazed stoneware is commonly referred to in Europe and North America as proto-porcelain, a term coined by the American scholar Berthold Laufer. The ash-glazed wares collected by Laufer in China at the beginning of the twentieth century are believed to be the forerunners of celadons, hence a prototype of porcelain.

Ash-glazed pottery that developed in the Shang and Zhou periods went into a decline, for reasons unknown, in the Spring and Autumn period. Ash glaze was used only on the few high-fired wares, distinguished by their groove patterns, that were produced in the Huai and Yangtze river basins. The large quantity of proto-porcelain that has survived and recent excavations in China, however, point to a revival of ash-glazed pottery production in the early Han period. It is not clearly understood why this occurred, but the historic conditions in China during the intermediate Warring States period give us some clues. Changes in economy and culture were frequent during this period. Chinese society was revolutionized by the beginning of ironware production and the minting of coins. Fresh ideas expounded by philosophers of

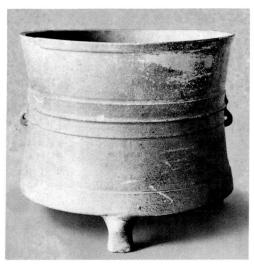

22. Stoneware *lian*. Ash-glazed ware, Warring States period. Museum of Far Eastern Antiquities, Stockholm.

the "Hundred Schools" and new fashions introduced by the horse-riding tribes of the north and the west stimulated Chinese arts and crafts, which had been stagnating since the Western Zhou period. The novel styles of the Warring States metal and lacquer wares are clear evidence of this. Ceramics did not undergo quite the same sort of upheaval, but magnificent ash-glazed wares were produced at this time in Chinese history.

Ash-Glazed Pottery of the Warring States Period

Examples of late Warring States ash-glazed wares have been unearthed from the region of the Huai and Yangtze river basins, where the high-fired wares with groove patterns were also discovered. Faithful reproductions of late Zhou bronzes, these wares are coated with a well-fused, smooth yellow green ash glaze. The glaze shows a remarkable improvement upon earlier versions; it is likely that particles of feldspar were mixed with the ash to stabilize the glaze and cause it to melt evenly.

The *ding, yi,* and *he* (tripod ewer) vessels in the Ashmolean Museum, Oxford; the *jian* (large basin) in the East Asian Museum, Berlin; the *zhong* in the Seattle Museum; the *lian* (cosmetic box) in the Museum of Far Eastern Antiquities, Stockholm (Fig. 22); the *he* in the Shanghai Museum (Pl. 4); and the *chunyu* (drum) in the Brundage Collection, San Francisco, are all examples of late Warring States ash-glazed ware. Orvar Karlbeck and W. Hochstadter were the first to point out the excellent ash glazing. Karlbeck gave these stoneware vessels the name "Early Yue ware" to mark them as the fore-

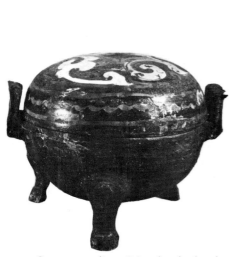

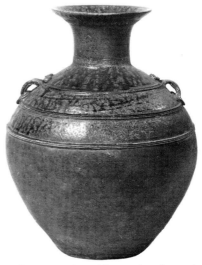

23. Stoneware *ding*. Painted ash-glazed ware, Western Han period. H. 18 cm. Hunan Museum.

24. Stoneware jar with two handles. Ash-glazed ware, Western Han period. H. 42.5 cm. Private collection.

runners of the Old Yue celadons, the ware produced in the Yuezhou area. Strictly speaking, these cannot be called "Yue ware" since they were produced much earlier than Old Yue ware, which did not appear until the Eastern Han period, and may not have had direct influence on Old Yue ware.

The shapes, resembling those of the bronzes discovered at the tombs of the Chu kingdom in Shouxian County, Anhui, suggest that this pottery may have been manufactured in the Zhejiang area. If, as Chen Wanli claims, they were fired at Shaoxing in Zhejiang, then these wares would be the ultimate predecessors of Old Yue ware, for the district of Shaoxing was later to become the headquarters of the Yue kilns.

It is thought that the late Warring States ash-glazed stoneware originated in a conscious effort to revive the traditional ash-glazing technique of the Shang and Zhou periods, and that this effort was undertaken in response to the request of a powerful person in the kingdom of Chu. The attempt proved fruitful, as is evident in the excellent glaze quality and careful reproduction of bronze forms.

The late Warring States ash-glazed stoneware may have provided the inspiration that led to the flood of proto-porcelain wares in the early Han period. Ironically, it may have been too excellent a predecessor, for the Han proto-porcelain proved to be inferior in glaze and form, as will be explained later.

The Appearance of Proto-Porcelain

The ash-glazed pottery of the late Warring States period, first appearing in

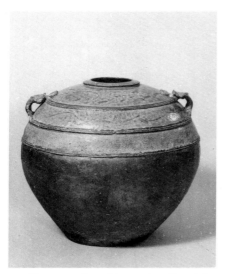
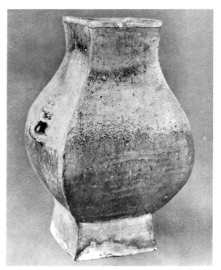

25. Stoneware jar with two handles. Ash-glazed ware, Western Han period. H. 31.4 cm. Private collection.

26. Stoneware *fang*. Ash-glazed ware, Western Han period. H. 40 cm. Private collection.

Zhejiang where the Yue kilns would later spring up, must have had a surprising impact upon the contemporary Chinese culture. Kilns of many other areas probably attempted to make copies, but it was not until the Han period that a proto-porcelain was successfully produced.

These proto-porcelain stonewares also attempted to duplicate bronze shapes, but the distinguishing characteristics of the bronzes were omitted, the shapes of the proto-porcelain soon becoming stylized (Figs. 23–24). This imperfect reproduction of bronze shapes was apparently not very important, however. Their thick bodies were firmly contracted and covered on the outside with a well-fused ash glaze, making these wares much more utilitarian than the gray and black wares made for daily use up to this time. This aspect was probably all that was needed to make the proto-porcelain popular with the people of the time.

Though this ware is usually referred to as the ash-glazed pottery of the Han dynasty, the proto-porcelain glaze did not in fact completely fulfill the function of a glaze in that it did not coat both the interior and exterior of the vessel. Therefore the glaze alone would not prevent the permeation of liquid. The high temperature needed to melt the glaze, however, caused the clay body to contract firmly, simultaneously melting the feldspar and iron in the clay. This provided some resistance against permeation. The degree of contraction is evident in the shiny reddish exposed portions that are produced by the iron content of the clay in an oxidation atmosphere at some point late in a reduction firing.

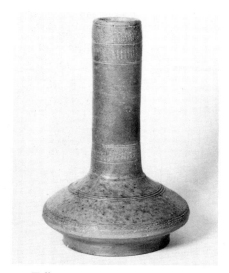

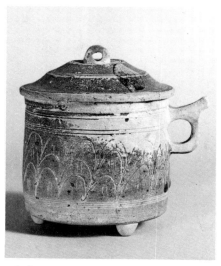

27. Tall-necked stoneware vase. Ash-glazed ware, Western Han period. H. 24.4 cm. Private collection.

28. Stoneware cup with cover and handle. Ash-glazed ware, Western Han period. H. 11.5 cm. Private collection.

The Two Basic Shapes of Proto-Porcelain

Proto-porcelain ware consists of basically two kinds of jars. One has a rounded body with a high neck spreading at the mouth, a flat base, and two monster-mask ring handles attached at the shoulders (Fig. 24). The neck and handles are copied from the *zhong* bronze, but the pottery vessel lacks the distinctive high foot of the bronze, which may have been omitted for functional reasons. The other jar has the same type of handles on a spherical body and a low neck or a flat mouth with an upturned rim (Fig. 25). The stylized monster mask was derived from the *taotie* mask, which was an important motif in ancient Chinese hieratic art. Its meaning is not clearly understood but is traditionally considered to be a protection against devils.

These two basic shapes are often decorated with several horizontal lines, either grooved or raised in relief from the shoulder to the waist, which divide the body into several sections and accent the body shape. Sometimes these sections are decorated with patterns of incised undulating lines, or with animal and cloud designs etched with a spatula. The Old Yue celadon, which followed, also employed two similar basic forms: two kinds of handled jars, one with a wide, low neck and the other with a high neck and a dished mouth. That two similar shapes should have been the representative types of Old Yue ware suggests that the Old Yue forms evolved from those of proto-porcelain.

There are other shapes found in proto-porcelain ware, though not many. Some of these are copies of bronzes, such as the *zhong* with its high foot, the

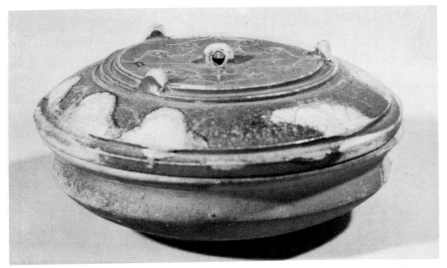

29. Stoneware covered box with incised quatrefoil pattern. Ash-glazed ware, Western Han period. D. 19 cm. Private collection.

fang (square jar; Fig. 26), and the *ding* with its lid. In the area of Anhui and Hunan we find such irregular shapes as tall-necked bottles (Fig. 27), covered boxes with openwork decoration, and covered cups with handles (Fig. 28). Some of these have a thin coating of ash glaze (Fig. 29).

The majority of the proto-porcelains discussed above are most likely products of the region south of the Yangtze River basin since they are fairly different in shape from the green or brown glazed ware produced in the north at that time.

5

Green and Brown
Lead-Glazed Earthenware

In addition to the gray pottery with its painted and black variations and the ash-glazed pottery already mentioned, Han and Three Kingdoms pottery included a low-fired lead-glazed earthenware known as green and brown glazed ware. Low-fired glazed ware, which had flourished in West Asia since early times, came to be widely used in China as well, though not until the beginning of the Han dynasty (206 B.C.–A.D. 220). Only a few exceptional pieces of this type were made in China before that time. One is a light green glazed jar (Fig. 30) belonging to the Nelson Gallery of Art, Kansas City, that is traditionally attributed to the find from the site of Jincun in Luoyang, famous for its artifacts of the Warring States period. Other examples include the small vases coated with colored glazes compounded probably of frit, one of which belongs to the Tokyo National Museum. The similarity in quality between the glazes and later lead glazes suggests that these pieces were precursors of the Han and Three Kingdoms low-fired lead-glazed pottery. There is some difficulty, however, in confirming this because of the scarcity of such pieces and the great span between the Warring States and Han periods. More research is needed in this area.

Techniques of Low-Fired Glazing

The low-fired green and brown glazes are composed chiefly of silicate of a vitreous nature to which a copper oxide is added to create a green color or an iron oxide to create a brown color. This addition of copper or iron oxide alone does not constitute a true glaze. Some sort of paste or flux is required to make the glaze fuse and adhere to the clay body of the vessel. The addition of a lead

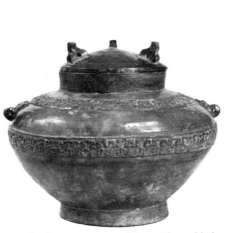

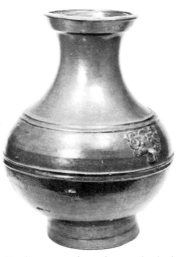

30. Earthenware covered jar with molded decoration, green lead glaze. Warring States period. H. 19.7 cm. Nelson Gallery of Art, Kansas.

31. Earthenware *zhong*, brown lead glaze. Western Han period. H. 37.3 cm. Osaka Municipal Museum of Art.

flux made the solution a true glaze. This type of glaze is known as low-fired lead glaze to distinguish it from another type of low-fired glaze developed in West Asia that uses a soda flux. Glaze colors will vary with the type of flux used. Copper oxide combined with a lead flux produces the green of Han-period green glazed wares. A soda flux produces the same bright blue as the blue glazed faience ware of ancient Egypt.

Insufficient understanding of the function of flux in a glaze led to the belief that Han green and brown glazed wares were simply attempts to copy the low-fired glazed wares of West Asia. The differences in flux, however, discount this theory, though similarities in the use of low-fired glazing techniques make it difficult to deny that West Asian soda-fluxed glazes must have had some influence upon the Chinese wares. During the Eastern Zhou period, trade was lively between East and West; West Asian pottery and glazing techniques are likely to have been introduced into China during that time.

Seiichi Mizuno, a Japanese archaeologist, has advanced the theory that the Chinese potters originally attempted to use the West Asian soda glaze without alteration, but this ended in failure since the soda glaze would not stick to the highly viscous Chinese clay. To make the glaze compatible with the clay, the soda was replaced with a lead flux long used in China for alchemy.

There is an alternative theory concerning the origins of low-fired lead-glazed wares. A lead-fluxed glaze was first developed in the West sometime in the third century B.C. No kiln sites have yet been discovered, but green and brown glazed wares and wares of both colors, one on the interior and the other

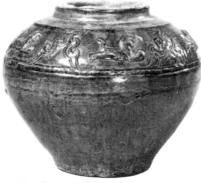 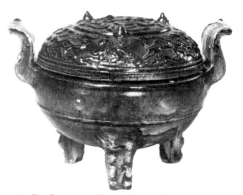

32. Small earthenware jar with molded decoration, green lead glaze. Eastern Han period. H. 13.3 cm. Private collection.

33. Earthenware *ding* with molded decoration, green lead glaze. Eastern Han period. H. 18.5 cm. Private collection.

on the exterior of the vessel, have been unearthed along the Mediterranean coastal region of Greece, Asia Minor, Turkey, and Syria. These pieces are made of the same viscous reddish clay used for the terra cotta and earthenware of those regions. This seems to verify that the Egyptian type of soda glaze was not suitable for the clay of these wares. A suitable glaze was eventually devised with the substitution of lead for the soda flux, thereby making possible the production of a green glazed pottery that differed from the Egyptian-style blue faience ware. The lead-fluxed glaze of the West must have provided stimulation for the development of low-fired glazing techniques in China.

The Beginning of Green and Brown Glazes

At what point in the Han period did green and brown glazes first begin to appear? Studies of the excavated pieces available lead to the conclusion that the brown glazed ware was the first to appear, in the middle of the Western Han period. The green glazed ware made its appearance a little later, sometime in the latter half of the same period, and far surpassed the brown in quantity. As green glazed ware became much more popular, production of brown glazed ware seems to have gradually declined during the Eastern Han period. The earlier development of the brown ware can be explained if one considers that the glaze coloring agent was an iron oxide readily available and familiar to the Han potters as a pigment for painted pottery. The brilliant quality of the green glaze, however, brought on the decrease of brown pottery production. Both the brown and green glazed wares were produced solely as *mingqi* used

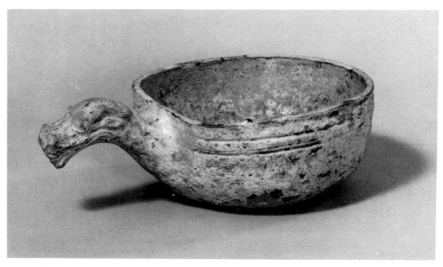

34. Earthenware ladle, green lead glaze. Eastern Han period. L. 25 cm. Private collection.

as offerings in prayer and commemoration of the dead and sealed within the tomb.

Production Techniques

The body of these wares is fine-grained clay with iron content. Very similar to the earlier painted and gray earthenwares in quality, the unglazed portions of the green and brown glazed wares have a red tint caused by iron in an oxidation firing cycle. Oxidation firing at low temperatures brought out the bright colors of the glazes.

Most of these wares, other than those of irregular shape, were fashioned on a potter's wheel. Some show traces of having been thrown on the wheel, especially on the base where a cord was used to cut the finished pot off the wheel. The thick walls are thought to be intentional because the higher fragility of the low-fired ware made it necessary to make the vessel as stable as possible. Decoration consists of incisions on the suface with a comb and a spatula, molding in low relief (Figs. 32–33), impressions on the surface of the ware, and applied molded decoration (Fig. 31).

Glaze was applied in thick, rich coats except on the base and the interior of hollow vessels such as vases; only visible exterior portions were glazed. Since they were funerary vessels, there was no need to be concerned about leakage and hence no need to glaze the vessel interiors.

Unlike the ash-glazed wares, the green and brown glazed wares were fired at low temperatures between 700 and 800°C. Peculiar characteristics due to

35. Earthenware covered box, green lead glaze. Eastern Han period. H. 16.7 cm. Private collection.

the firing practice are evident: many pieces were fired upside down, causing the glaze to run from the foot to the mouth, where it stopped in prominent drops. The contemporary high-fired ash-glazed ware does not show this peculiar trait.

Characteristic Shapes

The green and brown glazed wares are usually copies of contemporary bronze and lacquer vessels, which they were meant to replace as funerary vessels. The most basic shapes are of *zhong* (Fig. 31) and *pou* (Fig. 32). The *zhong* is characterized by a high foot, bellied body, and tall neck ending usually in a dished mouth. On either side of the body are monster-mask ring handles molded in raised relief. The *pou* has a subspherical body with a low neck. There are also *ding* (Fig. 33), *pan* (high-footed dishes), *xi* (basins), ladles (Fig. 34), handled cups, covered boxes (Fig. 35), cylindrical *lian* (Pl. 20), "Boshanlu" incense burners in the shape of a Taoist sacred mountain (Fig. 36), and a variety of lamps (Fig. 37). Another very different genre includes a variety of figurines and miniature objects such as wells (Fig. 38), mortars, ovens (Fig. 39), storehouses, and other buildings (Fig. 41).

The green and brown glazes were used separately; only rarely were both glazes applied to the same pot. After a pot was completely coated with the brown glaze, then the green glaze might be used to highlight the decorative motifs (Fig. 40). Apparently the unstable nature of the green glaze causes it to peel when in contact with the brown glaze coating underneath, which is

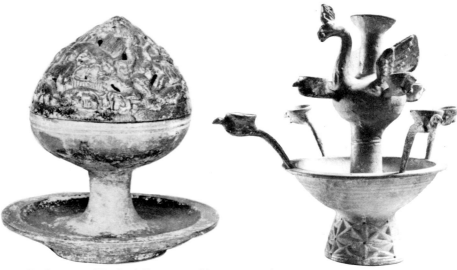

36. Earthenware "Boshanlu" censer with molded decoration, green lead glaze. Eastern Han period. H. 21.6 cm. Osaka Municipal Museum of Fine Art.

37. Earthenware lamp, green lead glaze. Eastern Han period. H. 50.7 cm. Tenri Sankōkan.

38. Earthenware model of well with stamped pattern, green and brown lead glazes. Eastern Han period. H. 8.4 cm. Waseda University.

39. Earthenware model of oven, green lead glaze. Eastern Han period. H. 36.4 cm. Kyoto University.

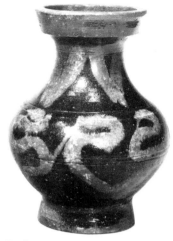

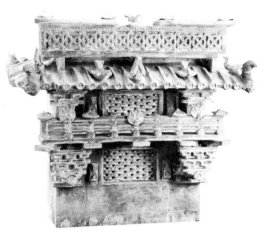

40. Earthenware *zhong*, green and brown lead glazes. Eastern Han period. H. 28.5 cm. Private collection.

41. Earthenware model of building, green lead glaze. Eastern Han period. H. 49.8 cm. Private collection.

probably why there are so few examples of this type. The opposite of this procedure, that is a green glaze coating with brown highlights, has never been found. This may be due to the composition of the two glazes and the way in which they react to each other.

Most surviving instances of the green glazed ware have a lustrous surface (Fig. 35). This luster is a result of decomposition of the glaze during centuries of burial. The surface of the glaze has weathered and separated into several thin membranes through which the light filters, resulting in a silvery iridescence. The brown glazed wares seldom have this luster, probably due to the dominance of iron in the glaze.

Distribution

Green and brown glazed wares were distributed throughout central China, predominantly in Shaanxi and Henan. The official kilns for funerary vessel production, rather than the production of utilitarian vessels, were in the areas centering around Chang'an, the Western Han capital, and Luoyang, the Eastern Han capital. The aristocrats who were awarded the funerary vessels also lived in these areas. It is therefore natural that a great number of the green and brown glazed wares should have been discovered there. Just as so many of these official vessels were true copies of the bronzes of that time, so the miniature clay buildings (Fig. 41) reflect the architecture of that time and give a sense of the atmosphere of central China in the Han dynasty. There are certain examples of figurines (Fig. 42) unearthed from the Changsha site in Hunan

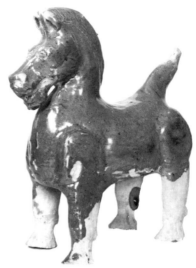

42. Earthenware horse, brown lead glaze. Western Han period. H. 31 cm. Osaka Municipal Museum of Fine Art.

and green and brown glazed vessels excavated from Nanchang, Jiangxi, that differ considerably from those of central China. This particular group of figurines and other wares must have been produced at other local kilns, probably in the south.

The above is simply a rough outline of the development of low-fired green and brown glazed wares, the first wares to be mass-produced in China. Their most distinct characteristics are their brilliant color and luster. When we consider that the Chinese people of those times were already familiar with more advanced glazing techniques, it seems odd that the green and brown wares were not developed further. The glaze would have been more striking on a white body; for this a white slip could have been applied as was often done with the painted gray pottery. By glazing both the outside and the inside, the vessels would have become more utilitarian. For a more durable ware, the clay bodies could have been fired once before glazing for firm contraction, and then they could have been fired again at a low temperature after glazing as the ancient Japanese did with their green glazed wares.

There is no trace of such improvements having been attempted at any time in the three hundred years during which this type of ware was produced. These beautiful wares were only meant as funerary vessels; such usage would not have been a stimulus for further development of glazing techniques. Though Western peoples showed a great interest in low-fired wares, the Chinese did not; high-fired ware always predominated in Chinese ceramics history.

6

The Rise of the Yue Kilns

The Beginning of Old Yue Ware

It is generally believed that the ash-glazed pottery so popular during the Han period was at first produced in several different areas south of the Yangtze River. Some time in the Eastern Han dynasty, production was gradually centralized. A pottery production center at that time required an abundance of fine clay, wood for fuel, and ash glazes, and a canal system to transport the final products for widespread distribution. The region of Yuezhou, centered in Shaoxing, Zhejiang, apparently met these qualifications. Large groups of kilns were established in the counties of Jiuyan, Deqing, Shangyu, and Shangdong, where a great quantity of refined ash-glazed stoneware was turned out. It was these kilns that marked the establishment of the celadon kilns commonly known as Yuezhou *yao, yao* meaning a kiln or kilns and also the ware itself. The magnificient ash-glazed pottery produced in this region during the Warring States period has already been discussed. It is most likely that the tradition of these ash-glazed wares was revived in the Eastern Han period and continued through a long and uninterrupted time of production.

The dating of the beginning of the Yue kilns in the Eastern Han period is supported by certain circumstantial evidence such as the sampling of ash-glazed ware unearthed from the ancient Xinyang tomb in Henan. The specimens from this brick tomb of the second century A.D. include jars with four lugs and dished mouths, *xi* (basins), and bowls. Seiichi Mizuno and Fujio Koyama believed these to be products of Yue kilns. The style of the jars and the

43. Stoneware *xi* (inverted), ash glaze. Yue ware, Jin dynasty. Ashmolean Museum, Oxford.

44. Stoneware *xi* with stamped basket-weave design, ash glaze. Yue ware, Jin dynasty. D. 28.3 cm. Private collection.

stamped basket-weave pattern applied on the exterior of the *xi* (Fig. 44) do indeed show characteristics of Old Yue celadon, the precursor to the Tang type, and are distinct from other common Han ash-glazed wares.

We therefore know that, at the very latest, Old Yue ware must have made its first appearance as early as the second half of the Eastern Han period. As the age of the Three Kingdoms evolved into the Western Jin period, the production of Old Yue ware steadily expanded and covered a larger and larger area. Recent investigations in China prove that more than ten groups of kilns including Xiaoshan and Yuyao existed in Zhejiang alone. It has also become clear that Yue-type kilns producing ash-glazed stoneware were scattered over a broad expanse including Jiangsu, Fujian, Hunan, Sichuan, and Guangdong provinces. It is evident then that the term Old Yue cannot be restricted to the proto-celadon ware of the Yue kilns alone but must include the Yue-type celadon produced throughout the southeast coastal region.

Features of Old Yue Ware

Although it is difficult to define the basic character of Old Yue ware, there are some general features common to the pottery produced in this region. The clay is plastic, close-grained, and highly contractive in firing. A certain amount of iron in the clay caused the unglazed portions of the vessels to turn a bluish gray color in reduction firing. Many of the Yue-type kilns used small lumps of clay as spurs to prevent the pottery from sticking to the kiln floor during firing. As a result, there are many pieces with pale patches haloed

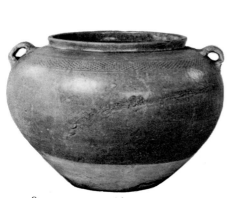

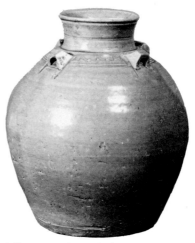

45. Stoneware jar with stamped pattern, ash glaze. Yue ware, Three Kingdoms or Western Jin period. H. 13.7 cm. Kyoto University.

46. Stoneware jar with four lugs, ash glaze. Yue ware, Jin dynasty. H. 27.8 cm. Private collection.

in reddish brown on the base that were left by these clay spurs (Fig. 43).

Though most Old Yue ware was formed on the wheel, irregular shapes and applied ornamentation were made by molding or hand-pinching. The ash glaze covering these vessels is a mixture of ash, feldspar, and lime. The ash was obtained from wood and ferns, plentiful south of the Yangtze River and high in iron. Old Yue ware displays two types of glazes, one highly transparent and glossy and the other translucent with a dull luster. It is likely that the translucent glaze contained more feldspar. The difference in glaze tone seems to be more a result of variations in firing cycles than of differences in time and place of production. This ware was meant for practical use and was coated with glaze inside as well as out.

Old Yue ware is held in high esteem because of its great superiority over its predecessors, a superiority that lies in the quality of the glaze. As glaze ingredients were refined and improved upon, the glazes themselves became less and less uneven in texture and color. Different temperatures of reduction firing have produced colors ranging from a bluish olive green to a light green. Old Yue ware cannot stand comparison with the Late Tang Yue celadon and the true celadon of the Song dynasty, but it still shows considerable advance in technique.

Recent examinations made in China have verified that the Old Yue ware of the Shangyu kilns in the Eastern Han period has a 0.16 to 0.18 percent water-absorption rate, proving that these examples are the same quality as perfect celadon wares. My examinations of some shards of this type through the good

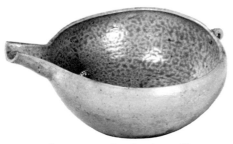

47. Stoneware *yi*, ash glaze. Yue ware, Eastern Han or Three Kingdoms period. L. 20.5 cm. Private collection.

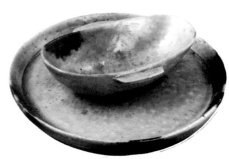

48. Stoneware cup on saucer, ash glaze. Yue ware, Southern Dynasties period. D. 16 cm. Kyoto University.

offices of Feng Xianming, a ceramics expert, reveal that they are indeed perfect specimens of celadon ware.

Characteristic Shapes

Many of the shapes of Old Yue ware produced at the beginning of the Six Dynasties period were copies of bronze vessels. Specimens of *xi*, a basin with a wide rim, and stemmed bowls with monster-mask ring handles have been discovered in the tomb of Xinyang, previously mentioned. *Lian* and *you* (handled wine vessels) shapes have also been discovered. These shapes began to deviate from their bronze prototypes at a very early stage, becoming more functional and refined. It should also be noted that there are no copies of typical *ding* and *zhong* bronze shapes to be found. The absence of these shapes seems to imply a gradual drift away from the need to remain true to the original forms of the ritual and ceremonial bronzes and lacquerware.

The greater portion of Old Yue ware has new and unique shapes. These shapes are the first indication of the development of pure pottery forms. This is very significant, for up to this time in Chinese ceramics history, all Chinese earthenware and stoneware, except for painted pottery and stamped pottery, borrowed their shapes from ritual bronze and lacquer vessels. It was not until the appearance of Old Yue ware that Chinese pottery was revolutionized, becoming a fully independent craft.

Old Yue ware established pottery as something unique: cheaper than bronze, easier to produce than lacquer, and yet durable and water resistant.

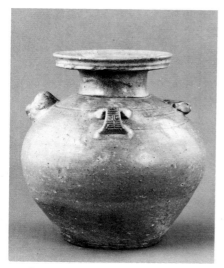

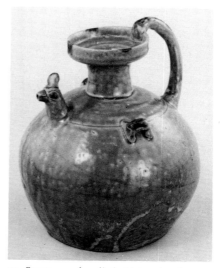

49. Stoneware chicken-head jar, ash glaze. Yue ware, Western Jin period. H. 16.5 cm. Private collection.

50. Stoneware handled chicken-head ewer, ash glaze with iron spots. Yue ware, Eastern Jin period. Yamato Bunkakan, Nara.

There are traces of this trend in the stylization of *zhong* bronze shapes in other Han ash-glazed wares, but it was not until the advent of the Yue kilns that the field of ceramics firmly established its independence.

The most common Old Yue shapes are variations on two kinds of jars. One of these basic forms, evolved from the *zhong*, has a dished mouth on a rather high neck. The other has a subspherical body and a wide mouth on a short, straight neck (Fig. 45). It seems to have evolved from the *pou*.

There are many variations derived from these two basic shapes. For example, there are *zhong*-shaped jars with slightly flared mouths (Fig. 46) and top-heavy, elongated *pou*-shaped jars. All of the variations have one common characteristic: small, functional lugs attached at the shoulders. The earlier Han ash-glazed wares of these types bore monster-mask ring handles. Originally, the rings provided a means of carrying the pots, but later they became purely decorative and were molded in relief. As if in contrast, the two to eight small lugs found on Old Yue ware are quite sturdy and functional. It is easy to deduce that a cord must have been passed through the lugs to secure a lid.

Chicken-Head Ewer

The most distinctive of all the many Old Yue utilitarian forms (Figs. 47–48) is a type of ewer known as the chicken-head ewer. The basic form is a jar with a dished mouth, a bird-head spout jutting out from the shoulder, and a thick handle opposite the spout and curving from the rim of the mouth to the shoulder. There are small lugs through which a cord can pass.

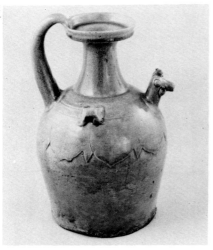

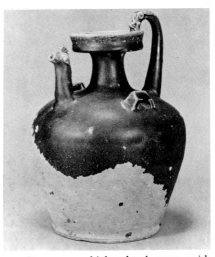

51. Stoneware chicken-head ewer with handle, ash glaze. Yue ware, Southern Dynasties period. Private collection.

52. Stoneware chicken-head ewer with handle, black iron glaze. Deqing ware, Eastern Jin period. H. 25.4 cm. Tokyo National Museum.

The first chicken-head ewer to be discovered was unearthed from a tomb of the Western Jin dynasty (265–317) bearing the date "second year of Yongning" (302). Its spout, in the form of a bird head, is short and stocky, and there is no handle. Instead, molded legs project from below the spout and a tail from the back of the jar. There are wings with incised and pecked details done with a spatula on either side of the body. Another early chicken-head ewer with less explicit decoration appears in Figure 49.

Originally this was nothing more than ornamentation in the form of a bird on a vase with a dished mouth. As time passed, however, the bird head was extended and a handle was attached. Emphasis was on the functional character of the ewer (Pl. 5, Fig. 50). The majority of the chicken-head ewers that have been discovered to date belong to the Southern Dynasties (420–589) and are representative of the final stage of their evolution (Fig. 51). The chicken-head ewer was a completely new shape originated by the makers of Old Yue ware. Still, there is evidence that the basic elements of the Chinese chicken-head ewer were imported from other countries. The oinochoe, which closely resembles the Old Yue chicken-head ewer, was being produced in large quantities from the Mediterranean region throughout West Asia at much the same time and probably stimulated the development of the chicken-head ewer.

Animal-Shaped Wares

Old Yue ware includes other animal-shaped vessels as well. There are examples in the shape of lions and sheep, apparently meant for ritual use. The lion prob-

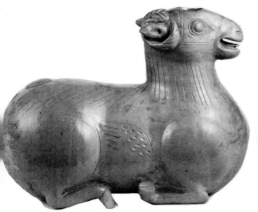

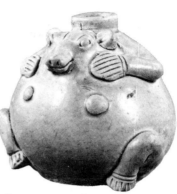

53. Stoneware jar in shape of a sheep, ash glaze. Yue ware, Three Kingdoms period. H. 27.5 cm. Private collection.

54. Stoneware candlestick in shape of a beast, ash glaze. Yue ware, Southern Dynasties period. H. 7.1 cm. Private collection.

ably represents a Han-dynasty monster that symbolized the protective deity of tombs. Under the influence of the Buddhist arts, the monster was gradually transformed into the figure of a crouching lion. Sheep designs had long been in use for the decoration of bronze vessels and represented sacrificial offering. The sheep of Old Yue ware is a faithful reproduction in a crouching pose (Fig. 53). These animal-shaped pots have a circular opening on the back or the top of the head and have hollow bodies. They could have been wine containers, such as the *zun,* or could have been used to hold flags that warded off devils.

In the Han dynasty an animal figure, resembling a squatting bear, was often used for the foot of a bronze vessel or as a weight. This form was borrowed for a type of Old Yue lampstand that consists of an oil dish supported on the head of a bear squatting in the center of a basin (Fig. 54). There is a certain vessel similar to the previously mentioned lion-shaped pots that has a curved horizontal handle on the back and a wide, open mouth. Called a *huzi,* literally meaning tiger cub, this may have been a chamber pot. Another example of an animal-shaped vessel is an openwork censer in the form of a bird cage with a molded bird perched on the top (Fig. 56). There are other even more peculiar and humorous designs such as small vases with the legs and head of a frog applied in relief, said to symbolize the frogs of the many creeks and brooks south of the Yangtze, and flasks with mouths shaped like turtle heads and flippers attached to the body (Fig. 57).

Funerary-vessel sets of animal figures are also intriguing; pigs surrounded by

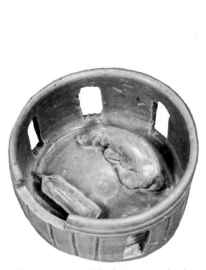

55. Stoneware model of pigpen, ash glaze. Yue ware, Southern Dynasties period. D. 12.7 cm. Private collection.

56. Stoneware censer with openwork, ash glaze. Yue ware, Western Jin period. H. 19.5 cm. Jiangsu Museum.

a small fence (Fig. 55) and chickens poking their heads out of rounded hen coops. It is a pleasure to look at these lifelike creations. Another ritual vessel, associated with popular Taoism, is a stoneware urn comprised of an elongated body with a group of molded miniature buildings, animals, and figures arranged in precarious confusion from a brim protruding from the shoulder of the urn and covering the mouth.

The Emergence of Iron Glaze

More than ninety percent of Old Yue ware is glazed with the well-known Yue celadon glaze composed of ash and feldspar. Sometime in the Eastern Han period, blackish brown iron glaze also made its appearance in the Yuezhou area. According to recent excavations at the Shangyu kiln site, it is clear that, although this type of ware was first produced by the Shangyu kilns, it is actually the products of the Deqing kilns from the Eastern Jin period that are better known today (Pl. 17, Fig. 52).

Vessels covered with a blackish brown iron glaze have been unearthed from a tomb in Hangzhou that is dated 364. This iron glaze coats jars with dished mouths, chicken-head ewers, small boxes, and cylindrical jars. Two prominent characteristics of this ware are that they were found in pairs and all had lids. The glaze is simply a celadon glaze supplemented with finely ground, natural iron oxide. A small quantity of iron results in a brown, while a large amount causes the glaze to turn almost black. Whether brown or black, the glaze usually has a beautiful luster, except when too much iron was added, causing crystals

57. Tortoise-shaped stoneware flask, brown iron glaze. Yue ware, Southern Dynasties period. D. 22.5 cm. Kyoto University.

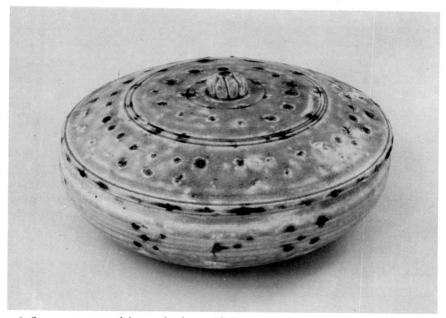

58. Stoneware covered box, ash glaze with iron spots. Yue ware, Eastern Jin period. D. 20.8 cm. Private collection.

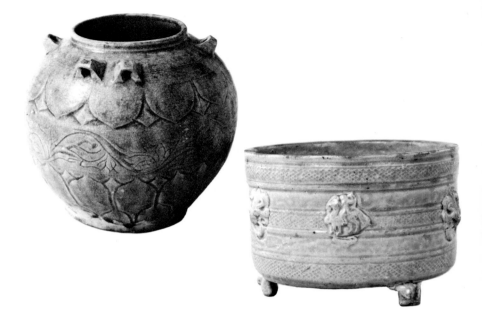

to form and dulling the glaze. The development of this iron glaze may well have been the result of attempts to copy the Han low-fired brown glaze. This would have been a simple matter for the potters of the Yuezhou area.

Celadon with Iron Spots

The iron glaze gave rise to a new glazing technique. A vessel was first coated with celadon glaze and then dotted with iron glaze before it was fired. The final product was a celadon vessel with brown iron spots. The Deqing kilns fired both iron-glazed wares and celadons, and thus the accidental splashing of the iron glaze onto a vessel coated with celadon glaze and ready to be fired probably led to this type of glazing. Jars and covered boxes are often decorated in this manner (Fig. 58). There are also some small jars shaped like a toad and spotted to resemble the real animal. The iron glaze is always dotted on, never used for linear motifs. There is a covered box in the Ashmolean Museum, Oxford, decorated with lines arranged in rows, but even these lines are composed of small iron dots.

Refined Decorative Techniques

Many Old Yue vessels are decorated with impressed motifs and carved patterns. Over time, these motifs and patterns were stylized and made increasingly complicated. The lotus-petal motif is one of the most notable. This particular design, including lotus petals facing both up and down, probably developed under the influence of the many different forms of Buddhist art being intro-

59. Left: stoneware jar with carved lotus-petal design, ash glaze. Yue ware, Southern Dynasties period. H. 20.8 cm. Shanghai Museum.

60. Right: stoneware *lian*-shaped wine vessel with stamped and molded decoration, ash glaze. Yue ware, Jin period. D. 16.2 cm. Tenri Sankōkan.

61. Stoneware jar with dished mouth, ash glaze. Yue-ware type, Southern Dynasties period. H. 26 cm. Chinese government.

duced into China at that time. One of the earliest examples is a simple lotus-petal motif stamped on a chicken-head ewer excavated from a Western Jin tomb (Fig. 65). Later, the design was executed in carved relief (Fig. 59), variation being introduced with the development of multiple, layered lotus petals.

The lotus-petal motif was especially popular. Other Buddhist motifs such as lions, phoenixes, Buddha-like figures, and attendants were molded and then luted onto the body of the vessel. Though not of Buddhist inspiration, the twelve animals of the Chinese zodiac and the four animals of the cardinal points (tortoise, tiger, bird, and dragon) were also applied in the same manner (Fig. 60). The molding technique was adapted from the small decorative panels in relief originally found on Persian-style metalware. Raised rings, also a distinctive feature, encircle the elongated necks of Old Yue jars with dished mouths (Fig. 61).

7

The Beginning of Northern Celadon

The celadon wares made in Yue-type kilns scattered throughout the provinces south of the Yangtze River show considerable variety in style and decoration. These wares include peculiar openwork vessels resembling incense burners (Fig. 62) and vessels with spouts resembling candlesticks. Both were produced in Hunan and Fujian. Many vessels with carved lotus-petal decoration were recently unearthed from the site of the Hongzhou kilns in Fengcheng, Jiangxi (Pl. 6). The first celadons of northern China that appeared in the sixth century were probably just an extension of the process by which local kilns adapted and transformed Old Yue styles and techniques.

The Celadon Jars of the Feng Tombs

Four large jars decorated with molded lotus petals in high relief (Fig. 63) were discovered in the 1950s in the tombs of the Feng clan in Jiangxian County, Hebei, dating from the Northern Dynasties through the Sui dynasty (fourth through seventh century). A chemical analysis of the clay and glazes of these jars has provided proof that they are products of the northern kilns. There was quite a sensation among ceramics historians world-wide when China announced the results of the tests. There are celadon jars similarly decorated (Fig. 64) to be found in various collections around the world, but until the discovery of the Feng jars, their date and place of production had long been a matter of debate. The Chinese reports on the excavations and chemical analysis have made it fairly certain that they were products of the northern kilns and produced in the early or mid-sixth century.

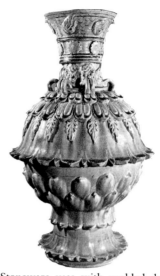

62. Stoneware censer with openwork design, ash glaze. Yue-ware type, Southern Dynasties period. Hubei Museum.

63. Stoneware vase with molded decoration, ash glaze. Northern Qi period. H. 66.5 cm. Palace Museum, Peking.

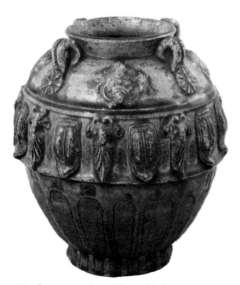

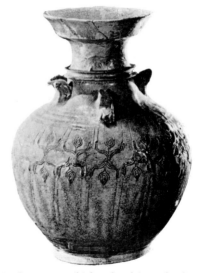

64. Stoneware jar with molded decoration, ash glaze. Northern Qi period. H. 19.2 cm. Kyoto National Museum.

65. Stoneware chicken-head jar, ash glaze. Yue-ware type, Western Jin period. Jiangxi Museum.

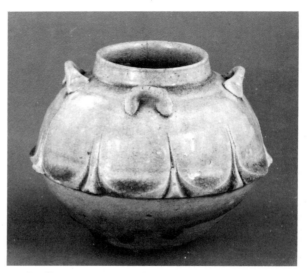

66. Small stoneware jar with carved lotus-petal design, ash glaze. Yue-ware type, Southern Dynasties period. H. 11 cm. Private collection.

Celadon had been flourishing earlier in the south, but it was not until the sixth century that it was first produced in the north. The early northern celadon ware was little more than a duplication of the flourishing celadon ware of the more progressive south. Comparison of the two wares reveals a number of similarities in shape and ornamentation.

The large jars from the Feng tombs of the north seem complicated because of the application of detailed, layered molding. Careful examination, however, reveals that the basic shape is a simple tall-necked jar with four lugs at the shoulders and two raised bands running around a flaring neck. This general shape is common in the Old Yue ware of the south produced in the Eastern Jin and Southern Dynasties. It is also to be found among the Old Yue chicken-head jars (Fig. 65) of the Western Jin period.

Lotus-petal motifs found on Old Yue ware are generally incised or carved in relief, not molded in the ostentatious manner of the Feng jars. There are, however, some Old Yue examples with ornamentation that anticipates the emergence of the elaborate molded decoration of the northern celadon. Jars with lugs (Fig. 66) have been unearthed from many sites in the south, including the Southern Dynasties tombs in Changsha. Drooping lotus petals are carved onto these vessels with just the tips of the petals protruding from the body. If the lotus petals were layered one upon the other, the highly ornamented variation found in northern celadon would be evident. Roman Ghirshman has pointed out that this sort of ornamentation shows strong influence from the gold and silver wares, embellished with repoussé or applied panels, of Sassanian

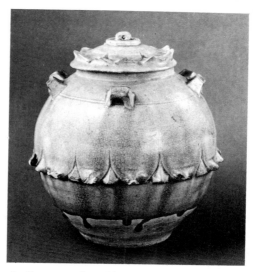

67. Stoneware jar with carved lotus-petal design, ash glaze. Northern Qi period. H. 24.3 cm. Tokyo National Museum.

Persia (third to seventh century). Beginning in the Northern Wei period (386–535), many peoples of Persian descent immigrated to northern China, and there could well have been some Persian influence on the celadons.

Other jars of the Feng type have been excavated from Wuchang in Hubei and elsewhere. In the Henan region, a slightly different type of jar was discovered (Fig. 67) that more closely resembles a Southern Dynasties Old Yue jar (Fig. 66) than it does the Feng jar. The difference in style suggests that at least two groups of kilns were producing northern celadon at the time. Feng Xianming suggests that the relatively simple jars just mentioned were even more simplified later, finally evolving into the very plain Sui celadon jar with only one or two raised bands around the body.

Differences from Old Yue Ware

Northern celadon differs most notably from Old Yue ware in its glaze tone. The northern celadon glaze tends toward a cloudy, slightly mottled bluish white (Fig. 68). This is probably because the northern potters made their glaze of straw and fern ash, with a relatively high silicate content, while the Old Yue glaze was made mainly of wood ash. A vase with molded ornamentation in the Ashmolean Museum, Oxford, displays the mottled opaque quality of the northern celadon glaze, especially where the glaze has collected. The glaze of this particular vase is a brownish black, thought to be the result of a large amount of iron.

Northern celadon clay is fairly white, slightly rough, and sandy. Old Yue

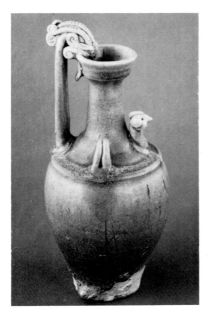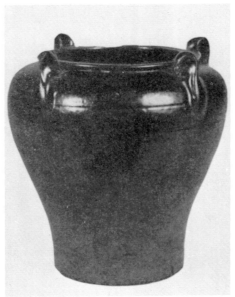

clay is gray, plastic, and close-grained. White clays usually contain little iron. The quality of the white clay in the north is the prime reason northern ceramics later surpassed the southern celadon. This same white clay had given birth to white ware near the end of the Northern Dynasties. One other point of note is that clay spurs were also used for the northern celadon pots when they were fired in a reduction kiln. The northern celadon ware, however, does not show the reddish brown spur marks on the base, characteristic of Old Yue ware.

Northern Black Ware

Two very different types of ware emerged from the development of northern celadon. One is the white ware mentioned above, which will be discussed in the next chapter, and the other is a high-fired, black glazed ware. The earliest examples of northern black glazed ware (Fig. 69) were discovered in a Hebei tomb dated 566. This find sets back the period of black glazed ware production to the mid-sixth century, a date much earlier than was originally hypothesized.

It is not surprising that the north should produce a ware in imitation of the brownish black ware of the Old Yue kilns. What is of note is that the northern black glazed ware surpassed the southern ware. A black glazed vase (Fig. 70) belonging to the Yamato Bunkakan, Nara, and fashioned like a chicken-head ewer but without the head, was once thought to be an Old Yue piece of the Southern Dynasties. Close examination, however, reveals several characteristics differing from Old Yue ware. One is that the black glaze completely covers the pot, even on the base where there are still traces showing a cord was used to cut

68. Left: stoneware chicken-head ewer with handle, ash glaze. Sui dynasty (565). H. 24.8 cm. Private collection.

69. Right: small stoneware jar with four lugs, black glaze. Northern Qi period. H. 14 cm. Hebei Museum.

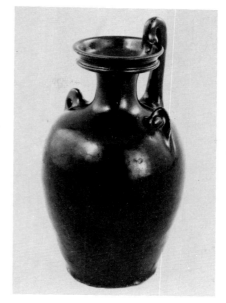

70. Stoneware ewer with handle, black glaze. Northern Qi period. H. 14.8 cm. Yamato Bunkakan, Nara.

the pot off the wheel. Small holes in the glaze on the base indicate the use of wedge-shaped clay spurs in firing. The thickness of the glaze and its deep tone are further evidence that this piece is not of the Old Yue kilns. Similar characteristics are found in several black glazed jars with lugs (Fig. 69) and in other pieces excavated from sites in Hebei. These vessels are coated with the same smooth, thick black glaze with its brown tint and dull luster. It is evident from the quality of the glaze and the manner in which it was applied that these vessels and the pot in the Yamato Bunkakan are examples of the black glazed ware of the north.

8

From Celadon to White Ware

The Beginning of White Porcelaneous Ware

As has already been pointed out, the clay body of northern celadon is relatively white compared to that of Old Yue celadon and therefore gives the glaze a brighter tone. The celadon glaze of both northern and Old Yue ware is primarily an ash glaze containing iron that acts to produce a bluish green color in a reduction firing. A colorless, transparent glaze is achieved when the bluish green tint is toned down. If the clay body is white to begin with, this results in white porcelaneous ware.

During the Northern Qi dynasty (550–77), the potters of the north apparently discovered an ash glaze that contained very little iron and made the production of white porcelaneous ware possible. This ware was made from a kaolin-type clay that produced a soft, translucent texture after firing. White porcelaneous ware should be distinguished from white porcelain, which consists of a mixture of kaolin and China stone, found in the south and producing a hard, transparent texture. Ten pieces of white ware (Fig. 71) were found in the tomb of Fan Cui, dated 575 and located in Anyang, Henan. According to Feng Xianming's report, these pieces have a refined white clay body, which is firmly contracted by high firing and coated with a finely crackled transparent glaze.

Other samples of this type of white ware (Figs. 72–73), excavated later, appeared in the exhibition of archaeological treasures from the People's Republic of China, held in Europe and Japan in 1973. These pieces were dis-

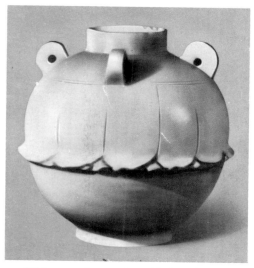

71. White porcelaneous jar with four lugs, transparent glaze. Northern Qi period (575). H. 20 cm. Hunan Museum.

covered at Sui tomb sites of the later sixth century through the early seventh century. It is probable that these wares are the improved and refined successors of the Fan Cui white porcelaneous wares. The clay bodies of both are grayish white, firmly contracted, and coated with a transparent glaze composed of ash and feldspar. They are true white porcelaneous ware, though their glaze still shows either a yellowish or bluish tint, which is due to a small amount of iron in the ash. On some of the pieces, the glaze is applied over a white slip. The transparency and crackling of the glaze may be the result of a relatively high ash content.

The Age of White Porcelaneous Ware

White porcelaneous ware attracted the popular taste with the brilliancy of its white surface. This fascination led to the decline of celadon production. Excavation of Tiejianglu, one of the oldest of the Gongxian kilns in Henan, where white porcelaneous ware was produced from the Sui through the Tang periods, has yielded fragments of Sui celadon stemmed trays and bowls together with pieces of white porcelaneous ware. This seems to indicate a changeover at the Gongxian kilns from celadon production to the production of white porcelaneous ware shortly after the end of the Sui dynasty.

Feng Xianming, who investigated the Gongxian kiln sites, further points out that the reference to "offerings of white ware as tribute from Henan during the Kaiyuan era (713–42) . . ." in ancient Chinese literature could be referring to the Gongxian kilns. He bases this theory on the fact that fragments

199156

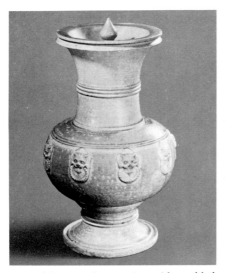

72. White porcelaneous jar with molded decoration, transparent glaze. Sui dynasty (595). H. 39 cm. Chinese government.

73. White porcelaneous covered jar, transparent glaze. Sui dynasty (610). H. 12.5 cm. Shaanxi Museum.

of white porcelaneous ware dug from the remains of the Daming Palace in Chang'an, the Tang capital, are the same as those found at the Gongxian kiln sites.

There was a rapid decline in Old Yue ware production soon after the end of the Sui dynasty. This is evident from the decreasing number of Old Yue pieces excavated from sites dating from the latter part of the seventh century to the end of the eighth century, through the Early and Middle Tang periods. It seems clear that celadon production in the Yue and Yue-type kilns was drastically reduced during this time. This was a period of transition from the age of celadon to the age of white ware.

Characteristic Shapes

While there are a considerable number of white porcelaneous wares that are derivations of the traditional celadons, there are also new forms that were thought to be more suitable for a white vessel. The jar with a dished mouth was transformed into a pear-shaped vessel with a shortened neck (Fig. 74). The jar with four lugs, a dished mouth, and carved lotus-petal motifs disappeared, to be replaced by an undecorated ovoid jar with four simple lugs, a low neck, and a low foot (Fig. 75).

The chicken-head ewer also underwent alteration. One style that developed is an oinochoe-type ewer without the chicken head, with a curving handle and projecting spout made to pour from a dished mouth, commonly known as a lobed mouth (Fig. 76). Another is a jar with a dished mouth and two

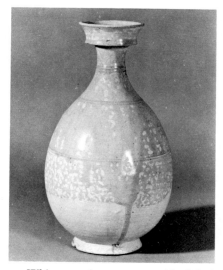

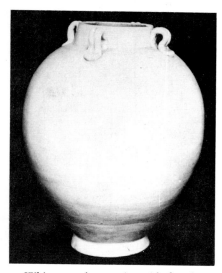

74. White porcelaneous vase with dished mouth, transparent glaze. Sui or Early Tang period. H. 22 cm. Private collection.

75. White porcelaneous jar with four lugs, transparent glaze. Early Tang period. H. 23.2 cm. Osaka Municipal Museum of Fine Art.

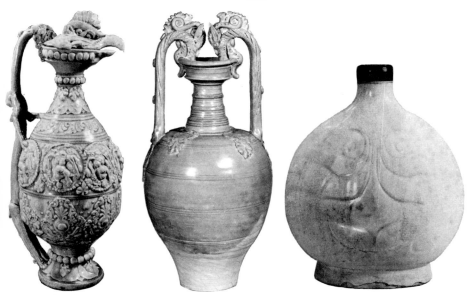

76. Left: white porcelaneous ewer with molded decoration, transparent glaze. Early Tang period. H. 41.2 cm. Palace Museum, Peking.

77. Middle: white porcelaneous amphora with dragon-head handles, transparent glaze. Sui or Early Tang period. H. 49.5 cm. Private collection.

78. Right: white porcelaneous flask with carved palmette design, transparent glaze. Early Tang period. H. 35.6 cm. Victoria and Albert Museum, London.

CHARACTERISTIC SHAPES · *53*

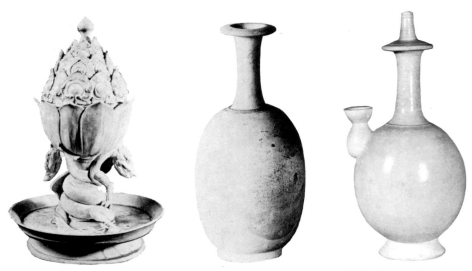

79. Left: white porcelaneous "Boshanlu" censer. Early Tang period. H. 38.2 cm. Yamato Bunkakan, Nara.

80. Middle: white porcelaneous vase with slender neck, transparent glaze. Early Tang period. Victoria and Albert Museum, London.

81. Right: white porcelaneous *kundika*, transparent glaze. Early or High Tang period. H. 26.3 cm. B.S.N. Niigata Museum.

82. White porcelaneous cups and tray, transparent glaze. Sui or Early Tang period. Tray: d. 28.5 cm. Private collection.

handles, one of which was applied in lieu of the chicken head. This particular style of jar is called an amphora with dragon-head handles (Fig. 77) since the upper portions of the handles are embellished with dragon heads.

There is still another oinochoe-type ewer with a lid in the shape of a phoenix head known as the phoenix-head ewer. One example of this kind of ewer, originally discovered in Jixian County, Henan, and belonging to the Palace Museum, Peking, has elaborate molded decoration applied over the whole body. Motifs include such exotic designs as palmettes, lotus petals, pearl beads, and West Asian musicians (Fig. 76). This ware is thought to be a faithful copy of the metalware of Sassanian Persia.

Ornamentation in the Persian metalware style is sometimes seen on other white porcelaneous wares such as candlesticks, pilgrim flasks (Fig. 78), stemmed bowls (Pl. 13), and incense burners, including the "Boshanlu" censers (Fig. 79) mentioned in Chapter 5. Still, this elaborate decoration is not seen on white porcelaneous ware as often as on the three-color wares, which will be discussed later. It is likely that plain shapes were preferred for white ware to enhance the ware's whiteness. The refinement of the Six Dynasties celadon bowls, which had thick walls and a wide mouth, into delicate plain-white bowls with high, thin walls (Fig. 82) is an example of this simplification.

Another form, originating in the metalwork of the Six Dynasties period, is a slender-necked vase with an elongated ovoid body and a low foot (Fig. 80). The Buddhist *kundika,* a ewer for holy water, resembles this vase with the addition of a projecting collar and spout (Fig. 81). Not only were these various shapes refined in the white ware, but their utility was improved as well.

9

The Revival of Lead-Glazed Earthenware

There is no satisfactory explanation of what happened to the low-fired brown and green lead-glazed earthenware that had been so popular in central China during the Han dynasty. In the south, production of the lead-glazed ware was drastically reduced when celadon came to the fore. In central China, the gradual disappearance of the ware can be attributed to centuries of upheaval suffered by the region after the removal of the Western Jin empire to the south. The name for this period given by Chinese historians—the Five Principalities and Sixteen Kingdoms (317–439)—indicates the state of confusion. Low-fired glazed ware was at its lowest point from the fourth century to the first half of the fifth century.

Tomb Finds

The technique was never lost, however. Production of lead-glazed earthenware revived in the middle of the fifth century when the Northern Wei dynasty was at last stabilized. The large number of green and brown glazed figures and horses unearthed from the tomb of Sima Jinlong (484) in Datong, Shanxi, verify this revival. The remains of a temple near this tomb also yielded a number of green glazed roof tiles which provide us with further evidence. Low-fired green and brown glazed vessels that can be dated to the Northern Wei have not yet been discovered, but it seems quite possible from the evidence of the figures, horses, and tiles mentioned above that this ware was revived in all forms around that time. The earliest examples found as of the present writing date to the Northern Qi dynasty.

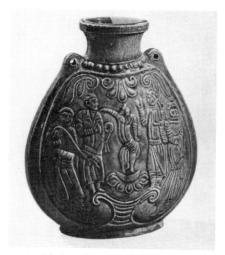 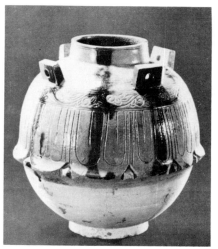

83. Molded earthenware flask with Central Asian dancing motif, brown lead glaze. Northern Qi period (575). H. 20.5 cm. Henan Museum.

84. Earthenware jar carved with lotus petals in relief, light yellow glaze over green glaze streaks. Northern Qi period (576). H. 24 cm. Palace Museum, Peking.

Glazed pilgrim flasks of amber brown (Fig. 83) were also excavated from the tomb of Fan Cui (575) in Anyang, Henan, where the earliest examples of white porcelaneous ware were discovered. These flasks are cast in a two-part mold decorated with exotic West Asian motifs in relief. The flasks are then coated with a shiny amber glaze covering the whole surface. Similar pilgrim flasks in green also exist. The tomb of the Feng clan in Jingxian County, Hebei, previously mentioned, had several white clay bowls and vases coated with a green glaze. Broad, vertical streaks of green glaze under a light yellow glaze embellish lotus-petal-design jars (Fig. 84) discovered at the tomb of Li Yun (576) in Puyang, Henan. These examples of low-fired green and brown glazed ware are rather few in number but still enough for us to conjecture that production of low-fired lead-fluxed ware was revived at least by the Northern Qi dynasty.

There are several new variations on the traditional low-fired lead glazing worthy of note. One is the use of a white clay that greatly enhances the glaze color. Another is the use of the green glaze with a contrasting yellow glaze; this technique foreshadows the birth of Tang three-color ware. The yellow glaze was derived by reducing the iron content of the brown glaze. These features do not appear on the low-fired green and brown glazed ware made before the Northern Qi period. Diversification of the ware continued through the Sui and Tang dynasties.

Persian Influence

Jars (Fig. 85) and vases (Fig. 86) with elaborate applied molded decoration such

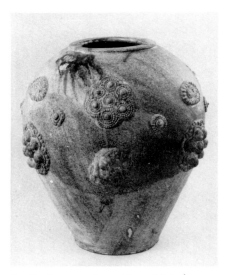

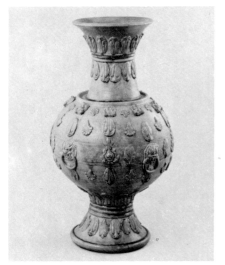

85. Earthenware jar with molded decoration, green lead glaze. Northern Qi period. H. 36.0 cm. Private collection.

86. Earthenware vase with molded decoration, brown lead glaze. Northern Qi or Sui dynasty. H. 45.5 cm. Private collection.

as palmettes, angels, and flaming pearls are to be found among the lead-glazed ware of the Northern Qi period. It has already been pointed out that these motifs and their method of application can be traced back to imported Persian metalwares. The popularity of the Persian motifs and their use on celadon and white porcelaneous wares has already been noted.

A green glazed incense burner, "Boshanlu" (Pl. 21), in the shape of a cosmic mountain, merged these Persian influences with a distinctive Chinese style to create a new fashion. A stem encircled by dragons supports a lotus-shaped burner with a conical lid composed of layered palmette panels. Examples of this kind of Boshanlu incense burner can be found in the Palace Museum in Peking and in a private collection in Kobe.

Such elaborate decoration, however, did not remain popular for very long. Plain shapes and subdued decoration came to be preferred just as they had been in the white porcelaneous ware. There are only a few specimens of low-fired monochrome glazed ware produced in the Sui through the Early Tang period that still remain in existence, but there are enough to demonstrate the simplification process. A green glazed ewer with bellied body, low neck, and lobed mouth, belonging to the Yamato Bunkakan in Nara, has only some simple ornamentation on the handle. A vase with four strap lugs (Fig. 87) in the Osaka Municipal Museum of Fine Art and a pear-shaped vase with a dished mouth in the Victoria and Albert Museum, London, are brown glazed and have no applied decoration.

After it was revived in the Northern Qi period, there was no noticeable

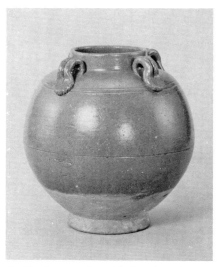

87. Earthenware jar with four lugs, brown lead glaze. Early Tang period. H. 18.8 cm. Osaka Municipal Museum of Fine Art.

expansion of low-fired glazed ware from the Sui to the Early Tang period. A large number of low-fired monochrome figures were excavated from the tomb of Zheng Rentai (664) in Liquan, Shaanxi, but only three small green glazed jars, each with four lugs, were found. Excavations of other tombs of the same period yielded similar results. For some reason, low-fired glazed ware production entered a period of stagnation. Only the tomb figures continued to be produced at the same rate as before. In contrast, celadon, white porcelaneous ware, and black glazed ware abound in these same tombs.

10

Tang Three-Color Ware

Of all the wares in China's long history of ceramics production, the pottery most admired for its ornate beauty is Tang three-color ware. This ware was made for only a short period of time, and yet numerous examples are found today. It must have been produced in large quantity to meet a popular demand. In studying this ware, it is important first to define what is meant by three-color ware. The term denotes wares with green, brown, and white glazes. It is not actually a white glaze, but rather a transparent glaze over the white clay body. There is a derivative ware with an indigo glaze made from cobalt, in addition to the other glazes. Another variation uses only two glazes. The term three-color ware is used loosely to refer to all three of these types.

The Origins of Tang Three-Color Ware

Although Tang three-color earthenware is held in high esteem, little is known about its history. It is not even known exactly when Tang three-color ware was first produced. Monochrome green or brown wares were revived at the end of the Northern Dynasties and attempts were made at using two different glazes on the same vessel about that time also. Beginning in the Sui and early Tang periods, the clay was more refined, producing a whiter body, which gave the glazes a much brighter, clearer tone. Figurines were often coated with a colorless, transparent glaze derived from a yellow glaze. Three glazes—green, brown, and transparent—were known and in use, as was a white clay that enhanced the glazes. It should have been a simple step to proceed to three-color ware, yet the process took a long time. There is a hundred-year gap

88. Three-color earthenware bowl. High Tang period
(706). H. 7.4 cm. Shaanxi Museum.

between the emergence of Sui monochrome glazed wares and three-color
ware.

The earliest known examples of three-color ware date back to the beginning
of the High Tang period (684–756). They were excavated from the tombs of
Prince Yide and Princess Yongtai, which date from 706. The three-color pieces
found in these tombs are mature examples of the ware (Fig. 88). There must
have been some kind of transitional ware that predates these pieces, but none
has been discovered as yet. A systematic study of the Tang tombs dating from
Early Tang (618–84) to High Tang is only now underway. There is one small
piece of evidence pointing to the existence of a transitional ware: a fragment
of a lid knob splashed with indigo glaze under a colorless, transparent glaze.
The fragment was discovered in the tomb of Zheng Rentai (664). More of such
fragments and whole pieces are expected to be uncovered soon. They will
help to fill in the missing gaps in the history of the development of Tang three-
color ware.

A white clay was necessary to produce the pure white of Tang three-color
ware. Much of this ware is believed to have been produced by the Gongxian
kilns in Henan, noted for white porcelaneous ware production, but it is unlikely
that these kilns were the sole producers of the large amount of Tang three-
color ware remaining today. There may have been other kilns in the areas of
Chang'an and Luoyang. A number of three-color pieces have slightly pinkish
bodies coated with white slip. The difference in the clay indicates a different
origin of production.

THE ORIGINS OF TANG THREE-COLOR WARE · 61

89. Three-color earthenware vase with concave cover. High Tang period. H. 12 cm. Private collection.

90. Three-color earthenware covered jar. High Tang period. H. 21.4 cm. Private collection.

Most examples of Tang three-color ware were formed on the potter's wheel, but there are some irregular shapes such as rhytons, duck- or shell-shaped wine cups, pilgrim flasks, and flattened ovoid ewers made in molds. Ornamentation generally consists of molded motifs that were cast separately and then applied onto the vessel in imitation of Western metalware. Impressed patterns were another common form of decoration.

Decorative Glazing Techniques

The primary decorative element of Tang three-color ware is, of course, the glazes. These were not applied in distinctly separate color fields. Rather, the different colors run into and mingle with each other, creating a dreamy, fantastic color scheme. The basic glaze coat is colorless and transparent and acts to reveal the white clay body, which acts as one of the glaze colors. There are two methods of applying the basic glaze. One is to coat the whole vessel first before applying the other glazes. The other method, though it is rare, is to reverse the procedure, applying the transparent glaze over the other glazes. In both cases the colored glazes streak and blur because the basic glaze acts to make them more fluid during the firing (Fig. 89). Colored glazes were applied in the following ways:

1. Spotting. Colored glazes were spotted over the base coat. The knob with indigo spots discovered in the tomb of Zheng Rentai, mentioned above, was glazed in this manner. The glazes of vases and jars such as the one illustrated

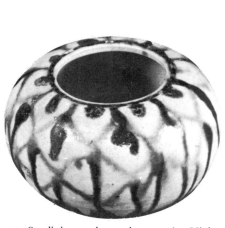

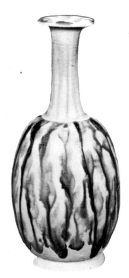

91. Small three-color earthenware jar. High Tang period. Private collection.

92. Three-color earthenware tall-necked vase. High Tang period. H. 21.8 cm. Private collection.

in Figure 90 were applied in this way. Potters knew that glazes would run easily on such shapes.

2. Diagonal Lines. Glazes were drawn on the vessels in diagonal streaks that ran into each other when the vessels were fired (Fig. 91). The lines are either parallel, intersecting, or zigzag.

3. Dripping. This glazing technique is the most typical. Green, brown, and indigo glazes were dripped over the base coat with a small ladle. The glazes spread into the base coat and mingled with each other in the kiln, resulting in beautiful, fluid stripes (Fig. 92). The effect is enhanced by variations in the quantity of the glaze and the portion of the vessel on which it is applied.

4. Brushing. In this method the glazes are applied with a brush so that each color band has a distinct, rather stiff quality (Fig. 93). White mottles, done in wax resist, are scattered over the surface to soften the effect. This technique is most commonly seen on flat dishes, trays, and rectangular chests. Because the glazes would not run as freely on such flat surfaces, it was possible to create carefully contrived motifs. Motifs stamped onto a ware retained the glaze with fluted edges (Fig. 94) that prevented the colors from spreading and mixing.

5. Wax resist. The wax-resist white mottles are one of the most appealing features of Tang three-color ware. Wax was dripped onto the base glaze,

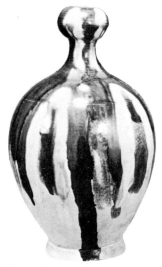
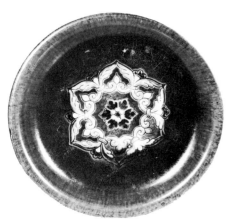

93. Three-color earthenware vase with bulbous mouth. High Tang period. H. 35.4 cm. Tokyo National Museum.

94. Three-color earthenware tray with three feet. High Tang period. D. 24 cm. Private collection.

usually in a dotted pattern, though there are occasional wax-resist floral patterns made of dots (Figs. 95, 97). Over this the colored glazes are applied. The wax dissipates when the vessel is fired, leaving soft white mottles. The colored glazes fade near the edges of the resist area, giving the mottles a blurred outline.

Because Tang three-color ware employs low-fired, lead-fluxed glazes, it has an iridescent quality. The effect is not as strong as that of the green Han ware, but the Tang glazes do have a slight luster reflecting the color spectrum like a soap bubble. It is this soft brilliancy that adds the finishing touch to Tang three-color ware.

Characteristic Shapes

The rich variety of Tang three-color ware reflects the complexity of Tang society. The three-color ware shows so much diversity precisely because it was meant as funerary ware. Thus, Tang three-color ware included forms traditionally belonging to other crafts, such as pottery duplicates of wooden trays and silver cups. Some silver and wooden wares must have been buried in tombs on occasion. But these wares were costly, and so their use as funerary vessels was generally avoided since they were also in use as daily utilitarian vessels. The Tang three-color copies were made to replace the more precious objects. In this respect three-color ware differs from the Changsha celadon and Ding white porcelaneous ware which were made exclusively as utilitarian wares.

There is a restrained tension expressed in the dynamic swelling shapes of

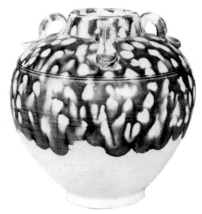

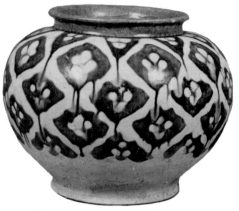

95. Small three-color earthenware jar. High Tang period. H. 12.4 cm. Private collection.

96. Three-color earthenware jar (*mannenko*). High Tang period. H. 18 cm. Private collection.

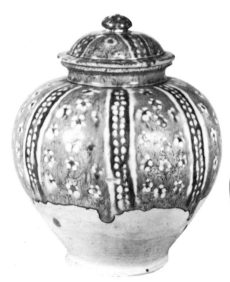

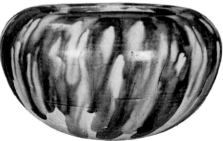

97. Three-color earthenware covered jar (*mannenko*). High Tang period. H. 27.3 cm. Private collection.

98. Three-color earthenware subspherical jar. High Tang period. H. 12.5 cm. Private collection.

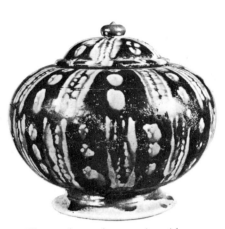

99. Three-color earthenware jar with cover. High Tang period. H. 21 cm. Chinese government.

100. Three-color earthenware *fu* with three feet. High Tang period. H. 20.5 cm. Private collection.

Tang three-color ware that seems to be a reflection of the high spirits of the people of Tang China. The strong contrast of rich swelling lines in the neck and base serve to create a superb balance. The characteristic shapes of Tang three-color ware can be broadly classified into the following categories:

1. Jars. There are many large vessels in this group. One is a jar with a globular body, a low, straight neck, and a low foot (Figs. 96–97), known in Japan as a *mannenko,* a "ten-thousand-year jar" to hold foodstuff for eternity. Some have dome-shaped lids with flaming-pearl knobs. Another round jar has a semispherical body and no foot (Fig. 98). This type has a flat mouth and slightly concave flat base. Lids are domed or concave with a flaming-petal knob. Occasionally there is a variation with a wide, spreading foot (Fig. 99) or rabbit-shaped lugs applied around the mouth.

A kind of cooking vessel, commonly known as a *fu* (Fig. 100), is fashioned with three legs, often shaped like animal legs, attached to a semispherical jar. In the example shown, the mouth spreads out slightly to accommodate a flat lid with a flaming-pearl knob, but few lids of this type have been discovered. The *fu* was a shape derived from a bronze cooking vessel and probably served as a funerary-vessel substitute for the bronze.

2. Vases and Ewers. The basic Tang three-color vase has a tall, slender neck on a globular or ovoid body. There is a ewer (Fig. 101) that is essentially of this shape with the additions of a handle and a lobed mouth.

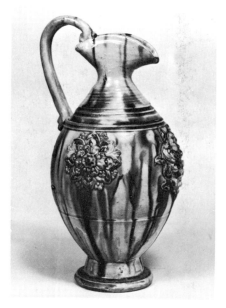

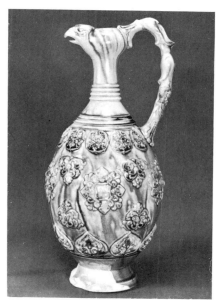

101. Left: three-color earthenware ewer with lobed mouth. High Tang period. H. 25.4 cm. Private collection.

102. Right: three-color earthenware phoenix-head ewer with handle. High Tang period. H. 36.8 cm. Private collection.

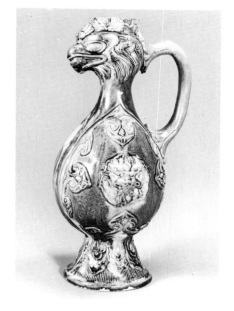

103. Three-color molded earthenware phoenix-head ewer. High Tang period. H. 27.8 cm. Private collection.

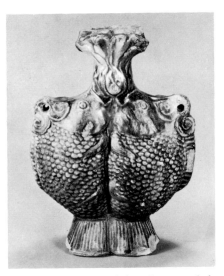

104. Three-color molded earthenware flask in double-fish shape. High Tang period. H. 20.5 cm. Private collection.

The phoenix-head spout attached to a bulbous mouth appears on another variation, marking the beginning of the phoenix-head ewer. Some of these have handles shaped like a grass stem and ornate applied molded motifs of palmettes, lotus petals, and phoenix medallions (Pl. 24, Fig. 102), which were faithful reproductions of Sassanian silver and gold metalware. These ewers are the most magnificent Tang three-color ware.

Another type of phoenix-head ewer is characterized by its flattened ovoid body decorated with exotic motifs (Fig. 103). This variation was made in a two-part mold and the two sides with relief motifs were luted together with clay paste. A handle was added later. The mouth opens at the top of the head of a phoenix with a pearl in its beak. Amphoras embellished with dragon-head handles (Pl. 22) also belong to this group of elaborately decorated ewers. A certain kind of pilgrim flask has a peculiar shape composed of two fish facing each other (Fig. 104). The design is symbolic of carp climbing the Longmen waterfall and commemorates a happy advancement in a person's life. Gourd-shaped vases with bulbous mouths surmounting a slender neck have also been found among Tang three-color ware, though they are rare.

3. Trays. The Tang three-color tray is usually circular with a flat underside and very often supported upon three legs. The legs take on various forms such as bullets, drums, animal legs, or leaves curving outward. Sometimes a tray is supported on one spreading hollow foot.

The exteriors of the trays are generally glazed one color except for a round

105. Three-color earthenware high-footed tray with wax-resist decoration. High Tang period. D. 13.8 cm. Tokyo National Museum.

area in the center of the underside. Much of the interior is given over to elaborate decoration. Some rare trays have motifs of four petals applied in different colors with broad brush strokes (Fig. 105). The streak and blur of the glaze gives an attractive effect.

Most three-color trays are decorated with impressed motifs in the center surrounded by smaller impressed patterns. The motifs applied in the center portion are either of Indian lotus flowers (Pl. 23) or eight lotus leaves arranged in a circular floral design around a bird holding a spray of flowers (Fig. 106). The Indian lotus motif is often surrounded by a cloud design. All of the impressed patterns are usually filled with different colored glazes.

There are other trays in the form of floral petals or leaves. The rim is scalloped in four, six, or eight foliations that are turned up to form the interior of the tray. The center is decorated with impressed patterns (Fig. 107) or applied molded motifs. Another type is colored with two different glazes, one in the center and the other along the tray rim to create a border. Circular trays with high walls and without feet, resembling basins, have also been found (Fig. 108).

4. Bowls and Cups. A typical bowl has a wide, spreading mouth and a profile that narrows from a raised ring around the center of the body down toward the bottom (Fig. 88). These bowls have low, rather large feet with flat bases. The central ring is reminiscent of a metalware design.

Cups of a simple shape are common, with the same high walls as the white porcelaneous cups, accentuated with slightly everted mouths. Some examples

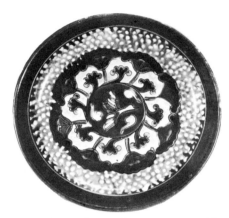

106. Three-color earthenware tray with stamped motif, three feet. High Tang period. D. 28.9 cm. Private collection.

107. Three-color earthenware tray with four feet. High Tang period. W. 16.4 cm. Eisei Bunko Foundation, Tokyo.

of this type of cup have straight sides that angle out sharply from the foot and have a ring handle (Fig. 110). This type of cup is a copy from Western metalware. Another example inspired by metalware is a shallow bowl with a convex base, which is embellished with molded dots and a quatrefoil pattern on the exterior (Fig. 109).

Wine cups are often of irregular and exotic shape. The most commonly seen are horn-shaped wine cups, copies of rhytons. Some have a dragon head at the tip of the horn. One variation is a wine cup shaped like a goose turning its head back (Fig. 111). Molded decoration of scrolled flowers and dots in relief embellish the goose in a manner suggestive of Western metalware. There are also cups shaped like conch shells (Fig. 112).

5. Others. Small boxes with lids, for incense or medicines, are usually flat and bevelled at the edges (Fig. 113). Some of the larger boxes have a flaming-pearl knob on the lid.

Other shapes include miniature inkstones, chests (Fig. 114), and pillows made as funerary vessels. The inkstone is circular and supported by many animal legs (Fig. 115). The chest, for storing treasures, has a hinged cover, legs, and a lock.

The Rise and Decline of Tang Three-Color Ware

A study of the many shapes, glazing methods, and decorations of Tang three-color ware reveals a considerable number of similarities that combine to create

108. Three-color earthenware *xi* with stamped floral motif. High Tang period. D. 24 cm. Private collection.

109. Three-color earthenware bowl with molded decoration. High Tang period. D. 9.7 cm. Private collection.

110. Three-color earthenware cup with loop handle. High Tang period. H. 7.5 cm. Private collection.

111. Three-color earthenware duck-shaped cup with molded decoration. High Tang period. L. 11.7 cm. Private collection.

112. Three-color earthenware shell-shaped cup. High Tang period. L. 10.7 cm. Private collection.

113. Three-color earthenware covered box with wax-resist decoration. High Tang period. D. 9.5 cm. Private collection.

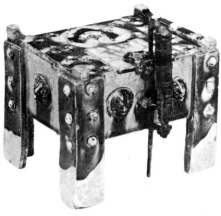

114. Three-color earthenware chest. High Tang period. H. 12.7 cm. St. Louis Museum.

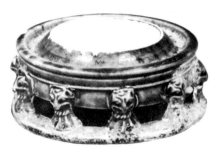

115. Small earthenware inkstone, green lead glaze. High Tang period. D. 5.4 cm. Kyoto University.

a common style with no relation to differences in shape. This suggests that even if Tang three-color wares were not all actually produced at the same time and place, they were certainly produced over a relatively short span of time in a limited area. Recent investigations in China have provided even more evidence supporting this theory.

Most of the tomb sites that yielded specimens of Tang three-color ware date back to the first half of the eighth century. The tombs are situated close together in Chang'an and Luoyang where the aristocrats of the High Tang period congregated. The kilns that produced three-color ware must have been located in the same region. Their products were made exclusively for an upper class that used silver, gold, jade, glass, and white procelaneous ware as everyday vessels. As funerary vessels, the polychrome may have seemed well suited to an aristocratic afterlife.

The outbreak of the An Lushan rebellion (755–63) marked the end of the High Tang period. The power of the established aristocracy diminished rapidly. Without their patronage it was inevitable that three-color ware production would decline also. The brilliant pottery disappeared as suddenly as it had appeared.

Marbled Ware

Marbled wares first appeared in the Tang period. Two clays, white and brown, were rolled out into slabs of the same size, which were then folded and pressed together repeatedly. The result was a slab patterned to resemble the veins of

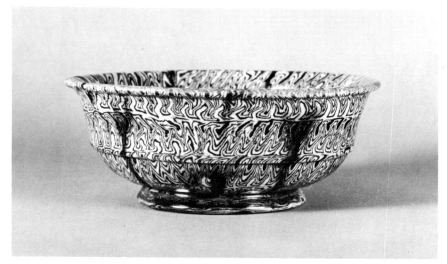

116. Marbled earthenware bowl, yellow glaze with green streaks. High Tang period. D. 17 cm. Private collection.

marble or wood grain. This slab was cut into slices that were set neatly in a mold to shape the vessel or object. Tang marbled earthenware was coated with a light-green or brown lead glaze and fired at a low temperature. The ware could not be made on a potter's wheel because the pattern of veins would naturally flow in the one direction in which the wheel was turned and thereby destroy the marbled effect.

Small vessels of about fifteen centimeters are the most common among marbled wares. This was probably because a large vessel might be distorted by the different shrinkage rates of the two clays in firing.

Marbled wares include trays with three legs, wine cups, bowls (Fig. 116), spittoons, pillows, and *fu*. The marbled pattern is most effective on the flat surfaces of the pillow, which may explain the elaborateness of the pillow patterns. There are other examples in which patterned panels inlaid with white clay on a brown ground are used for the sides of the pillow.

Marbled wares were made in miniature, a fact which implies that they were meant as funerary vessels. Marbling techniques continued to be used well into the Five Dynasties and Song periods. The kilns throughout Cizhou produced a few utilitarian vessels made of marbled clay.

11

Tang Black Ware, White Ware, and Celadon

The beautiful Tang three-color ware is representative of the ceramics of that time, but it was made for only one purpose, as *mingqi,* or funerary vessels. In the mainstream of Chinese ceramics history, three-color ware holds a minor position. Tang black ware, white ware, and celadon are more significant.

Black Ware

Black ware probably evolved in much the same manner as white ware, the emergence and early development of which have already been discussed.

There are black glazed tall-necked vases (Fig. 117); ewers with lobed mouths (Fig. 118) or with short spouts; round jars with high feet; jars with four lugs; *fu* (Fig. 119); and cups (Fig. 120). There are no elaborately decorated black glazed phoenix-head ewers or amphoras with dragon-head handles, nor any pieces embellished with molded decoration.

A different form of decoration was attempted with black ware by incorporating a white portion of the body to contrast with the black. This effect was achieved in a variety of ways. One technique was to coat some portions of a vessel with black glaze and others with a transparent glaze that would reveal the white clay body underneath. This was a kind of black-and-white ware. A variation of this type of ware was to coat the exterior of the vessel with black glaze and the interior with transparent glaze. There are several bowls, trays (Fig. 121), and handled cups glazed in this manner. The combination of black and white suggests that black glazed and white porcelaneous wares were sometimes fired together in the same kiln. Fragments of black as well as of

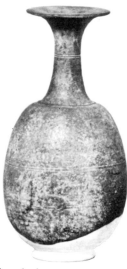

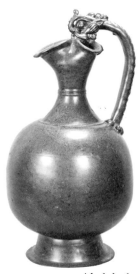

117. Tall-necked stoneware vase with black glaze. Sui dynasty. H. 23.9 cm. Tokyo National Museum.

118. Stoneware ewer with lobed mouth, black glaze. Early Tang period. H. 39.5 cm. Kyūsei Hakone Art Museum.

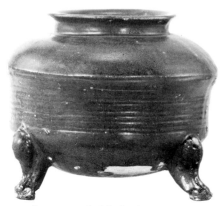

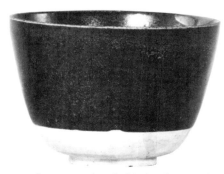

119. Stoneware *fu*, black glaze. High Tang period. H. 18 cm. Tokyo National Museum.

120. Stoneware bowl, black glaze. Early Tang period. H. 7.8 cm. Private collection.

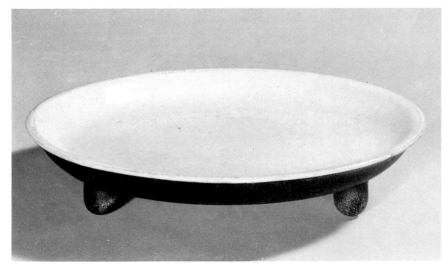

121. Three-footed stoneware tray, black and white glazes. High Tang period. D. 27.8 cm. Osaka Municipal Museum of Fine Art.

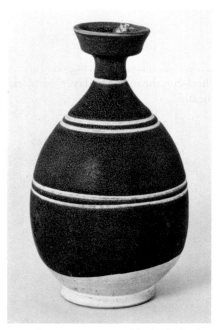

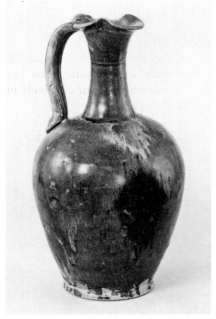

122. Stoneware vase with incised glaze decoration, black glaze. Early or High Tang period. H. 22.3 cm. Private collection.

123. Stoneware ewer, black glaze with blue-white mottling. High Tang period. H. 30 cm. Private collection.

124. Stoneware drum, black glaze with bluish white daubs. High Tang period. L. 22.2 cm. Palace Museum, Peking.

white ware have been excavated from the Gongxian kiln sites. The potters of these kilns had probably been experimenting with the two-toned black-and-white ware.

A vase with a dished mouth (Fig. 122) shows yet another glazing technique. A horizontal groove pattern has been wheel-cut through the layer of black glaze to expose the white clay body underneath.

Glazing techniques were apparently still immature before the High Tang period, which is why the black glazed wares produced up to that time are not uniform in color. Colors vary from sepia to blackish brown to black. In most instances minute iron crystals have formed on the glaze surface to create a matte finish. An excellent example of this is a vase with a lobed mouth and dragon-head handle (Fig. 118) that belongs to the Hakone Museum.

Black Ware with Blue-White Mottling

There are some Tang black wares suffused with an opaque blue-white glaze over the black glaze. The Idemitsu Art Gallery, Tokyo, and the Ataka Collection, Osaka, each have an example of a rounded, high-footed jar with an opaque blue-white suffusion that is mottled and streaked (Pl. 18). The blue-white glaze is made from a straw ash. Vessels glazed in this manner were common in both the Middle Tang and Late Tang periods. Examples include *mannenko* (Fig. 125), jars with two lugs, and short-necked ewers (Fig. 123), all of which have the comparatively slender body characteristic of this period.

These wares are now known to be products of the Huangdao kilns in Jiaxian

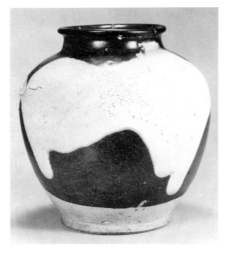

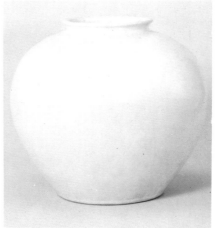

County, Henan. Most were produced in the Middle and Late Tang periods, though the two rounded jars in the Idemitsu and Ataka collections are products of the High Tang period. Three-color jars (Fig. 99) with covers, fashioned in the same style as these two jars, have been excavated from tombs in Luoyang, Henan, that also date back to the High Tang period. This provides further proof that the two jars in the Japanese collections are of the same period. Their glazing, blue-white straw-ash glaze dripped freely over the black glazed body, is very similar to the glazing technique used on the High Tang three-color ware. A black glazed drum with dripped glaze and a refined shape, in the Palace Museum, Peking (Fig. 124), probably also dates from the High Tang period.

We can conclude from the evidence of these various samples of black ware, though they are few, that black glazed ware with blue-white mottling first began to be produced in the High Tang period. Production seems to have continued through the Middle and Late Tang periods as well.

Glazing techniques changed in the Middle Tang period (756–827). After the unrestrained glazing of the High Tang, the blue-white glaze came to be applied more sparingly on only one or two large areas of a vessel (Fig. 125).

White Ware with White Translucent Glaze

White porcelaneous jars with four lugs and vases with dished mouths, which had been produced in large quantities earlier, disappeared with the advent of the High Tang period. They were replaced by *mannenko* (Fig. 126), amphoras

125. Left: stoneware jar (*mannenko*), black glaze with blue-white mottling. Middle or Late Tang period. H. 18.9 cm. Private collection.

126. Right: white porcelaneous jar (*mannenko*), translucent glaze. High Tang period. H. 24 cm. Private collection.

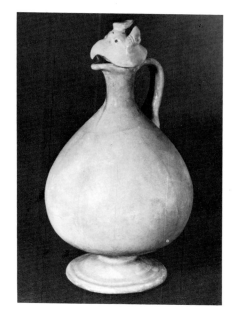

127. White porcelaneous phoenix-head ewer, translucent glaze. High Tang period. H. 28.5 cm. Tokyo National Museum.

with dragon-head handles, phoenix-head ewers (Fig. 127), and lobed-mouth ewers. These High Tang white porcelaneous wares underwent many changes.

Careful inspection reveals that some of these pieces have a different glaze quality from their predecessors. The earlier ware has a transparent glaze coating with finec razing. Some of the High Tang wares are coated with a milky white translucent glaze with very little crazing. The milky white effect is created by a high feldspar content and a fusing point higher than the older glaze, which was composed primarily of ash.

New kilns must have produced the High Tang milky white ware, for no shards of that type have been discovered at the Gongxian kiln sites. The emergence of a new type of white porcelaneous ware is significant. Not only the body of the vessel but the glaze as well is pure white, and the ware is less subject to staining because of the lack of crazing in the glaze where impurities could seep through.

Xingzhou White Ware

A discussion of Tang white ware immediately brings to mind Xingzhou ware, a name that appears frequently in ancient Chinese literature. The Xingzhou kilns in Neiqiu, Hebei, are first mentioned by Lu Yu in his *Cha Jing*, or *The Classic of Tea*, which he wrote in the Middle Tang period. This fact implies that white porcelaneous wares produced before this period should not be included in Xingzhou ware. Though Xingzhou ware has certain similarities with the translucent white porcelaneous ware of the High Tang period, it does

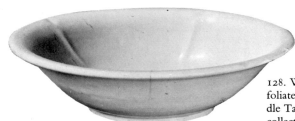

128. White porcelaneous bowl with foliate rim, translucent glaze. Middle Tang period. D. 24 cm. Private collection.

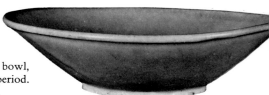

129. White porcelaneous bowl, translucent glaze. Late Tang period. D. 14 cm. Private collection.

show distinct differences in shape. Xingzhou white porcelaneous ware consists mainly of utilitarian vessels such as bowls (Figs. 128–29), cups, plates, and small ewers, some of which have a white slip coating on the body. By the time Xingzhou ware appeared, such typical High Tang forms as rounded jars, or *mannenko,* and amphoras with dragon-head handles were no longer made.

The utility of Xingzhou ware sets it apart from other Tang wares, which were made primarily as ritual vessels and were usually extremely large. The decline of the aristocracy would account for this, for they were the ones who required the larger vessels. As the aristocracy went into a decline, a growing demand among the common people for everyday vessels led to the mass production of white porcelaneous ware.

The considerable demand for these wares and the political instability of central China at the time are the most likely reasons for the relocation of the white-ware kilns to Neiqiu, Hebei, where fine kaolin-type clay was plentiful. The Xingzhou kilns also stimulated the rise and development in the same province of other kilns in the Late Tang period (827–907). The Ding kilns were established in Quyang County and became famous for their white porcelaneous ware, which will be discussed in Chapter 13.

Characteristic Shapes of Tang White Ware

The most common form taken by the utilitarian white porcelaneous ware of the Middle and Late Tang periods is that of a shallow bowl with a wide, spreading mouth. A few of these bowls are slightly curved, but most have relatively

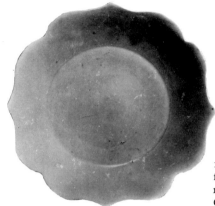

131. White porcelaneous saucer with foliate rim. Ding ware, Five Dynasties period. D. 9.7 cm. Private collection.

130. White porcelaneous plate with foliate rim. Ding ware, Five Dynasties period. D. 17 cm. Kempe Collection, Stockholm.

straight sides that distinguish them from the rounder vessels of the High Tang.

There are several variations on this basic form. Bowls with a foliate rim divided into four sections (later, ribbing was added to the interior as in Fig. 128); bowls with a rolled rim (Fig. 129); and bowls with a deeply cut foliate rim (Fig. 130). Other forms include saucers with a distinct central ring and foliate rim composed of five petals curving inward at the lip (Fig. 131), small subspherical jars with a flat, wide mouth (Fig. 132), and elongated ewers with a short spout (Fig. 133). The ewers, also to be found in black ware, often have double or triple bundled loop handles.

Two layers of excavation at the Ding kiln sites, dated to the Late Tang and early Five Dynasties periods, have yielded specimens of each of the white-ware styles discussed above. This indicates that the Ding kilns began their production as early as the Late Tang period, paralleling the Xingzhou kilns.

Some of these specimens have a white translucent glaze over an application of white slip, and others are coated with only a transparent glaze over a kaolin-type clay body of exceptional whiteness. The difference in the glazing may be caused by the different white wares produced by different kilns. We cannot be certain of this yet, however, since the exact location of the Xingzhou kilns is still not clear. Both types of wares are excellent examples of hard porcelaneous ware, which helps to explain their great popularity.

A great number of white porcelaneous wares of the Middle and Late Tang have been excavated, not only from sites in China, but from archaeological digs in West Asia, Southeast Asia, Korea, and Japan as well.

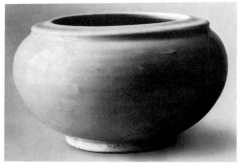

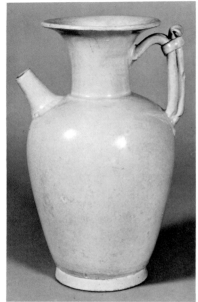

132. White porcelaneous jar. Ding ware, Five Dynasties period. D. 10.5 cm. Kempe Collection, Stockholm.

133. White porcelaneous ewer with bundled handle. Five Dynasties period. H. 22.1 cm. Private collection.

The Revival of Yue Celadon

Production of Yue celadon, so popular in the Six Dynasties through the Sui periods, had fallen off drastically in the Early and High Tang periods. Only a few Yue pieces have been discovered that were produced at that time, and they are clumsily made without any trace of technical improvement. Their style can in no way measure up to that of the other wares that flourished in the Early and High Tang.

Yue celadon was revived in the ninth century, during the Middle Tang period. An excellent celadon ewer with a short octagonal spout and handle attached to a pomegranate-shaped body (Fig. 134) was excavated from a tomb dated 810 in Shaoxing, Zhejiang, the center of the Yue kilns. The taut shape and uniform light-green glaze of this vessel show a degree of refinement that far surpasses that of the Old Yue ware.

The renewed Yue kilns must have initiated production at this time. Other representative examples of the revived Yue celadon include tall-necked vases with eight-faceted bodies and gourd-shaped vases.

Most of the new Yue products, however, were shallow wide-mouthed bowls produced at the same time. These bowls comprise the greater part of the surviving number of Tang-period Yue pieces (Fig. 135). Some of the bowls have rolled lips and ribbed sides, others have foliate lips similar to those seen among the white porcelaneous bowls of the north. The evolution of Yue celadon accelerated between the Late Tang and Five Dynasties periods.

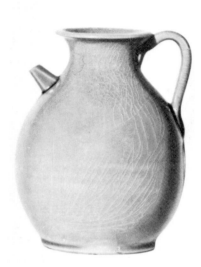

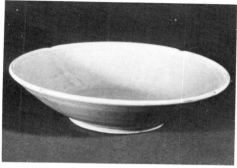

135. Celadon bowl with foliate rim. Yue ware, Late Tang period. Private collection.

134. Celadon ewer with handle. Yue ware, Middle Tang period (810). H. 13.4 cm. Palace Museum, Peking.

By the beginning of the Five Dynasties period a variety of covered boxes begin to appear with increasing frequency.

A beautiful glaze tone, known as "secret color," was a major boost to this steady evolution. The improvement in the glaze was partly due to its being applied over a more finely grained clay body than that of Old Yue ware. The finer grain helped to stabilize the glaze, glaze ingredients were refined, and more feldspar was added. The resulting soft, slightly translucent, light olive green was the first achievement in the refinement of ash glaze, which had been in continuous use since the Shang dynasty (Fig. 136).

Carved Decoration

The carved decoration that began to appear on Yue celadon contributed to the popularity of the ware. The earliest decoration was of incised motifs cut into the surface of a vessel with the tip of a spatula. The oldest known example is a ewer fragment bearing the inscription, "first year of Dazhong (847)." A flowing floral motif is incised onto the ribbed sides. By the Five Dynasties period, relief carving, by cutting obliquely with a chisel along the outline of a pattern, was common.

Pottery imitations of gold and silver metalware had been popular ever since the High Tang period. This probably accounts for the prevalence of carved decoration. Deeply carved floral motifs, patterns in high relief, and openwork designs were also popular. Earlier carved decoration was notable for its spontaneity, but that of the Five Dynasties is exquisitely detailed.

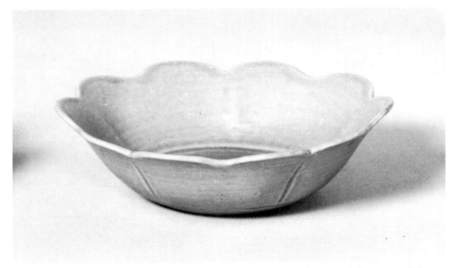

136. Celadon bowl with scalloped rim. Yue ware, Five Dynasties period. D. 14 cm. Private collection.

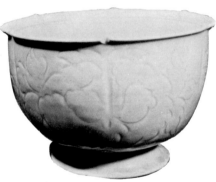

137. Celadon bowl with carved peony motif. Yue ware, Five Dynasties period. Private collection.

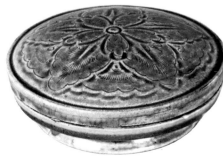

138. Celadon covered box with carved decoration. Yue ware, Five Dynasties period. D. 13 cm. Private collection.

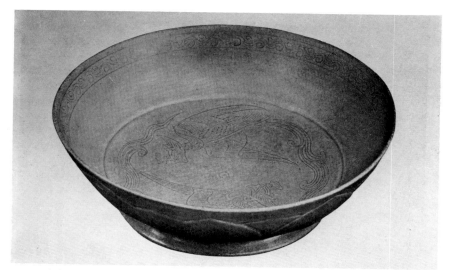

139. Celadon bowl with incised decoration. Yuyao ware, Five Dynasties period. D. 17.6 cm. Percival David Foundation, London.

The Qian princes of Wu-Yue were active patrons of the Yue kilns during the Five Dynasties period. The excellence of the decorated celadon produced at that time is evidence of this. The new decorative technique brought Yue celadon to the fore, displacing the mostly undecorated white ware of the north. Common carved motifs include an Indian lotus or peony combined with floral scrolls and an arrangement of flying birds; two facing parrots; palmettes surrounded by lotus petals; cranes and clouds; a pair of butterflies; dragons and clouds; dragons and waves; rows of a repeated coin motif; and surging waves (Figs. 137–39). These patterns used on Yue celadon had an accomplished style all their own. They were to establish a precedent for the superior decorative motifs of the Northern Song wares, which were soon to make an appearance.

12

Southern Celadon

Archaeological excavations in China are continually clarifying facts about the locations of the celadon kilns of the Late Tang and Five Dynasties periods. In addition to Yue ware, a large amount of celadon ware was produced in the provinces south of the Yangtze River, including Anhui, Jiangxi, Hunan, Sichuan, and Guangdong.

Yuezhou Kilns of Hunan

In *The Classic of Tea,* Lu Yu writes " . . . the wares of Yuezhou [Zhejiang] and those of Yuezhou [Hunan] are all blue in color. . . ." This indicates that the Yuezhou kilns of Hunan must have been producing a celadon similar to the Yue celadon. The Yuezhou kiln sites were recently discovered in Yueyang, Hunan, present-day Xiangyin County, which is also the site of the Xiangyin kilns. The shards excavated from these kiln sites resemble celadon wares discovered in Late Tang and Five Dynasties tombs in Changsha and the surrounding area. These pieces help us to fill in the sketchy outline of the development of the Yuezhou kilns of Hunan.

The Yuezhou wares are made with a sandy, fine-grained red clay. Their thin walls are lightly coated with a finely crazed celadon glaze that is slightly yellow from an insufficient reduction firing. There are many instances in which the soft red soil has seeped through the crazing in the glaze to stain the vessel. Representative shapes include deep bowls with foliate rims, sharply executed tall-necked vases carved with lotus petals whose tips protrude from the body of the vessel (Fig. 141), and stem-cups resembling wine cups. A close relationship

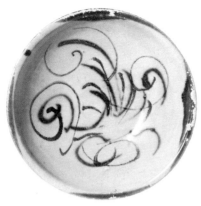

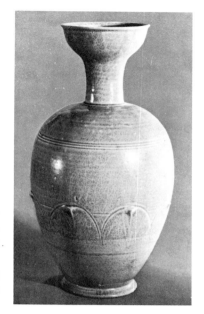

140. Stoneware bowl, yellow ash glaze over green and brown painting. Tongguan ware, Middle Tang period. D. 13.7 cm. Private collection.

141. Stoneware vase with carved lotus-petal design, ash glaze. Yuezhou ware, Hunan, Five Dynasties period. Hunan Museum.

between the Yue and Yuezhou wares is indicated by these archaeological finds.

A fairly recent discovery has been made of kiln sites of the Sui dynasty in Xiangyin. Studies indicate that a yellowish brown celadon ware with simple impressed or carved motifs was fired in these kilns. At present, detailed studies have been made of only a few specimens. Further research should yield more precise information.

Tongguan Kilns

Discoveries of a rather distinctive ware have made the kilns in Changsha famous. One of the kiln sites that has been excavated is known as Tongguan. These kilns produced a yellow stoneware with motifs painted in ferric brown and copper-oxide green (Pl. 7, Fig. 140). The motifs are painted onto a white slip that covers a fairly coarse, grayish clay body. An ash glaze then coats the painted vessel. The ash glaze is yellow, similar to the color of the Yellow Seto ware of Japan. This is not the traditional color of other celadons since the Tongguan celadon was fired in an oxidation atmosphere. The exposed clay portions have a red tint caused by the oxidation of the iron in the clay.

The glaze surface ranges from a transparent brightness to a somewhat cloudy finish with minute crazing running throughout the surface. The glaze has peeled off from portions of the vessel on many examples, an indication that the glaze did not always adhere well to the clay body.

There are two techniques used in decorative painting. One is a freehand style done with a brush, which is used to depict birds and flowers. This style is

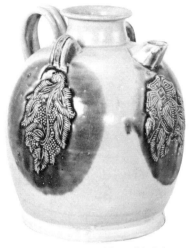

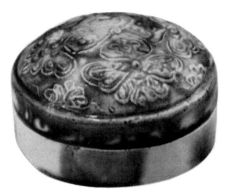

142. Stoneware ewer with molded decoration, yellow ash glaze over iron spots. Tongguan ware, Middle or Late Tang period. H. 21.5 cm. Private collection.

143. Three-color earthenware covered box with molded floral motif. Middle or Late Tang period. Museum of Far Eastern Antiquities, Stockholm.

most often found on bowls and pillows. One bowl of this type is decorated with calligraphy in iron oxide and bears the date, "third year of Kaicheng" (838). This bowl provides invaluable evidence helping to pinpoint the duration of activity at the Tongguan kilns. Painted motifs seem to have been an innovation of the Tongguan kilns because other Middle Tang wares, with rare exceptions, are not decorated in the same manner, though carved patterns and applied molded motifs were commonly employed.

The second technique involved the application of darkish brown glaze, often over the limited area of applied molded decoration luted onto ewers (Fig. 142), over which yellow ash glaze was applied. The molded elements include palmettes, paired birds, and West Asian motifs. Ewers with this type of decoration are found widely distributed throughout Southeast Asia and West Asia. This wide distribution, in addition to the exotic designs, suggests that the Tongguan kilns exported much of their ware. Most of the Tongguan vessels have thin walls, some of the ewers having walls thinned by beating.

There are some small dishes and covered boxes decorated with the same sort of patterns as the molded motifs of the yellow stoneware ewers and then coated with a green or brown low-fired lead glaze (Pl. 25). It is likely that these dishes and boxes were from the Tongguan kilns and were successors to the low-fired glazed wares of the Early and High Tang periods. In the same sense, other wares coated with three-color glazes (Fig. 143) can be considered a local representation of Tang three-color ware.

A high-fired green glazed ware that was also produced by the Tongguan

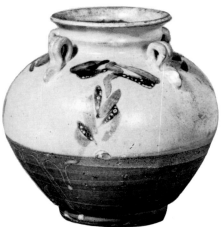

144. Stoneware pillow, green glaze. Tong-guan ware, Late Tang period. L. 14.7 cm. Private collection.

145. Stoneware jar, light yellow ash glaze over green and brown motif on white slip. Qionglai ware, Middle or Late Tang period. H. 17 cm. Private collection.

kilns is worthy of note. The glaze is a straw-ash translucent glaze combined with copper oxide. When fired at a high temperature, this glaze turns an opaque, mottled green color. Only a few examples of this ware are known today. They include some pillows (Fig. 144) and covered boxes made of a fine-grained, soft white clay that is quite different from the yellow stoneware.

Qionglai Kilns

Wares similar to the green and brown painted yellow stoneware of the Tong-guan kilns were produced by the Qionglai kilns in Sichuan (Fig. 145). Qionglai ware resembles Tongguan ware in its use of white slip on a reddish body, the green and brown painted decoration, and the oxidation firing that gives a yellow tint to the ash glaze. The only notable difference is the somewhat cruder formation of the Qionglai vessels. The Qionglai kilns were probably collateral kilns to the Tongguan kilns.

13

The Beginning of Song Ceramics:
Ding Ware

An Archaeological Study of the Ding Kiln Sites

Song wares did not simply appear with the advent of the Song dynasty. The evolutionary process leading up to Song ceramics is generally believed to date back through the Five Dynasties to the Late Tang period. Archaeological evidence from the Ding kilns, noted for their white porcelaneous ware, strongly supports the theory of a long evolutionary process.

Fujio Koyama, a ceramics historian, discovered the Ding kiln sites of Jiancicun in Quyang County, Hebei, in 1941. Thorough excavations and careful research were conducted by the Chinese from 1960 to 1962. Three major layers of fragment deposits have been discovered that date from the Late Tang, Five Dynasties, and Song periods.

Yellow glazed pieces are the most numerous of the fragments in the Late Tang layer. There were also yellow-green brown glazed pieces and a quantity of white porcelaneous ware. The yellow ware, with its gray clay body covered with white slip and yellow ash glaze, appears to be the type of yellow stoneware produced in Tang China by kilns located north of the Yangtze River.

The white porcelaneous wares also have an undercoat of white slip, indicating a close relationship with Xingzhou white ware, described in Chapter 11. The fragments of these wares include pieces of bowls and plates with rolled rims, foliate rims, and four- and five-foiled rims. None have the unglazed mouth rims, from being fired upside down, that are a principle feature of the

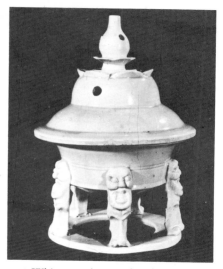

146. White porcelaneous five-footed censer.
Ding ware, Northern Song period (977).
H. 24.4 cm. Dingxian Museum.

Ding white porcelaneous ware of the Song dynasty. The bottoms are unglazed, and the pieces lack decoration. Fragments from the Five Dynasties period are much the same as the Late Tang ware. The bodies are usually thicker than those of the Song, but several dishes show a refinement in execution that is superior to their Late Tang counterparts. Most bowls have large unglazed foot rings.

There is a parallel improvement in the quality of the clay along with the refinement of shapes during the Five Dynasties period. Some pieces are coated with white slip, but the pure whiteness of the clay of most of the vessels makes such an application unnecessary.

Small pillows excavated from the Ding kiln sites and from Five Dynasties tombs nearby are worthy of special notice for their simple carved patterns. The Yue kilns had already begun to use carved decoration in the Late Tang period, but the Ding kilns did not adapt the technique to white ware until the Five Dynasties period. This was the basis from which the fluently carved Song dynasty Ding ware was to develop.

The Ding white porcelaneous wares with carved and impressed decoration, which are the best known, were discovered in the topmost layer of the excavation. The location tells us that the Ding kilns first began producing this type of ware in the eleventh century, shortly after the Northern Song dynasty was established.

The faint blue tint of the Late Tang and Five Dynasties vessels has changed to an ivory white, characteristic of Song-dynasty Ding ware. The difference in the glaze tone seems to be the result of some degree of oxidation in the kiln at-

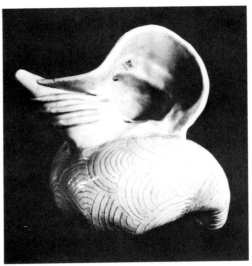

147. White porcelaneous conch-shaped cup with incised design. Ding ware, Northern Song period (977). H. 20 cm. Dingxian Museum.

mosphere, since there is no apparent difference in the composition of the glaze.

Ding Ware Excavated from Northern Song Pagodas

It is unfortunate that there has been no opportunity to examine the fragments discovered at the Ding kiln sites. Fortunately, "An exhibition of archaeological finds of the People's Republic of China," held in Europe and Japan in 1973, did include authentic specimens of very early Northern Song wares from the latter half of the tenth century. The Song pieces in the exhibition were discovered in the foundations of two pagodas in Dingxian County, Hebei. One pagoda is dated A.D. 977, the other 995. More than a hundred pieces of Ding ware were unearthed from both the pagodas. The wares found in the pagoda dated 977 retain traces of late Tang and Five Dynasties influence.

A covered incense burner supported on five legs shaped like monsters and connected by a foot ring (Fig. 146), for example, is quite similar to Tang three-color ware and metal incense-burner styles. A conch-shaped wine cup decorated with an incised wave pattern (Fig. 147) is another form also found in Tang three-color ware.

"Second year of Taiping Xingguo" (977) is inscribed in ink on a shallow bowl with a flat base (Fig. 148). Six indentations forming a foliate rim and rather crude incised decoration inside the bowl, so unlike the refined carving of the Northern Song Ding wares, are further evidence that Ding wares still had traces of Tang and Five Dynasties styling.

Other Ding kiln products of the late tenth century include small rounded

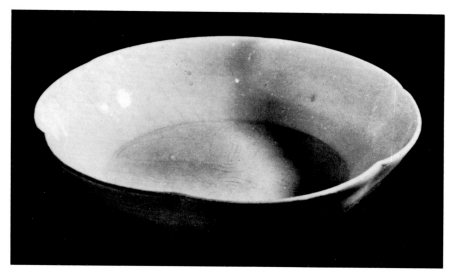

148. White porcelaneous bowl with foliate rim. Ding ware, Northern Song period (977). D. 21.9 cm. Dingxian Museum.

jars shaped like mandarin oranges with incised flaming pearl motifs covering the body (Fig. 150).

Another good example, important because it shows the transition in styles, is a shallow bowl with a wide, spreading mouth (Fig. 149). The rim is turned up at an acute angle. This is a shape common to late Tang and Five Dynasties wares. The resemblance ends there, however. Layered lotus petals carved in relief decorate the bowl instead of the usual incised ornamentation. This type of carved decoration, an example of which can be seen on the jar in Plate 14, was especially prevalent at the height of Ding production from the end of the tenth century through the eleventh century. Accordingly, the discovery of this bowl is very significant in that it bears the combined characteristics of the two different periods.

Other pieces of a very different nature were discovered mixed in with the transitional wares. Two *kundika,* exhibited in Japan, have the refined, slender formation characteristic of the Northern Song style. They do not have any features retained from the earlier Ding styles.

Both *kundika* are decorated with motifs in sharp relief. One is carved with layered lotus petals curving up from the base to the waist of the vessel. The other is ornamented with floral petals with the rounded tips arranged in opposite directions around the bottom and shoulder; incised motifs are added for embellishment. The distinctive beveled relief decoration is not yet evident, but still these two ewers are one step further in the refinement process.

The pagoda dated 995 contained more sophisticated wares, finely formed

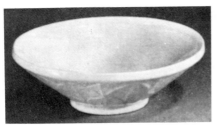

149. White porcelaneous bowl with carved lotus-petal design. Ding ware, Northern Song period (977). D. 21.9 cm. Dingxian Museum.

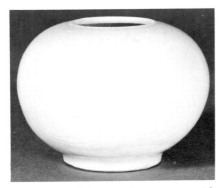

150. Small white porcelaneous jar with incised flaming-pearl design. Ding ware, Five Dynasties period. H. 6.5 cm. Tokyo National Museum.

151. White porcelaneous bowl with carved peony-scroll design. Ding ware, Northern Song period. D. 22.6 cm. Osaka Municipal Museum of Fine Art.

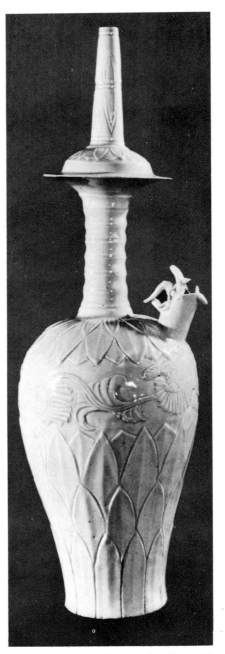

152. White porcelaneous *kundika* with carved peony motif. Ding ware, Northern Song period (995). H. 60.7 cm. Dingxian Museum.

153. White porcelaneous plate with carved lotus-scroll motif. Ding ware, Northern Song period. D. 26.2 cm. Freer Gallery, Washington, D.C.

with carved decoration. Only one sample, a *kundika,* is necessary to illustrate the superiority of these finds. About sixty centimeters high, with a dragon-head spout, this *kundika* (Fig. 152) is decorated with deeply carved, multiple layers of lotus petals, facing up and down, and a floral scroll pattern, both of which were popular with the Song Ding wares. The floral scroll is accentuated, not only by being large and clearly delineated, but also because it is deeply carved. By the eleventh century such powerful expression disappears from Ding ware, which came to be characterized by fluently carved but shallow motifs. The shift from strong, deeply cut motifs to shallow flowing lines can also be traced among other Northern Song wares.

Features of Ding Ware

Ding ware was made of an extremely fine kaolin-type clay. When fired at a high temperature, the silicate and alumina in the clay crystallize, increasing the hardness of the clay. This quality and the plasticity of kaolin-type clay allows it to be fashioned into extremely thin-walled wares. The thinness of Ding bowls and cups is due to this.

The transparent ash glaze used at the Ding kilns was so well suited to the clay that there is very little crazing. Oxidation at some point in the firing has given the glaze a faint yellow tinge. The slightly uneven glaze coating causes the yellow to appear as prominent streaks in some areas. Even this apparent flaw is highly appreciated—the yellow streaks are known as the "tear drops" of Ding ware.

154. White porcelaneous plate with molded design of birds and flowers. Ding ware, Northern Song or Jin period. D. 21.7 cm. Ataka Collection, Osaka.

155. White porcelaneous vase with carved lotus-flower motif. Ding ware, Northern Song period. H. 24.1 cm. Percival David Foundation, London.

The rims of many Ding bowls are bound with metal. The metal covers the unglazed sandy rim from which the glaze was scraped off before firing. This was done so that the bowls could be fired upside down. As the Ding potters strived to produce thinner and thinner pots, they discovered that the high temperature necessary to fire the kaolin-type clay often caused the wares to warp and crack. This problem was resolved by firing the vessels upside down. The glaze was scraped off the mouth rim so that the bowls would not stick to the sagger. By firing the wares in this peculiar way it was also possible to completely glaze the feet of the vessels.

In the early stage, the Ding kilns produced ewers, vases, jars, incense burners, wine cups, pillows, and stands. Most of these wares were undecorated. By the beginning of the eleventh century, flatter, shallower shapes such as plates, platters (Fig. 153), and bowls (Fig. 151) came to predominate. It was at this time that elegantly carved motifs in low relief became popular. In fact, this style of decoration was so popular that the undecorated Ding wares nearly disappeared. Occasionally pieces of Ding ware decorated with molded patterns in low relief (Pl. 15, Fig. 154) instead of the carved motifs can be found. Apparently a later innovation, this molded decoration is amazingly intricate though somewhat stiff.

The eleventh-century Ding kilns continued to turn out a few jars and vases (Fig. 155), but these were rather crudely decorated compared to the flat ware. Historical writings record that many kilns attempted to imitate these wares as the fame of the Ding kilns spread far and wide. This suggests the possibility

156. Stoneware bowl with floral motif in gold leaf on black glaze. Ding ware, Northern Song period. D. 13.7 cm. Yamato Bunkakan, Nara.

that many of the examples discussed above were not actually produced by the Ding kilns at all, but by other Ding-type kilns.

Black and Red Ding Ware

White porcelaneous ware is what first comes to mind when speaking of the Ding kilns, but these kilns also produced some red and black ware. Whether these wares were actually made at the Ding kilns is unclear, but this will be discussed in Chapter 15.

Both the black and red colors were derived from an iron glaze. Some have gold-leaf motifs baked on at a low temperature (Fig. 156). Their fine clay bodies and precise formation make these rare black and red vessels unique among Ding wares.

14

Northern Celadon: Yaozhou Ware

The wares traditionally referred to in the West as northern celadon have at last been identified as products of the Yaozhou kilns in Shaanxi. They were called northern celadon to distinguish them from the Yue celadon of the south, but it was not known where in the north these celadons had originated.

In Japan the northern celadons were once known as Ru celadon because of the ware's resemblance to shards unearthed from ancient kiln sites in Linru County, Henan. The Ru kilns did produce a very similar celadon, but it is now known that most of the typical northern celadons are Yaozhou ware. As a result, the inexact term northern celadon is rarely used today.

The Rise of Yaozhou Celadon

It is necessary to distinguish northern celadon from Yueh celadon because in some respects the two wares resemble each other. The Yaozhou kilns abruptly began producing Yue-type celadon sometime in the late tenth or early eleventh century. The kilns themselves had apparently been active from the Late Tang period, but carved celadon did not emerge until the Northern Song period. Similarities in terms of quick development, the type of glaze tone, and, in particular, the decorative carving techniques, strongly suggest that Yaozhou celadon had its genesis in the Yue kilns.

In the Five Dynasties period, under the enthusiastic support of the Qian princes of Wu-Yue, the Yue kilns, especially at Yuyao, produced superior celadons with a beautiful glaze tone, called "secret color," and finely carved decorative motifs. The house of Qian was destroyed, however, by the North-

157. Celadon covered bowl with carved peony-scroll motif. Yaozhou ware, Northern Song period. D. 11.5 cm. Private collection.

158. Celadon vase (*tuluping*) with carved peony-scroll motif. Yaozhou ware, Northern Song period. H. 16.7 cm. Ataka Collection, Osaka.

ern Song empire in 978, and the kingdom of Wu-Yue then came to an end.

Without the support of the royal family, the Yue kilns dropped into a steady decline; the wares produced after the fall of the patrons do not show a trace of their former excellence. Yaozhou celadon made its appearance at just about this time, suggesting a direct link between the decline of the Yue kilns and the rise of the Yaozhou kilns.

Features of Yaozhou Celadon

The Yaozhou kiln sites are located in Tongchuan, Shaanxi. Excavation of the sites conducted by the Archaeological Research Institute of Shaanxi in 1959 revealed that these kilns had produced the wares formerly known as northern celadon.

The Yaozhou celadon clay is fine grained and grayish white, contracting tightly in firing. The glaze coats the whole vessel except, in general, the footring, where the exposed clay is often a scorched red along the edges because of the reaction of the clay to the glaze when the vessel was fired.

The basic glaze color is an olive green ranging in tone from dark to light, but without any bluish tinge. It is the higher transparency that distinguishes this glaze from the Yue glaze, which it resembles in other respects. The glaze surface has a glossy finish despite its comparatively thin application. Crackles are scarce and difficult to detect since the clay and glaze were well suited, apparently shrinking at the same rate when fired.

Yaozhou celadon surpassed Ding ware in both variety and quantity. Com-

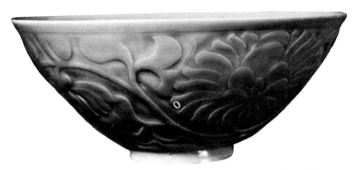

159. Celadon bowl with carved peony-scroll motif. Yaozhou ware, Northern Song period. D. 17.8 cm. Art Institute of Chicago.

mon Yaozhou celadon shapes include bowls, plates, platters, vases, and ewers, though the vases and ewers number considerably fewer than the bowls and plates.

Yaozhou bowls (Fig. 159) are generally shallow with a spreading mouth and a neatly executed, wide, low foot, similar to Ding and Yue bowls, though some have an inverted rim. There are also deep bowls with a slightly everted rim and a small, narrow foot. These bowls may originally have had lids, like the lidded bowl shown in Figure 157. Yaozhou plates and platters have flat or rolled rims (Pl. 8). Some of the vases are in the *meiping* style, known as a "prunus vase," with a high-shouldered body, narrowing toward the foot, a short neck, and small mouth. Others have a form known as the *tuluping* style (Fig. 158). A tall-necked Yaozhou ewer with ribbed sides and its own bowl (Figs. 160–61), which was discovered in Korea, is a superb example of the exquisite Yaozhou execution. Other ewers are kettle-shaped with dragon-head spouts and are supported on three legs. A rather unique Yaozhou form is the pillow with indented sides.

There are other examples of Yaozhou celadon such as small jars, vases, incense burners balanced on high feet, and stem-cups, all decorated with a series of carved lotus-petal motifs that are slightly different from the usual Yaozhou motifs. Carved decoration is the most attractive feature of Yaozhou celadon. The most common style is an obliquely carved, or beveled, motif embellished with combed decoration. For example, the inner portions of peonies, lotus flowers, and leaves carved in relief are roughly combed

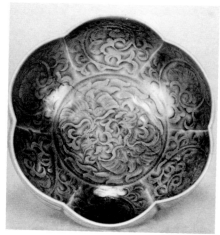

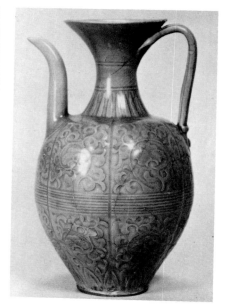

160–61. Celadon ewer and basin with carved phoenix and floral-scroll motifs. Yaozhou ware, Northern Song period. Basin: d. 15 cm; ewer: h. 29.1 cm. Tokyo National Museum.

to accentuate the motifs (Fig. 158). Another example is of fish surrounded by a design of combed waves.

The Ding kilns had been using carved decoration long before the Yaozhou kilns adopted this form of ornamentation; but the Yaozhou style of carving was somewhat different from that of the Ding kilns. Ding motifs were usually carved with shallow, oblique cuts and floral scrolls of vines or flower petals were simply incised with narrow lines. Yaozhou motifs, on the other hand, are deeply carved. Even thin vines and sprays of flowers were cut deeply and beveled along both sides of the motifs.

This technique gives a relief effect caused by the celadon glaze collecting in the grooves. The dark outline where the glaze collected contrasts well with the lightly glazed surface of the motifs. The shallow carving of Ding ware does not allow for such a contrast. The emphasis is instead on the fluency and flow of the lines. Light combing adds an extra accent to the Yaozhou carved decoration. The combed areas provide an intermediate level between the lightly colored motifs and their dark outlines.

15

Cizhou Ware

A close examination of Cizhou ware reveals considerable variation in clay and glaze, so much so that it is difficult to group pieces together under the name of Cizhou ware. There were kilns known as Cizhou in the area surrounding Handan, Hebei; these kiln sites were already undergoing archaeological study before World War II. The number of Cizhou pieces is so great, however, that it is doubtful that they could have all been produced by these kilns alone.

Distribution

The long-held theory that there must have been other kilns producing Cizhou ware was at last confirmed by studies conducted in China after 1949. Investigations of old kiln sites in Hebei, Henan, and Shanxi have made it clear that most of these kilns produced a variety of ware known collectively today as Cizhou ware. Even the lesser-known Henan kilns of Hebiji, Dangyangyu in Xiuwu County, Mixian County, Dengfeng, and Jiaxian County, in addition to the Shanxi kilns of Yuci and Pingding (Figs. 162–63), produced Cizhou ware.

Cizhou ware thus refers to a stoneware with many variations that was produced in a large area north of the Yangtze River. Differences in clay, glaze, and technique show up according to the district where a given piece was produced. All of these wares have been classified here under the term Cizhou ware because they do show basic uniformity in the application of white slip over a gray body followed by transparent glaze over the white slip. Variations range from the addition of carved decoration or a motif painted in black to an additional coating of a low-fired green glaze.

162. Stoneware shards excavated from Cizhou-type kilns. Northern Song period.

163. Stoneware shards excavated from Cizhou-type kilns. Northern Song period.

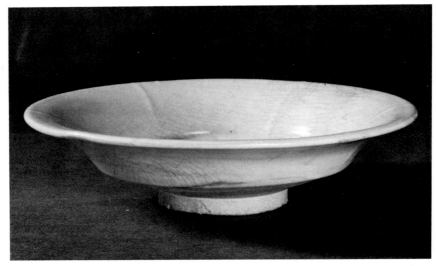

164. Shallow stoneware bowl, transparent glaze on white slip. Cizhou ware, Northern Song period. D. 17.6 cm. Private collection.

Features of Cizhou Ware

The following are some features common to all Cizhou ware. The clay body is usually darkish gray with a fine texture. A coarser clay was sometimes used, which turned red when it was fired. Later, Song three-color ware and Jin polychrome enameled ware were often made of this same coarse clay.

Cizhou wares were usually thrown on a wheel, except for irregular forms such as the pillow. The wheel was probably made of a large and heavy stone—marks on the wares indicate they were thrown very quickly, and a heavy wheel would have been necessary for this.

After a vessel was formed it was dipped into a white kaolin-type slip over which a colorless transparent glaze was applied. The vessels were then fired in an imperfectly oxidized kiln fueled with coal until they were firmly contracted, though not as firmly as celadon and white porcelaneous ware. The result is a type of stoneware the surface tone of which is softened by a somewhat yellowish glaze.

Application of white slip was a technique already in use on white porcelaneous ware as far back as the Northern and Southern Dynasties and the Sui dynasty. White slip had been used at the Ding kilns of the Late Tang dynasty and by various other widely scattered kilns in the Late Tang and Five Dynasties periods. Many of the northern kilns, not as well blessed with a plentiful supply of kaolin-type clay, used white slip on their wares in an attempt to imitate Ding white ware.

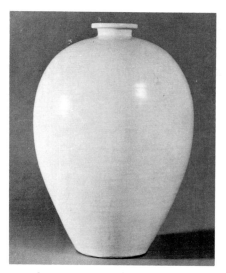 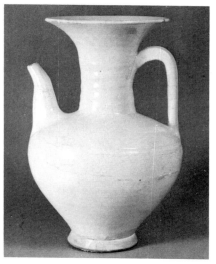

165. Stoneware vase, clear glaze on white slip. Cizhou ware, Northern Song period. H. 31.1 cm. Tokyo National Museum.

166. Stoneware ewer, clear glaze on white slip. Cizhou ware, Northern Song period. H. 29.3 cm. Tokyo National Museum.

Cizhou ware originated as one of these imitators, but the Cizhou potters did not stop at using white slip simply to create a white ware. They also experimented with contrasting the white with other clay and glaze colors. By branching off into a new realm, the Cizhou potters of the Song dynasty developed a ware that surpassed all the white-slipped wares of the past.

Characteristic Shapes and Decoration

1. Undecorated White Ware. This white ware is the earliest and most basic of Cizhou wares. Vessels are coated with white slip over which a transparent glaze is applied (Figs. 164–66). Thin, finely shaped bowls and vases in this style are attempts to imitate Ding-type porcelaneous ware.

Very often the surface of this undecorated ware is unevenly colored, as if water-stained. This is caused by impurities that have seeped through the crazed overglaze surface to permeate the white powdered layer of slip underneath.

There is a variation of this white ware daubed with light green copper-oxide glaze (Fig. 167). The daubs are usually inside bowls, on the shoulders of vases, and on the lids of covered boxes. This two-color ware is probably meant to imitate the three-color ware of the Middle and Late Tang periods and is therefore most likely one of the first types of Cizhou ware.

2. Incised and Sgraffito Ware. Wares coated with white slip were incised to reveal the gray body underneath, creating the impression that a gray design

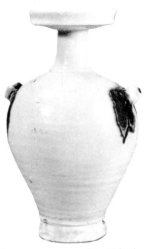

167. Stoneware vase with dished mouth, colorless glaze on white slip, green splashes. Northern Song period. H. 26 cm. Matsunaga Memorial Gallery, Kanagawa.

168. Stoneware vase with sgraffito decoration, transparent glaze on white slip. Cizhou ware, Northern Song or Jin dynasty. H. 39 cm. Shanghai Museum.

had been painted onto a white background. This technique had apparently been experimented with at a very early stage in Dengfeng and Mixian County in Henan. Vessels were decorated with incised motifs of birds, clouds, foliate scrolls, and figures against a ring-dotted background (Fig. 168). The rings were made with the tip of a bamboo stick. Some of this incised ware was first covered with a thin red slip made from hematite over which white slip was applied. Incised and ring-dotted patterns then appear to be inlaid with red clay (Pl. 28). These wares were produced sometime in the Northern Song dynasty. The ring pattern was derived from gold and silver metalwork styles of the Late Tang and Five Dynasties periods.

A technique known as sgraffito was also used. Designs were created by incising through the white slip and scraping away the slip around a motif to reveal the clay body underneath. This technique provides a stronger contrast of gray body and white slip than when the motif is simply incised into the clay body. Sgraffito also helps to create the illusion that the motif is in raised relief.

Usually the sgraffito motif was scraped to a depth of one to two millimeters (Pl. 31, Fig. 169), but there are occasional earlier examples with large motifs that are cut sharply and scraped deeply (Pl. 29). These large motifs and their boldness of execution are very appealing. Many pieces that are otherwise in a Five Dynasties style are decorated with deeply cut motifs, for example, tall-necked vases with dished mouths and peach-shaped pillows. Deep carving may actually be an older ornamental technique than the usual sgraffito decoration. A similar trend of deeply carved, large designs is found in the earlier Ding wares.

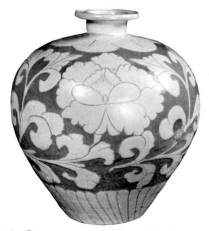 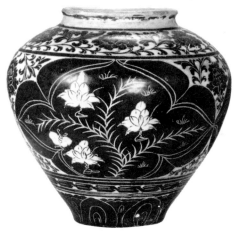

169. Stoneware vase with sgraffito decoration, transparent glaze on white slip. Cizhou ware, Northern Song period. H. 19.8 cm. Yamato Bunkakan, Nara.

170. Stoneware jar with sgraffito decoration, transparent glaze on black and white slip. Cizhou ware, Northern Song period. H. 24.3 cm. Private collection.

There is another even more striking technique in which motifs are created by scraping off portions of an iron-oxide black slip coating applied over the white slip (Pl. 30, Figs. 170–71). As a rule, motifs were left in black and the surrounding area scraped away to reveal the white slip ground. This gave the black motifs a pronounced raised effect.

There are some rare examples done in reverse with only the motif scraped out to leave a sunken white pattern on a black ground. A transparent glaze was coated over both types of ware before firing.

An effective contrasting of black and white required the utmost skill. Black slip was applied after the first coat of white slip had dried. Then the black slip had to be scraped off quickly without allowing it to soften the white. If the scraping was delayed, the moisture of the black slip would soften the white slip ground, and in such a situation the potter might cut right through both layers of slip, exposing the gray clay body. This would destroy the sharpness of the black and white contrast. It was necessary, therefore, for the potter to work quickly and skillfully.

Surviving examples of this ware often show motifs with ragged edges where the outline of the black motif was cut too deeply. Flaws like this were inevitable in a process where speed was required. But it is actually this kind of rough workmanship that gives the ware its vitality, a vitality that appeals in the same manner as rough-hewn sculpture viewed from afar.

Black-and-white sgraffito ware did not appear until the mid-eleventh century, indicating that it was an extension of the Cizhou sgraffito ware.

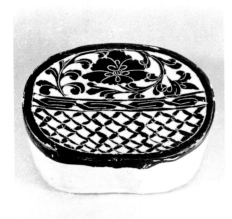

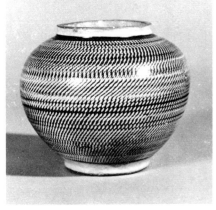

171. Stoneware pillow with sgraffito decoration, transparent glaze on black and white slip. Cizhou ware, Northern Song period. L. 23.8 cm. Private collection.

172. Stoneware jar with rouletting, transparent glaze on black and white slip. Cizhou ware, Northern Song or Jin dynasty. H. 9.5 cm. Umezawa Memorial Gallery, Tokyo.

Another variation of this ware is decorated with continuous chatter marks of white on a black ground (Fig. 172). This is known as a rouletting pattern and is created by the bouncing point of a flexible blade held against a vessel as it is turned on the wheel. Since the blade is held against the direction in which the wheel is moving, it chips away bits of the black slip to reveal the white underneath.

There are examples among all of these various sgraffiato wares, both gray-and-white and black-and-white, that are coated with a green glaze. These pieces were refired at a low temperature after the green glaze was applied. Another ware with iron-painted decoration on the white slip ground was sometimes glazed in this way also.

3. Iron-Painted White Ware. This is a very simple decorative technique, an iron-oxide solution painted on a white slip ground (Pl. 32, Figs. 173–74). Simple as it is, this ware did not flourish until the twelfth century, after the more complicated sgraffito designs had already been developed.

This points out one of the more interesting facts of Chinese ceramics history, that the people of the Song dynasty were most interested in the shape of a vessel. They accepted only such ornamentation as would harmonize with and preserve a vessel's shape. No decoration was allowed to mar or overpower the form.

As previously noted, the decorative techniques most commonly used in the Yue, Yaozhou, and Ding kilns were based on carving. This helps to explain

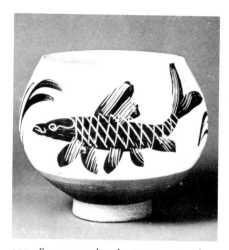

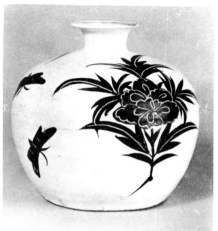

173. Stoneware bowl, transparent glaze over fish motif in black painted on white slip. Northern Song or Jin dynasty. H. 13.2 cm. Private collection.

174. Stoneware vase, transparent glaze over peony motif in black painted on white slip. Cizhou ware, Northern Song or Jin dynasty. H. 19.8 cm. Kyūsei Hakone Art Museum.

why the Cizhou kilns employed incised and scraped decoration before painted decoration, for in doing so they were simply following the tradition of the earlier kilns. The Cizhou incised and sgraffito techniques, used on a white slip ground, were usually applied in such a way as to make the decoration sink visually into the form, never letting it dominate or destroy the vessel's symmetry.

Black-and-white sgraffito ware is the one startling exception. The same scraping technique, leaving a motif in low relief, is used, but the contrast of black and white is extremely strong. This form of decoration does not seem in accord with the popular taste of the time, and yet the ware seems to have had wide appeal; the great number that remains to this day is evidence of this.

Creating this black-and-white ware was a difficult process requiring speed and a steady hand. As demand for the ware increased, there would have been a tendency toward simplification and standardization. This may be the background behind the emergence of a white-slipped ware with iron-painted decoration.

The sophisticated character of most Song wares makes it difficult to understand how this relatively crudely painted ware could have developed. Cizhou ware is the only known Song ceramic ware to have painted decoration applied with a brush. Its abrupt appearance was probably due to a chance experiment. Once it had appeared, however, the direct, expressive decoration must have endeared the ware to the people of those days.

So popular was the painted ware that it continued to be produced right

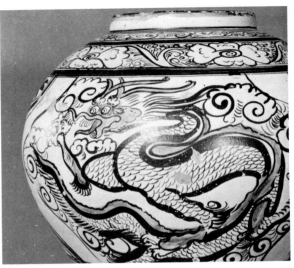

175. Stoneware jar, transparent glaze over dragon motif in brown painted on white slip. Cizhou ware, Yuan dynasty. H. 45.4 cm. Umezawa Memorial Gallery, Tokyo.

through modern times in northern China. A variation, made with the addition of painting in red slip and green copper-oxide glaze, originated in the Yuan dynasty (Fig. 175). A beautiful sky-blue ware (Pl. 33), coated with a glaze of copper and soda flux and fired at a low temperature, was also produced in the Yuan dynasty. These two wares show the influence of Persian pottery.

4. Overglaze Enameled and Three-color Wares. A brighter ware painted with polychrome enamels emerged after the iron-painted white ware. Known as Song enameled ware, this is the earliest known example of enameled stoneware in the world (Figs. 176, 178).

This ware was first fired with a white slip coating, as described under "Undecorated White Ware," then painted with red, green, and yellow enamels and fired again at a low temperature. The two firings were necessary because the enamels would only volatilize and dissipate if fired at too high a temperature.

It is important to keep in mind that the enamels were painted onto a previously fired glazed surface. This is different from the iron-painted white ware on which iron pigment was applied directly to the white slip before glazing.

Even when viewed through modern eyes, the Song enameled wares are very attractive with their motifs of grasses and flowers painted in bright primary colors on a warm white ground. The designs were quickly and simply applied with a brush. Their naiveté, like that of folk art, captures the imagination (Fig. 177).

From a historical point of view, however, they present us with problems

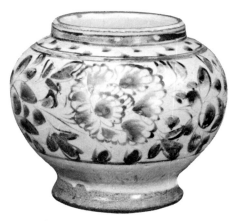

176. Stoneware jar with floral motif in enamels. Cizhou ware, Jin dynasty. H. 10.5 cm. Yamato Bunkakan, Nara.

177. Stoneware bowl with fish motif in enamels. Cizhou ware, Jin dynasty. D. 17.5 cm. Tokyo National Museum.

178. Enameled stoneware bowl with motif of duck swimming among water plants. Cizhou ware, Jin dynasty. D. 17.2 cm. Tokyo National Museum.

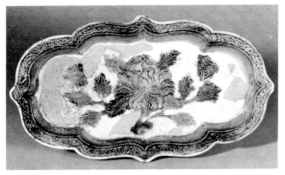

179. Three-color molded earthenware platter with peony motif. Liao dynasty. L. 26.5 cm. Tokyo National Museum.

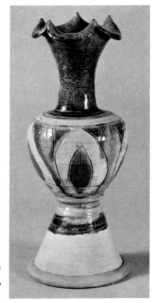

180. Three-color stoneware vase with foliate mouth. Cizhou ware, Jin dynasty. H. 24.7 cm. Idemitsu Art Gallery, Tokyo.

even more difficult to resolve than those of the iron-painted white ware. One is the problem of lineage. Before these enameled wares appeared there had been no tradition of painted color motifs in northern China. The Tang three-color ware might be considered a type of painted decoration, but they are too far removed in time.

It might be better to seek the genesis of this enameled ware in Song three-color ware and its predecessor, Liao three-color ware. Produced in the eleventh century under the influence of Middle and Late Tang three-color ware and Persian pottery, the Liao three-color ware with its crudely painted decoration seems closer than any of the other wares to Song enameled ware.

Song enameled ware should strictly be called Jin enameled ware since it was not produced until the twelfth century. This may help to explain the gap in taste between the colorful Jin enameled ware, on the one hand, and, on the other, the official celadon ware and Ding white ware, both so suited to Song taste with their deep and somber tone. It may be that the simple tastes of the Jin people, a horse-riding race of the north, came to affect the kind of ware produced by the Cizhou kilns.

Song three-color ware (Pl. 34, Fig. 180) appeared in the late Northern Song period, before the polychrome enameled wares. It is thought to have evolved from the Late Tang three-color ware with impressed and incised motifs and from Liao three-color ware, which was influenced by Persia. Much of Song three-color ware is utilitarian, taking on such forms as plates, pillows, vases, and ewers.

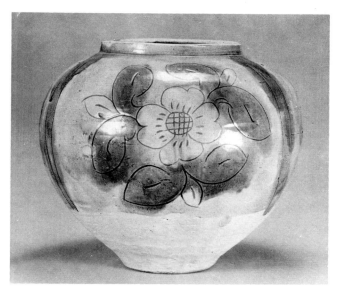

181. Three-color earthenware jar with incised peony motif. Liao dynasty. H. 24.7 cm. Private collection.

The Song three-color ware was decorated with motifs incised into a white slip ground, and the motif was then colored with different glazes. This technique is similar to that used on the Tang and Liao three-color wares (Figs. 179, 181).

16

Ru Celadon

In Japan it was believed for a long time that all the celadon ware now known as Yaozhou celadon was produced by the Ru kilns. This theory was based on the many celadon shards found at the Linru County kiln sites in Henan by the 1931 Ōtani expedition from Japan. We now know that northern celadon ware was produced by the Yaozhou kilns as well as the Ru kilns.

According to Feng Xianming, the Ru kilns fired only those wares that were decorated with impressed motifs. They did not produce the northern ware decorated with carved motifs. Impressed shards, unearthed from the Ru kiln sites, were displayed in Japan at an exhibition from China in 1965. Studies made by historians of the People's Republic of China confirm that the Ru kilns were the original producers of this type of celadon but that, for some unknown reason, the Yaozhou and other kilns soon took over the leadership in the production of this ware. The Ru kilns concentrated instead on the production of a special celadon ware generally known as Ru *guan* ware, or Ru official ware.

Ru Guan Ware

The word *guan* (or *kuan*) means official or imperial and implies that wares so designated were reserved for official use and as royal ritual vessels and were produced at pottery workshops set aside for this purpose. There is a longstanding theory that the official kilns had been established as early as the end of the Northern Song period in some part of Linru County, Henan, but there are still some details about these kilns that need to be clarified.

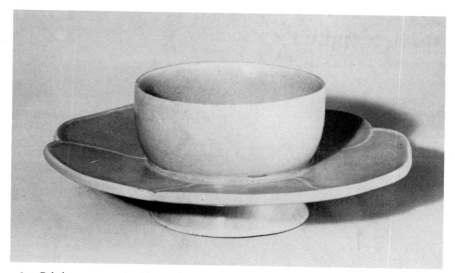

182. Celadon cup-stand with petal-shaped brim. Ru *guan* ware, Northern Song period. Brim: d. 16.8 cm. Percival David Foundation, London.

We know today of tens of specimens of a ware thought to be the product of the Ru official kilns. The clay of these pieces has a fairly high iron content, similar to that of Yaozhou celadon, and their sharply delineated forms are thickly coated with a semi-opaque grayish blue celadon glaze. It is thought that these wares are older than the products of the Southern Song official kilns and that they may date back to at least the end of the Northern Song period.

Bluish Celadon Glaze

With the Ru official ware, the formerly olive-green celadon glaze developed a blue tint; in other words, a true, perfected celadon color had at last been achieved. Some of the Five Dynasties Yue celadons were fired in an almost perfect reduction atmosphere, and yet they lack the requisite bluish tint and deepness of color that mark true celadon. The Ru official celadons were the last step in the long process of evolving a perfect celadon ware.

The Ru official potters thickened the layer of glaze, for they discovered that the deep blue they desired was most effectively brought out by repeated glaze applications. Only one glaze coat, even when fired in a reduction kiln, failed to produce the same blue. The Ru official blue has a deep, dark tone. As with the Yaozhou celadon, the color is deeper where the glaze has collected in the beveled grooves of the motifs.

A translucent white effect is created by the high feldspar content and numerous minute bubbles in the glaze. The blue appears softened, delicate, and clear due to this white tone. The thickness of the glaze caused crazing; the

crackling lines, running here and there on the surface, some deep, some shallow, create a myriad of variations in shade.

Ru official ware took on various shapes: a *lian*-shaped censer with three feet (Pl. 9), a *zun*-shaped vase, a tall-necked vase, trays with three legs or supported on a single low circular foot, deep basins, and a cup-stand (Fig. 182). Except for the cup-stand, these are all classical forms, appropriate as imperial vessels.

17

Jun Celadon

Another group of famous kilns existed in Henan near Linru County: the Jun kilns of Yuxian County. These kilns produced a unique celadon ware with a beautiful opaque blue mottled glaze. This glaze could be described as a deeper toned variation of the blue-white suffusion found on Tang black glazed ware (Pl. 18). The Jiaxian kilns in Henan produced this kind of black ware, and they were close to Yuxian County. It is easy to see their connection with the Jun kilns.

Opaque Blue Mottled Glaze

The Jun kilns are believed to have first produced celadon in the Northern Song period and to have continued production into the Jin and Yuan dynasties. There are no distinctive changes to be seen in Jun celadon throughout this period of production.

The clay is plastic with a fine texture, similar to Ru celadon, and contains some iron, which appears as a light brown on unglazed portions. Irregularly shaped narcissus bowls and flowerpots tell us that molds were used in addition to the wheel. Vessel construction was rather thick.

The most attractive feature of Jun celadon is the glaze. It is a celadon glaze, but a very peculiar type of celadon. This unique quality is caused by straw ash in the glaze; the silicate in the straw ash appears as small white mottles when the ware is fired. The effect of the white mottles suffused throughout the blue glaze is reminiscent of the bluish white light of the moon, thus this glaze is called "moon white," or opaque blue mottled, glaze.

183. Celadon plate, "moon-white" glaze with reddish purple splash. Jun ware, Northern Song or Jin dynasty. D. 18.2 cm. Private collection.

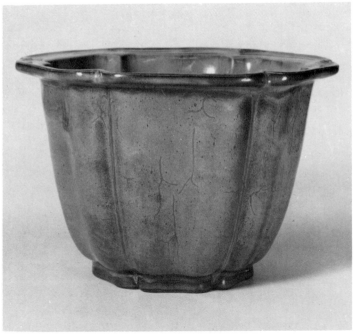

184. Stoneware flowerpot, "moon-white" glaze over reddish purple glaze. Jun ware, Jin or Yuan dynasty. D. 26.8 cm. Idemitsu Art Gallery, Tokyo.

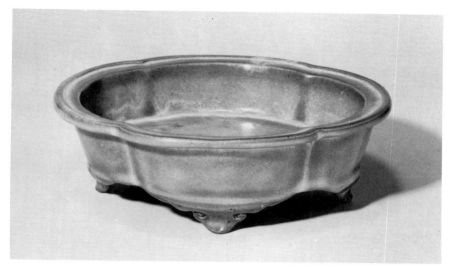

185. Stoneware narcissus bowl, "moon-white" glaze over reddish purple glaze. Jun ware, Northern Song or Jin dynasty. D. 19.8 cm. Idemitsu Art Gallery, Tokyo.

Jun ware glazing closely resembles that of Ru official ware. It has the same thick coating of repeated applications of glaze. The Jun and Ru official kilns probably had a very close association, for they were located near each other, and their celadon glazes are similar. It seems likely that Jun celadon made its appearance earlier than Ru official ware.

Some Jun celadons have reddish purple splotches on the moon-white glaze. These were created by spotting the vessels with copper-oxide before glazing and firing in a reduction kiln. The splotches vary from a subdued purple to a vivid reddish purple (Pl. 10, Fig. 183), depending on the thickness of the opaque blue mottled overglaze. Some of the more successful pieces resemble a rare natural jade.

Characteristic Shapes

Jun shapes include bowls, dishes, trays, cups, flowerpots, narcissus bowls, vases, jars, and incense burners. The most notable are the flowerpots (Fig. 184) and narcissus bowls (Fig. 185), whose sophisticated formation again suggests a tie with the Ru official kilns. The base is usually coated with a lustrous, thin iron coating and marked with numbers from one to ten. These numbers seem to indicate size, one being the largest and ten the smallest. With the exception of Jun ware, no other ware with such markings is known to exist. The Jun kilns continued production through and after the Jin dynasty, but the quality of the ware gradually declined, becoming coarse and unrefined.

18

Southern White Porcelain

Chinese ceramics is the best studied of all the world's pottery, and yet there are still numerous difficult problems in tracing its history. There are many cases in which the dates and districts of production have been determined but the exact location of the kiln is still not known. This is the situation with the information available about the kilns that produced southern white porcelain.

A white porcelain ewer in the British Museum (Fig. 186) is mentioned in almost every book on Chinese ceramics. It has a sharply sculptured phoenix head on a slender neck, and its body is carved with a design of peony scrolls bordered by two bands of lotus petals running around the elongated oval body. Apparently there was once a spout on one side, but it has been lost. This piece of white porcelain, with its somewhat grayish blue tint, was once widely thought to be a masterpiece of the Tang Jizhou kilns in Jiangxi, but it has gradually become clear that both the date and kiln were mistaken.

There are other white porcelains of this type: a large shallow bowl (Fig. 187), a small jar, and a grampus-shaped wine cup (Fig. 188), as well as an un-decorated ewer shaped like the one described above. The extremely fine-grained clay consists of kaolin and China stone and has a high feldspar and silica content, making the body contract firmly, a process known as porcelain-ization, when fired at high temperatures. The fired clay body of southern por-celain has a slightly translucent quality compared with that of Jingdezhen porcelain, noted for its pure transparency. The glaze, probably an ash glaze with a high feldspar content fired in a high-temperature reduction kiln, has a somewhat translucent, faint blue tint.

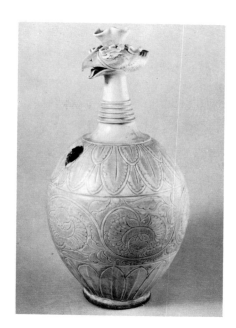

186. White porcelain phoenix-head ewer with carved peony design. Southern kilns, Northern Song period. H. 39.5 cm. British Museum.

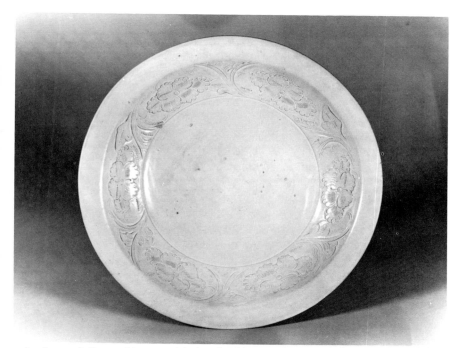

187. Large shallow white porcelain bowl with carved peony design. Southern kilns, Northern Song period. D. 32 cm. Idemitsu Art Gallery, Tokyo.

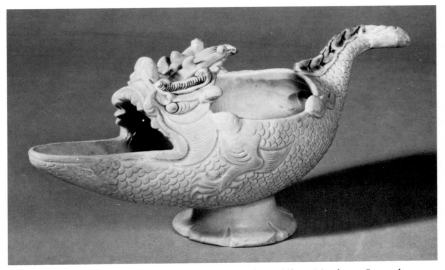

188. White porcelain grampus-shaped cup. Southern kilns, Northern Song dynasty. H. 9 cm. Private collection.

The decoration of southern white porcelain is as high in quality as that of the Ding and Xingzhou wares. Pieces decorated with carved designs that have been discovered number no more than seven or eight, including shards, but the magnificence of their fluently carved designs and their uniqueness is astonishing.

The carving is unique because the obliquely carved main motifs are combined with repeated stamped patterns of some detail. No other kilns of the Tang, Five Dynasties, and Song periods produced this kind of decoration. This tends to rule out the possibility that southern white porcelain was produced by Yue-type kilns. Current reports from China state that no shards of this ware have been found at the Jizhou kiln sites either.

Fragments of a phoenix-head ewer of the same quality, though of a slightly different style, found in Guangdong, now suggest that this white porcelain may be the product of the Chaozhou kilns in Guangdong.

Other examples of this type of ware have been discovered in Indonesia. They may have been manufactured for export and shipped from the port of Guangzhou. We assume that this southern white porcelain originated some time between the Five Dynasties period and the beginning of the Northern Song period.

19

Qingbai Ware of Jingdezhen

The Jingdezhen kilns, located in Fuliang County, Jiangxi, have been outstanding in ceramics production. Wares produced at these kilns from the Late Tang period include Yue-type celadon and Xingzhou-type white ware. It was not until the Northern Song dynasty, however, that Jingdezhen began to receive public acclaim. The ware of this period is known as *qingbai* ware, the earliest example of which is a vase that was discovered in a tomb dating from 1027 at Dingjiashan, Nanjing.

This vase has a small mouth and an elongated oval body that narrows toward the foot in a style known as *meiping*. A peony-scroll motif was impressed onto the entire rather coarse porcelain body, and a pale blue transparent glaze was then coated over the whole. The pale blue deepens to a darker blue wherever the glaze has collected in the grooves of the motif. This unique porcelain ware, a type that apparently falls somewhere between a celadon and pure white porcelain, is known as *qingbai,* or clear blue, ware. It is also known as *yingqing,* or shadow-blue, ware because of its delicate blue tone.

The earliest example of *qingbai* ware, the vase described above, is roughly formed, but the *qingbai* wares produced some sixty years later are practically flawless. We can see this excellence in a ewer and basin set (Fig. 189) found in a tomb dated 1087 in Susong, Anhui. Both the ewer and the basin have extremely thin walls, ribbed and decorated with sharp, exquisite designs. The mouth of the basin is scalloped. This find has helped us to date similar bowls and dishes with carved decoration (Fig. 190).

The clay body used for *qingbai* ware was composed of the kaolin clay avail-

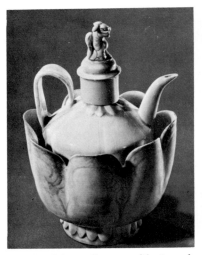

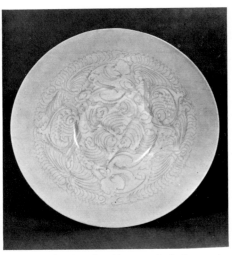

189. *Qingbai* set of ewer and basin, pale bluish glaze. Jingdezhen ware, Northern Song period (1087). H. 18.5 cm. Anhui Museum.

190. *Qingbai* bowl with carved design, pale bluish glaze. Jingdezhen ware, Northern Song period. D. 20 cm. Private collection.

able in the Jingdezhen area and China stone, also known as petuntse, a feldspathic material that has a high melting point. Due to this mixture, the clay was highly plastic and contracted tightly in firing. Jingdezhen wares are thus more finely executed than even the Ding wares, noted for their thin construction. They were also less susceptible to distortion when fired.

Qingbai ware is so delicate, its swiftly etched design and paperlike surface so fine, it appears as if it might shatter with just a touch. Before these fragile creations made their appearance, however, there was another type of *qingbai* ware with a thicker body and more deeply carved decoration. It is not known exactly when this ware was produced. Surviving examples include small jars decorated with overlapping lotus petals in the Yue style (Fig. 191); saucers with thick floral petals; a deep, cylindrical bowl carved with large lotus-scroll motifs that belongs to the Idemitsu Art Gallery, Tokyo (Pl. 16); and a small pillow decorated with deeply carved dragon motifs along its sides that belongs to the Victoria and Albert Museum, London. All of these examples are thought to be contemporaries of the early Cizhou and Ding wares because of the nature of their shapes and carved decoration.

The great number of *qingbai* wares found throughout both East and West Asia indicates how popular this ware was even outside China. The people of these regions must have been fascinated by the beautiful shadow-blue glaze and refined shapes characteristic of *qingbai* ware. This popularity encouraged the further development of the Jingdezhen kilns and later led to the establishment of similar kilns producing the same kind of ware in the southeast coastal region.

191. *Qingbai* jar with carved lotus-petal design, pale bluish glaze. Jingdezhen ware, Northern Song period. H. 14.5 cm. Private collection.

192. *Qingbai meiping* with combed spiral design, pale bluish glaze. Jingdezhen ware, Southern Song or Yuan dynasty. H. 25.6 cm. Idemitsu Art Gallery, Tokyo.

It is highly unlikely, therefore, that all *qingbai* wares were produced by the Jingdezhen kilns. The *qingbai* small dishes and covered boxes that have been discovered in Japan vary greatly in quality and style; many are probably the products of kilns in Fujian and Guangdong.

In the Southern Song period, the original Jingdezhen *qingbai* wares began to show some changes in style. Thick pieces became more prominent. Large vessels, such as *meiping* vases (Fig. 192), were formed with thick, heavy walls. The carved decoration on these wares does not have the vitality of its predecessors, and even the glaze is of a lesser quality. Some vessels made at this time are coated with a rather cloudy transparent glaze while others are overly glossy. There are *qingbai* bowls with the glaze scraped off the rim, suggesting that they may have been fired upside down like Ding ware, but their crude style and low-quality glaze indicate they were probably produced in the Southern Song period. The decline of *qingbai* ware was probably caused by the rapid development of the Longquan celadon of Zhejiang.

20

Temmoku of the North

Black ware production accelerated from the Tang dynasty through the Five Dynasties period. The stable nature of the glaze and the availability of the glaze ingredients allowed potters to produce this ware in quantity and to distribute the ware widely throughout nearly all the provinces of China. In the early Song dynasty two variations of this glaze were developed. One is the "moon-white" glaze of the Jun celadon, successors to the black glazed ware with a blue-white suffusion of the Tang dynasty. The other is *temmoku* glaze.

Temmoku referred originally to the black glaze of tea bowls, particularly those produced at the Jian kilns in Fujian. These tea bowls were used in the Zen temples situated on Mt. Tianmu in Zhejiang. Large numbers of this type of bowl were exported as tea utensils in the thirteenth century to Japan; hence this ware became known as *temmoku*, which is the Japanese pronunciation of Tianmu.

Henan Temmoku

The kilns of northern China were the major producers of black ware from the Tang through the Five Dynasties period. The art of *temmoku* glazing was probably first developed in the Cizhou-type kilns of the Song dynasty. This ware has generally been known as Henan *temmoku* ware, named after Henan Province, the center of production of Cizhou-type kilns.

Common *temmoku* shapes include jars (Figs. 193) and vases (Figs. 194–95). Though there are a few covered bowls and deep bowls, such shapes are relatively rare. This is one of the major differences between Henan and Jian

193. Stoneware jar with floral motif in brown iron. Henan *temmoku*, Cizhou-ware type, Northern Song or Jin dynasty. H. 15.7 cm. Private collection.

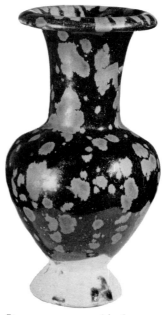

194. Large stoneware vase with brown iron-painted peony motif. Henan *temmoku*, Cizhou-ware type, Northern Song or Jin dynasty. H. 43 cm. Tokyo National Museum.

195. Stoneware vase with brown iron splashes. Henan *temmoku*, Cizhou-ware type, Northern Song or Jin dynasty. H. 20.8 cm. Private collection.

196. Stoneware bowl, persimmon glaze. Cizhou-ware type, Northern Song or Jin dynasty. D. 13.3 cm. Private collection.

temmoku ware. The Jian kilns, which will be discussed later, produced only *temmoku* bowls.

Henan *temmoku*-ware clay closely resembles Cizhou-ware clay, but the exposed portions of most Henan *temmoku* ware are a light buff color, since they were fired in an oxidizing atmosphere. Vessel construction is generally thick, except for a few bowls, and rough. This suggests that these wares were produced from the end of the Northern Song through the period of the Southern Song and Jin dynasties, rather than at the height of the Northern Song dynasty. There are other pieces whose shapes indicate they were made in the Yuan and Ming periods.

The black iron glaze is characterized by brown mottles. It is this particular characteristic that distinguishes Henan *temmoku* ware from other black glazed wares made up to the time of the Five Dynasties period. The glazes of Jian and Cizhou *temmoku* wares have the same mottling, though there is some variation in color and tone. This type of black glaze with mottling is known as *temmoku* glaze.

It is easy to explain how the brown mottling effect was produced. Some Henan *temmoku* ware is not mottled but is instead decorated with blurry brown motifs of grasses, flowers, and wide spirals. Before the vessel was coated with black glaze, these motifs were painted onto the vessel with a kind of pigment made of yellow clay slip with a high iron content. The same paint could be splashed onto the vessel with a quick motion of the brush, thereby creating the familiar mottled effect.

197. Stoneware covered bowl, persimmon glaze. Cizhou-ware type, Northern Song or Jin dynasty. H. 11.7 cm. Private collection.

When the vessel was fired, the yellow clay slip permeated the overcoating of black glaze, creating brown areas where the iron in the clay slip oxidized. The fluid overglaze blurred the edges of the motifs or splotches, making them appear hazy and indistinct. This decorative technique is the same as the underglaze painted decoration of blue-and-white ware. It was also used on the Cizhou white ware with underglaze iron painting. Instead of the transparent overglaze of the blue-and-white and Cizhou wares, however, Henan *temmoku* ware was coated with a transparent black glaze.

Underglaze iron painted white ware appeared as early as the late Northern Song dynasty. Henan *temmoku* ware was probably being produced by the end of the Northern Song period at the latest.

Henan Temmoku *Variations*

There is a variation of Henan *temmoku* glaze known as persimmon glaze. The overall color of this glaze is the same as that of the brown mottles of Henan *temmoku*. Bowls coated with this glaze are called persimmon *temmoku* (Figs. 196–97). Certain of these bowls are strongly formed and yet have extremely thin walls. In Japan, these are often called persimmon Ding or red Ding ware and are generally thought to be products of the Ding kilns. It is more likely, however, that they were produced by Cizhou Henan *temmoku* kilns.

Another variant of Henan *temmoku* is a black glaze applied without the yellow clay slip undercoating. It should properly be classified as a black or amber glaze rather than a *temmoku*. Some of the amber glazed pieces of this type are

198. Stoneware jar, black glaze over white ribs. Cizhou-ware type, Northern Song or Jin dynasty. H. 17.3 cm. Ataka Collection, Osaka.

decorated with incised patterns under the light amber glaze, which contains a small amount of iron. These pieces are known as the amber glazed ware of the Cizhou kilns.

Pieces coated with only the simple black glaze are, strange to say, extremely rare. There are only a few examples of black Ding ware, and it is not clear whether even these are authentic.

Another quite modern-looking example of black-and-white contrast is a black glazed ware with white ribbing (Fig. 198). This ware is quite well known. First it was decorated with rows of white kaolin slip ribbing squeezed out with a tube onto the clay surface of the vessel; then transparent black glaze was coated over the body. Due to the transparency of the glaze, the raised white ribs, where the glaze is very thin, stand out distinctly against the black ground.

21

Temmoku of the South

The southern kilns such as the Jian and Jizhou kilns were the leaders in *temmoku* production and were the ones to make the ware famous. And yet Henan *temmoku* of the north must have been produced first, for it was not until the Southern Song dynasty that the kilns of Jian and Jizhou began to produce their own *temmoku* ware. It is still a matter of debate whether the southern *temmoku* wares were produced under the influence of the north or evolved independently.

Jian Ware

The Jian kilns, located in Jian'ou County (modern Shuiji County) in Fujian, probably began manufacturing pottery in the Tang dynasty. Their fame grew rapidly from the Southern Song dynasty, when they first began producing *temmoku* ware, continuing through the Yuan dynasty, or even later. The Jian potters produced two kinds of stoneware bowls solely meant for drinking tea—one with an inverted mouth and the other with the mouth everted.

Jian stoneware bowls were made of a clay, containing iron, that turned a blackish brown in a reduction kiln. The unglazed bottoms of the bowls have a coarse, sandy quality. Close examination of shards reveals that the clay is not as coarse as it seems and that the sandy quality is the result of rough scraping of the foot when it was trimmed.

All the Jian *temmoku* bowls are wheel-thrown and usually have thick walls. The base of a Jian bowl is especially thick even though it has been cut deeply to form the foot. The unusual thickness probably served to stabilize

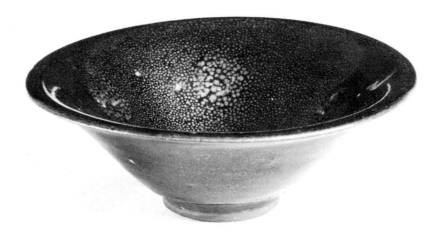

199. Stoneware tea bowl. Oil-spot *temmoku*, Jian ware, Southern Song period. D. 18.6 cm. Private collection.

the bowl by creating a low, heavy base and also prevented the bowl from cooling down quickly when it was filled with tea. The foot is ring-shaped and scraped shallowly along the inside rim, probably also for stabilizing the bowl.

The most notable feature of a Jian *temmoku* bowl is its mouth. The sides of the bowl gradually flare out from the bottom, constrict slightly near the mouth rim, and then flare out again. The effect is of a shallow groove ringing the mouth rim. This typical *temmoku* mouth is often said to resemble the head of a snapping turtle (Fig. 200). The bowl is well designed for drinking tea. The groove near the mouth acts as a boundary on the inside of the bowl, stopping the tea briefly and thereby forcing the drinker to take the hot tea in small sips.

Jian *temmoku* bowls were coated with the same double application of glaze as Henan *temmoku* ware, but on the Jian bowls, yellow slip was coated thinly over the whole surface before the rich black glaze was applied. The viscosity that causes the glaze coating to terminate in a thick welt just short of the base of the bowl is probably due to the high acidity of the glaze ingredients.

In the kiln, the rising heat causes the iron in the yellow clay slip to turn into minute crystals of ferric oxide, which come out on the surface of the black overglaze. Later, the glaze begins to bubble, and as each bubble bursts the crystals that had gathered around it rush in to fill the space. Stopping the firing just at this point and letting the kiln cool off gradually leaves the bowl covered with lustrous ferric oxide crystal spots commonly known as oil spots (Fig. 199).

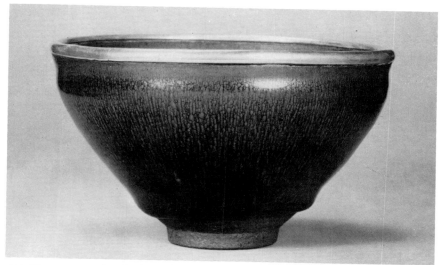

200. Stoneware tea bowl. Hare's fur *temmoku*, Jian ware, Southern Song period. D. 12.5 cm. Private collection.

The scarcity of oil-spot *temmoku* bowls in existence today suggests that it may have been extremely difficult to control the kiln atmosphere at just the right moment. No sooner do the ferric oxide crystals rush into a spot left by a burst bubble than they melt again and seep into the glaze. Stopping the kiln fire and letting the kiln begin to cool at this stage creates a streaked effect known as hare's fur *temmoku* (Figs. 200–201).

Most *temmoku* ware, including Jian *temmoku*, is suffused with an iridescence like that of the rainbow gloss on a lens. This iridescence is caused by the reflection of light from an extremely thin membrane, 1.5/10,000 mm thick. This membrane is especially evident right around the oil spots on some *temmoku* ware. With an extremely large spot the iridescence emanates a distinct spectrum. This is an accidental and very rare phenomenon. The wares that display this effect are called *yōhen temmoku*, after the brilliance of the sun. Tradition has it that people coveted these particular bowls to such an extent that they were willing to pay uncountable amounts of money for their possession. Today there are only four known *yōhen temmoku* bowls, all in Japan (Pl. 19).

Most Jian stoneware was fired in a reduction kiln. The black glaze has a bluish black tone, and the ferric oxide crystal spots and streaks are generally a silvery brown or silvery gray. This was because the reduction atmosphere was converted to an oxidation atmosphere just before the end of the firing. The deep black tone of Jian ware is in direct contrast to the brown hue of Henan *temmoku*, which was fired in an oxidation kiln only. This black tone is thought to have been developed deliberately for tea drinking.

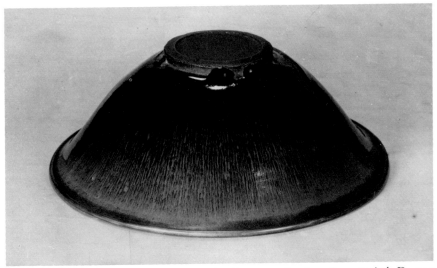

201. Stoneware tea bowl. Hare's fur *temmoku*, Jian ware, Southern Song period. D. 20.4 cm. Private collection.

The tea of the Tang dynasty was compressed into bricks, which were ground into particles and put in a *fu*-shaped tea kettle filled with hot water. The tea made with these bricks was either transparent brown or yellowish brown, colors well suited to contrast with white wares like Xingzhou ware. In the Song dynasty the tea was ground into a fine powder that was whipped into a froth before drinking. The frothy tea was a creamy greenish color that contrasted much better with the deep black of the Jian ware than it did with the white wares mentioned above.

The development of the Jian *temmoku* tea bowls parallels the development of powdered green tea. Jian *temmoku* bowls were produced exclusively for tea drinking. This limitation on their use also served to restrict the freedom of formation of Jian bowls and caused them to be turned out in a uniform style. This has made it difficult to distinguish between the *temmoku* bowls of the Southern Song and the Yuan periods.

The Influence on Northern *Temmoku*

The Jian oil-spot *temmoku* had a reverse influence upon the *temmoku* of the north. The Cizhou-type kilns of the north soon began to produce a unique kind of oil-spot *temmoku* ware that was different from the Jian predecessors. There are certain oil-spot *temmoku* bowls in existence today that are much smaller than the Jian bowls and are coated with a dense sepia-black glaze. These are northern oil-spot *temmoku* bowls (Fig. 202).

Shards excavated from the kiln sites in Xiuwu County, Henan, support the

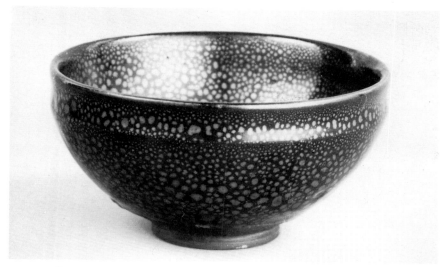

202. Small stoneware tea bowl. Oil-spot *temmoku*, Cizhou-ware type, Southern Song period. D. 9 cm. Ryokō-in, Kyoto.

theory that this kind of northern *temmoku* ware was produced in the same kilns that fired Henan *temmoku* ware. The body of these bowls should be a faint yellowish white, but the unglazed feet are stained with an iron slip that prevents confirmation of the clay color. It is not known why the iron slip coating was applied.

One possible theory is that the iron slip was used with the intention of attempting to duplicate the blackish brown color of the Jian *temmoku* bowls. An unglazed white foot would have distracted the viewer, detracting from the brilliant quality of the oil spots on the body of the bowl. The iron slip was probably applied to remedy this.

It is this kind of thing that strongly suggests that the northern *temmoku* bowls were produced under the influence of Jian ware. The inside of the foot-ring of the northern *temmoku* bowl is shallowly scraped out like the foot of the Jian bowl, again suggesting an attempt to copy the southern ware.

Glazing techniques were probably much the same as those used in the Jian kilns. The oil spots were created in the same way, but the black overglaze layer is too thin, much thinner than that of the Jian and Henan *temmoku* wares, to allow for much deepness or brilliance of tone. A large amount of lime in the glaze has created a matte finish. Because of a smaller amount of iron in the yellow clay slip, less than that contained in the yellow clay slip of the Henan ware, the final effect is of a dark sepia shade rather than the persimmon tone of the other *temmoku* wares. The northern oil spot *temmoku* ware must have been fired in an oxidation kiln rather than a reduction kiln.

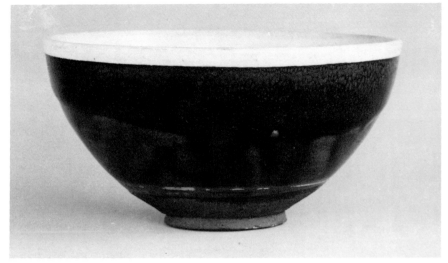

203. Stoneware tea bowl with white rim, *temmoku* glaze with silvery brown spots. Cizhou-ware type, Northern Song or Jin dynasty. D. 14.8 cm. Fujita Art Museum, Osaka.

We often see Jian *temmoku* bowls rimmed in silver or gold. The glaze coating was thin along the mouth because it ran down the sides of the bowl when it was fired, leaving the rim with a rough, sandy-textured edge. The metal band was used to cover this defect. On the northern *temmoku* bowls this should not have been necessary since the clay was of a much finer quality, but a similar technique was used occasionally for decorative effect.

Commonly known as white-rimmed *temmoku* (Fig. 203), these pieces were rimmed in white slip. The black glaze was coated over the whole bowl and then scraped off just along the mouth rim. First a white slip, then a transparent glaze was applied over the scraped-off portion. The result was a very attractive contrast between the white rim and the sepia body.

Jizhou Ware

There are still other variations of *temmoku* in the south. One of these, known as *taihi temmoku* (Fig. 204), was produced at the Jizhou kilns in Jiangxi. *Taihi*, meaning tortoise shell, refers to the yellow-mottled glaze surface of this ware. These yellow mottles on the black ground resemble a tortoise shell.

The Jizhou kilns were in production from the Five Dynasties period, but it was not until the beginning of the Southern Song period that they became truly famous, for this was when they began producing *temmoku* ware.

Jizhou ware is a fairly white stoneware, but rather coarse and without much plasticity. One of the two major shapes of Jizhou *temmoku* is a bowl that spreads out gradually from the bottom, unlike the Jian *temmoku* bowls with

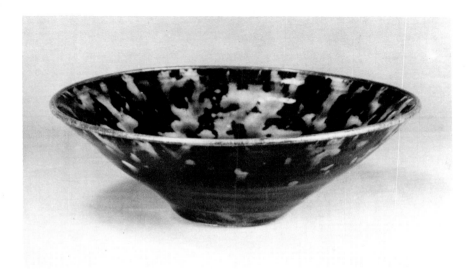

204. Stoneware tea bowl. *Taihi temmoku*, Jizhou ware, Southern Song period. D. 17.8 cm. Private collection.

constricted mouths, and the foot is so low as to be almost nonexistent. The purpose of this seems to have been to hide as much of the exposed white clay as possible. The second m jor shape is a shallow bowl with sides that are somewhat more rounded than the red Ding bowls. The foot of this type is also extremely low.

The tortoise-shell effect of Jizhou *temmoku* bowls was created by splashing a straw-ash glaze over a black glaze. When the bowl is fired, the straw-ash glaze mingles with the iron in the black glaze underneath to form yellow mottles. The glaze is not as thickly applied as on the Jian *temmoku* ware and is therefore not as glossy.

There are many examples of Jizhou *temmoku* bowls decorated with elaborate and varied designs. For example, there are motifs of plum blossoms, Chinese floral designs, auspicious Chinese characters enclosed in panels, phoenixes (Fig. 205), dragons, and butterflies. These motifs were created in a unique manner. Paper stencils were placed on the blac kglaze surface of the inside of the bowl and then a coating of straw-ash glaze was applied. When the bowl was fired, the paper stencil was naturally destroyed, but it prevented the straw ash from permeating the area it covered, and therefore a motif in black would remain against a background of finely mottled yellow.

In another variation the effect is reversed, a yellow mottled motif appears on a black ground. Called leaf *temmoku*, these were made by actually placing a leaf on the black glaze surface (Fig. 206). The high silicate content of the leaf caused it to leave the same yellow mottles as a straw-ash glaze when it

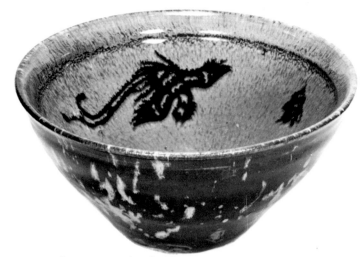

205. Stoneware tea bowl with paper-cut design. *Taihi temmoku*, Jizhou ware, Southern Song period. D. 12.7 cm. Kyoto National Museum.

206. Stoneware tea bowl. Leaf *temmoku*, Jizhou ware, Southern Song period. D. 15 cm. Private collection.

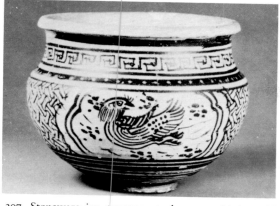

207. Stoneware jar, transparent glaze over bird motif in brown iron on white slip. Jizhou ware, Southern Song period. H. 11.7 cm. Private collection.

208. Stoneware vase with paper-cut design of plum tree, black glaze. Jizhou ware, Southern Song period. H. 22 cm. Museum of Fine Arts, Boston.

was fired. The result was a perfect impression of the leaf right down to the finest veins. The combination of natural and man-made mystery has made this type of *temmoku* highly valued.

The Jizhou kilns also turned out a few *temmoku* vases (Fig. 208). These vases were often decorated with the same stencil technique as the bowls.

An iron-painted white ware (Fig. 207), similar to Cizhou ware, was apparently also produced by the Jizhou kilns, but this has only recently been discovered, and not enough records or specimens have been found yet to allow for much commentary on this ware. A similar ware has been excavated from sites in the Philippines. This tells us that the Jizhou iron-painted white ware had a thinner construction and more finely painted motifs than the Cizhou ware. These kinds of differences are probably the result of variations in clay, kiln construction, and time of production.

Feng Xianming speculates that the Cizhou potters may have evacuated to Jizhou at the time of the Jingkang upheaval when the Song empire moved its capital to the south following the invasion of the Jin. The Cizhou potters could have continued to produce their iron-painted white wares at Jizhou. Later, their manner of painting spread to Jingdezhen, where it contributed to the birth of blue-and-white porcelain. This theory seems to be verified by the discovery of iron-painted white ware in the Philippines.

22

Longquan Celadon

In any discussion of the representative ceramics of China, celadon is the first to come to mind. And yet wares with a perfect celadon glaze did not appear until near the end of the Northern Song dynasty. It has already been noted that the Ru official kilns were the first to produce a true celadon glaze. But production at these kilns was cut short by the Jin invasion.

Though the tradition of the Ru official kilns was carried on by the Southern Song official kilns in the new capital of Hangzhou, twenty or thirty years passed before celadon production was resumed. There were certain unofficial kilns in Zhejiang, however, that produced a beautiful celadon ware imitating the Southern Song official ware. These were the Longquan kilns.

The Longquan kilns began production sometime in the Five Dynasties period as if to replace the Yue kilns, whose fortunes had plunged with the loss of the patronage of the Qian princes of Wu-Yue. The fluently carved designs and olive-green glaze of the early Longquan ware strongly suggest that the Longquan potters started out using techniques inherited from the Yue kilns.

Kinuta *Celadon*

Early Longquan celadon in the Yue style was extremely popular from the Five Dynasties period through the Northern Song dynasty. It was not until the beginning of the Southern Song dynasty, however, that stoneware with opaque bluish green celadon glaze, commonly known in Japan as *kinuta* celadon (Pl. 11), began to be produced.

Kinuta is a Japanese word that refers to a wooden mallet used to beat cloth

209. Celadon vase with phoenix-head handles. Longquan ware, Southern Song period. H. 26.2 cm. Private collection.

to soften and polish the material. Many of the pieces coated with the thick, bluish green glaze are vases resembling this mallet to the Japanese eye, hence the name *kinuta* celadon. Similar glazing techniques make it certain that there was a close association between the potters producing *kinuta* celadon (Fig. 209) and those producing Southern Song official ware.

The name Longquan is a general one encompassing kilns in ten or more different locations, including Dayao and Jincun in Longquan County. These kilns were highly productive following the development of the opaque bluish green celadon glaze. Longquan became known in many foreign countries through export of the celadon ware.

Longquan celadon is made of a grayish white, fine-grained clay. Oxidation of the iron in the clay just at the end of the firing process has left the unglazed portions of Longquan celadon a scorched red color. Though earlier vessels were fairly thinly constructed, this ware is rather thick in most cases.

The glaze, composed mainly of wood ash, varies little from the Yue celadon glaze. The only difference is in the application of the glaze. Longquan ware is coated with several applications of glaze, a technique also used at the Southern Song imperial kilns. The thick glaze coating that results from this has a beautiful deep color and gloss. In many instances the glaze is marked with minute bubbles throughout. These bubbles give the glaze surface a delicate, misty tone, which enhances the depth of the celadon glaze color.

The glaze color of *kinuta* celadon is directly related to the color of the clay. This clay turns a bluish gray in a reduction kiln. The translucent tone of the

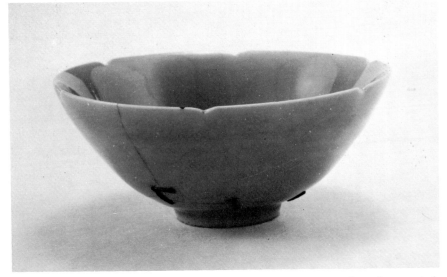

210. Celadon tea bowl, known as "Bakōhan." Longquan ware, Southern Song period. D. 15.4 cm. Tokyo National Museum.

clay serves as a background to the bluish green glaze, which is semitransparent, deepening the glaze color. A pure white clay would only overpower the celadon glaze with its brilliance. *Kinuta* celadon shows very little crazing, for the clay and glaze were well suited to each other.

Southern Song *kinuta* celadon includes bowls (Fig. 210), plates, vases (Pl. 11), jars, and incense burners (Fig. 211). There are no large pieces such as those produced in the Northern Song period. Some of the bowls are sharply executed, like black Ding bowls, and decorated with finely carved lotus-petal designs. Their style suggests they were produced at a relatively early stage.

The Yue-type celadon produced in the Northern Song period was often decorated with carved motifs of clouds, fish, and banana trees. By the Southern Song period, all carved patterns had disappeared, except for simple grooves. This was probably because the thick glaze coating of *kinuta* celadon destroyed the distinctive effect of such carved decoration.

Tenryū-ji Celadon

Kinuta celadon was very popular, not only in China, but in foreign countries as well. When the potters could no longer supply enough *kinuta* celadon to meet the accelerating demand, mass production techniques were adopted. The simplification of the production process increased the transparency of the glaze and left a green tint lacking the deep tone of the earlier *kinuta* ware.

It was at this stage that a decorative technique that would not have worked on the older ware came into use. Initially, designs were carved onto the surface

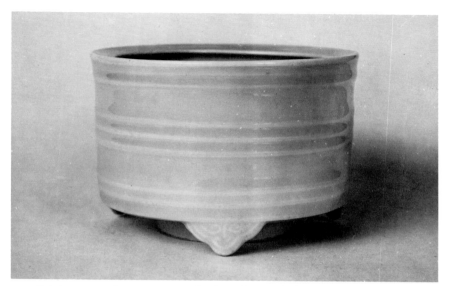

211. Celadon censer. Longquan ware, Southern Song period. H. 9.6 cm. Tokyo National Museum.

of the ware (Fig. 212), but later an even more efficient method of decoration was developed. Motifs and patterns were molded separately and then luted onto the surface of the vessel with a clay solution. The relief effect achieved by this was much less time-consuming than the carved motifs (Fig. 213). Molding peony flowers and leaves and then luting them onto a vessel was a simpler and quicker technique than freehand carving, even though it appears at first glance to be the more complicated of the two methods of decoration.

Celadons of this type have been known as Tenryū-ji celadon in Japan since great quantities of ware with molded decoration were brought from China mainly by trading ships licensed in the Muromachi period (1392–1568) by Tenryū-ji, a powerful temple in Kyoto.

The relief decorative technique was frequently employed on Longquan celadons produced from the Yuan dynasty in an attempt to disguise the glaze tone, which compared so unfavorably to that of the earlier, *kinuta* ware. Tenryū-ji celadon still manages to have a unique beauty despite this flaw, due to the deposits of glaze that collected around the outlines of the applied motifs. On some vessels the relief motifs alone are left unglazed. Their reddish color, caused by a high iron content, was also meant to distract the eye from the poor glaze tone. This type of decoration is most commonly seen in the form of dishes with paired fish motifs applied on the inside. The celadon glaze contrasts well with the reddish biscuit of the unglazed fish in relief.

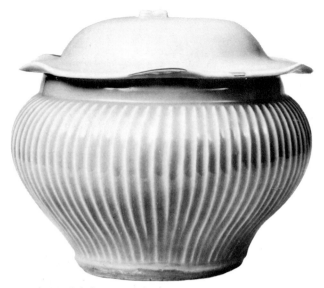

212. Celadon covered jar. Longquan ware, Yuan dynasty. H. 33.3 cm. Nezu Art Museum, Tokyo.

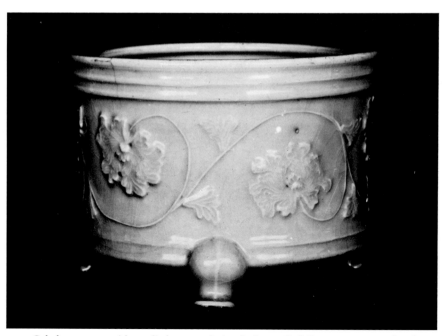

213. Celadon censer with applied peony design in low relief. Longquan ware, Southern Song or Yuan dynasty. H. 17 cm. Private collection.

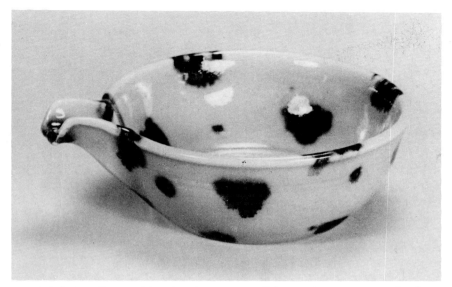

214. Celadon small-spouted bowl with iron spots. *Tobi seiji,* Longquan ware, Southern Song or Yuan dynasty. D. 17 cm. Fujita Art Museum, Osaka.

Spotted Celadon

Another, more elegant decorative technique was also used to cover the poor glaze quality. This was spotting with overglaze iron. The ware decorated in this manner is known as *tobi seiji,* or spotted celadon (Fig. 214).

Spotting with iron on celadon was first used on the Old Yue ware of the Eastern Jin dynasty and was also frequently used in the Changsha kilns from the Late Tang through the Five Dynasties period. The iron-spotted celadon of the Longquan kilns seems to have followed in these traditions.

Instead of applying the iron glaze with brush strokes, the Longquan potters dripped the glaze onto the surface of the ware from the tip of a well-charged brush. The iron spots created in this manner are particularly delicate, revealing variations in color not only between different spots but within a single spot as well. These spots show the celadon glaze to advantage in the same way as the occasional flaw found in blue and green jade.

Large Vessels

Tenryū-ji celadon continued to be produced from the Yuan through the first half of the Ming dynasty, when the blue-and-white ware and enameled ware of Jingdezhen began to become increasingly popular. With the rise of these new wares, Longquan celadon declined to a rough ware with a low-quality shiny glaze.

There is one factor worthy of note about this later celadon, however.

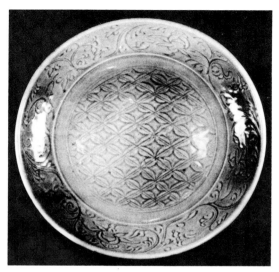

215. Large celadon plate with carved decoration. Long-
quan ware, Ming dynasty. D. 49 cm. Ardebil collection,
Teheran.

Large vessels covered with this kind of celadon glaze, seemingly never made
before this time, were produced in quantity in addition to the small and
medium vessels. It is therefore common to come across dishes of this type that
are fifty to sixty centimeters in diameter (Fig. 215). Large platters and vases
nearly a meter in width and height are also to be found.

Up to this time the production of such massive wares solely to impress would
have been contrary to Chinese traditions. That such wares were produced
despite the fact that they were probably not so well accepted by the Chinese
themselves suggests there was an outside market, probably in West Asia. A
large number of these Chinese celadons and blue-and-white wares have
survived in West Asia and can be seen today in the Topkapi Palace of Istanbul
and the Ardebil Shrine Collection of Azerbaijan. Most of these pieces are
quite large and apparently fulfilled some particular function. The final effect of
the production of these large vessels was to create a taste for such wares among
the Chinese people, which was fully developed by the Ming dynasty.

A new potting technique was devised to create these wares. Two or three
sections of a vessel were potted separately and later joined. As a vessel increased
in size there was a corresponding increase in its weight. Even if it had been
possible to throw a whole vessel on one wheel the excessive weight would
have caused the pot to slump. Dividing the vessel into several pieces and join-
ing these pieces after they had dried was therefore the only way such large
wares could be made. The Jingdezhen potters of the Ming and Qing dynasties
adopted this potting technique even for some of the smaller wares.

23

Celadon of the Southern Song Official Kilns

The Northern Song dynasty collapsed soon after it had established its official kilns (*guan yao*), but the Southern Song imperial court reestablished the kilns in the new capital of Hangzhou. At least two different groups of kilns were established; the earlier one is known as Xiuneisi *guan yao* and the other as Jiaotan *guan yao*.

Potters of the Ru official kilns may have been the first to produce official Southern Song ware, but it is also likely that Longquan potters, who were already producing an excellent celadon ware at the time, were asked to work in the Southern Song official kilns.

The celadons produced by both of the Southern Song official kilns are magnificent and can hardly be differentiated. In this chapter they will be treated as one and simply referred to as Southern Song *guan* ware.

Southern Song *guan* ware is classified differently in China, Japan, and the West, which makes it rather difficult to determine the most typical features of this ware. Southern Song *guan* ware is made of two different types of clay, one a grayish white, fine-grained clay and the other a blackish, rather sandy clay with a high iron content. Only a small portion of the clay is exposed on these vessels. The grayish white clay is slightly scorched with traces of light red like that found on Ru and Longquan ware, and the blackish clay has a blackish brown finish. The grayish white clay was probably Longquan clay, while the blackish clay may have been a mixture of this clay and a clay with a high iron content.

The glaze quality of these wares is equivalent to the highest grade of Ru

216. Celadon vase. Southern Song *guan* ware. H. 23.2 cm.

217. Celadon vase. Southern Song *guan* ware. H. 23.1 cm. Idemitsu Art Gallery, Tokyo.

official ware or *kinuta* celadon. The opaque glaze coated on the grayish white clay shows very little crazing, indicating that the glaze and clay were well suited to each other. The glaze is a bright bluish gray. Some of this kind of *guan* ware can be classed with the highest quality *kinuta* celadon, and it is very difficult to distinguish between the two. Several foreign scholars object to Japan's classification of this ware as *guan* ware (Fig. 216).

Because of different contraction rates the glaze on the blackish clay ware is patterned with large and small crackles (Pl. 12, Fig. 217). This crazing of the glaze creates subtle variations of gloss and color, while the black clay body deepens the glaze color to a dark and somber tone. With a thick glaze coating, as is common on this *guan* ware, there are often minute irregular cracks shooting through the glaze at acute angles and causing a diffusion of light that creates delicate variations of gloss and tone.

This kaleidoscope effect of the *guan* celadons strongly resembles the surface of a natural jade stone. If the aim of celadon is to imitate jade, then these *guan* celadons come as close as possible to this goal. In this sense, the opaque bluish gray *guan* celadon made with blackish clay is superior to the celadon made of grayish white clay.

24

The Emergence of Blue-and-White Ware

Qingbai *Ware with Molded Decoration*

For a brief time, Jingdezhen *qingbai* ware declined in popularity as the Chinese people of the Southern Song dynasty became attracted by the *kinuta* celadon ware of the Longquan kilns. The Jingdezhen potters did not allow this situation to continue for very long, however. From the early Yuan period, they were experimenting with new techniques and variations of their wares in an effort to regain their former popularity.

One of these experiments, a decorative method of applying molded motifs onto the surface of a vessel, appears to have been a direct copy of the Tenryū-ji celadon technique. A pear-shaped *qingbai* vase with an applied molded peony-scroll motif (Fig. 218) is a good example of this technique for its motif is quite similar to that used on the Tenryū-ji celadon ware of the time.

A more complicated technique of applied molded decoration developed in which flower and leaf motifs were luted onto a vessel in sections, using small clay supports, to create the effect of openwork in relief. This design was probably derived from metalware openwork, which was in turn copied from certain ancient bronzes, particularly those of the Warring States period. This decorative technique was especially popular in the Song and Yuan dynasties.

A string of beads of trailed slip outlines the motifs on some of the pieces decorated in this manner (Fig. 219). A type of image of Guanyin, the Bodhisattva of Compassion, with the same kind of beaded ornamentation and bearing an inscription in ink of 1298 or 1299, was discovered at Yuan-dynasty sites in

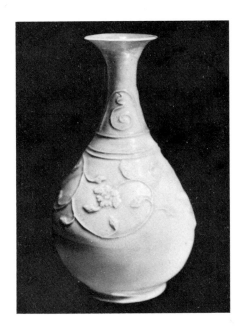
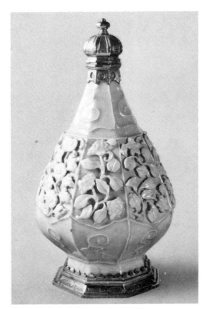

Peking. This suggests that this kind of beaded decoration was derived from that used on Guanyin images, but the exact date when this technique was adopted is unknown.

A *qingbai* ewer, known as the Gaignieres-Fonthill vase, in the William Beckford Collection, England, does give us a clue, however. This ewer is decorated in a manner similar to the Guanyin image mentioned above and has a metal crest attached that belonged to Louis the Great of Hungary (1342–82). Arthur Lane, a ceramics specialist, demonstrates that the metal crest was attached to the ewer in 1381; and John Ayers, a curator at the Victoria and Albert Museum, estimates that the ewer itself belongs to the first quarter of the fourteenth century.

The Beginning of Blue-and-White Ware

The exact dating of the first appearance of beaded decoration is important since it helps to date the advent of another underglaze decorative technique. There are four well-known vases that are decorated with molded motifs applied in the openwork style and surrounded by strings of beads. One of these vases belongs to the Percival David Foundation in London, another is in Japan, and two others were excavated from the site of Baoding in Hebei (Pl. 36). The applied openwork panels luted onto these vases are coated with a blue cobalt glaze and a red copper-oxide glaze. Furthermore, the upper and lower portions of these vases are painted with underglaze blue motifs. The presence of the new underglaze painting technique on vessels also decorated with beaded ornamentation

218. Left: *qingbai* pear-shaped vase with applied decoration, pale bluish glaze. Jingdezhen ware, Yuan dynasty. Fitzwilliam Museum, Cambridge.

219. Right: *qingbai* eight-faceted vase with applied decoration, pale bluish glaze. Jingdezhen ware, Yuan dynasty. H. 27.7 cm. Victoria and Albert Museum, London.

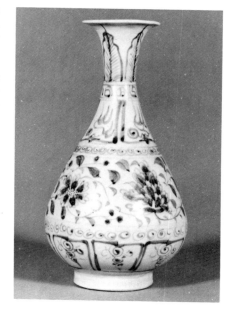

220. Blue-and-white vase with peony-scroll motif. Yuan dynasty. H. 24.2 cm. Private collection.

leads us to conjecture that the underglaze painting technique had been introduced at least by the 1320s. Recent archaeological surveys in China give additional information concerning this. A covered blue-and-white vase was discovered in a tomb dating to 1319 at Jiujiang, Jiangxi. This vase has a seven-ringed spire on the lid and two molded elephant heads and two lion heads on the shoulders. Decorative motifs include floral scrolls, cloud collars, and lotus petals. Judging from the form and motifs, it is evident that the vase is an early example of Jingdezhen ware. Thus it may be concluded that Yuan blue-and-white ware dates back to 1319 at the latest.

The emergence of this kind of underglaze blue decoration is significant in the history of Chinese ceramics. The underglaze iron painted white ware of the Cizhou kilns had appeared much earlier, but it was a monochrome ware. The new blue-and-white ware has a higher color quality. Because of this, it is not really possible to view these two types of underglaze painted wares in the same light. Blue-and-white ware represents a move toward polychrome decoration with green, purple, yellow, and red enamels. The appearance of the blue-and-white ware marked the first step toward a transition from a classical absorption with glaze tone to the modern concept of expressive painting.

The underglaze blue motifs on the four vases mentioned above, however, show a maturity of style that makes it hard to believe that this new decorative technique made its appearance suddenly. There must have been a process of gradual development, though it is still unclear through what stages this development actually progressed.

There are some other vases, of the same shape as the *qingbai* vases with molded and beaded ornamentation, decorated with underglaze light cobalt-blue motifs painted sparsely (Fig. 220). These may be the origin of blue-and-white ware.

Still, there are cases of wares that have made rather abrupt appearances, such as Tang three-color ware and Cizhou ware with sgraffito designs; and blue-and-white ware with its magnificent designs may be another such case. It is highly unlikely that blue-and-white ware existed in Jingdezhen in the Song period. Recent evidence supports this theory. A sunken trading ship discovered in 1976 off the coast of Korea near Sinan contained a great number of celadon and *qingbai* wares but no blue-and-white wares. The ship is believed to have sunk not much later than 1310, which suggests that blue-and-white ware was probably not yet being produced in the very early fourteenth century.

The Origins of Blue-and-White Ware

There must have been some impetus behind the revolutionary appearance of blue-and-white ware. What it could have been is difficult to determine.

There was already a trend toward painted decoration before blue-and-white ware made its appearance. The Cizhou kilns of the Jin and Yuan periods produced a plain, iron-painted white ware, an iron-painted white ware with red and green painting or with simple turquoise-blue glaze, and overglaze enameled ware. Vessels and tiles painted with dark glazes, known as Yuan three-color wares, were also being produced at that time.

According to Feng Xianming, Cizhou-type iron-painted white ware was being produced by the Jizhou kilns near Jingdezhen as well. This must certainly have been a strong influence on the development of blue-and-white ware. Cizhou potters may even have gone to Jingdezhen. In fact, fragments of Cizhou iron-painted white ware were unearthed together with early blue-and-white ware shards at the kiln sites of Hutian in Jingdezhen.

Another possible source of stimulation may have been Persian pottery. Persian potters had been manufacturing a low-fired, underglaze blue painted ware since the ninth century. It would not have been at all strange for the Persian people, who were customers for Chinese wares, to demand a ware similar to those made in Kashan and Mesopotamia but that employed the Chinese high-fired porcelain technique.

Whatever its origins, it is known that blue-and-white ware developed from the *qingbai* ware of the Yuan period. The *qingbai* overglaze, however, did not suit blue-and-white ware because its blue tint tended to obscure the blue motifs on the white porcelain body. A transparent glaze, as colorless as possible, was needed. Many attempts were made to remove the blue tint of *qingbai* over-glaze. Considerable success was finally achieved in the middle of the fourteenth century.

A pair of large vases (Fig. 221) belonging to the Percival David Foundation, London, are considered key examples of Yuan-dynasty blue-and-white ware. Both these vases bear the inscription "eleventh year of Zhizheng," placing them sometime in 1351. They are covered with a nearly transparent glaze.

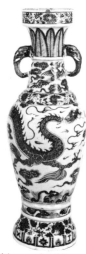

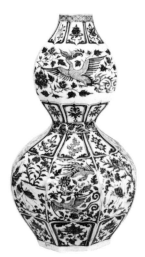

221. Large blue-and-white vase with elephant-head handles. Yuan dynasty (1351). H. 63.6 cm. Percival David Foundation, London.

222. Large blue-and-white gourd-shaped vase with faceted sides. Yuan dynasty. H. 58.2 cm. Kikusui Handicraft Museum, Yamagata.

Characteristic Shapes and Motifs

The makers of blue-and-white ware experimented with different shapes and motifs even as they worked to improve the overglaze. The result was a great variety of shapes including large jars, vases, large gourd-shaped vases (Fig. 222), *meiping* and a *meiping* variation with faceted sides, pear-shaped vases, ewers, a type of ewer derived from a West Asian metal prototype (called *sensanpin* in Japan; Pl. 38), flask-shaped ewers, pouring vessels, and various kinds of large platters, bowls, and stem-cups. Motifs include such traditional designs as peony and lotus scrolls, fish swimming in a lotus pond (Fig. 223), ducks, phoenixes, peacocks, dragons, *qilin* (a mythical animal), horses in the sea (Fig. 224), fruit, rocks and trees, as well as scenes from contemporary plays (Fig. 225).

All of these shapes and motifs, ranging from the sturdy and severe to the graceful and refined, are full of life and seem to reflect the dynamic, high-spirited age in which they were made. They are classified as being in the Zhizheng style. Recently a considerable number of these Zhizheng-style blue-and-white wares have been discovered and have become quite well known around the world. It is now known that the middle of the fourteenth century was the "golden age" of blue-and-white ware.

Most Zhizheng-style blue-and-white ware is densely painted with numerous motifs, though there are a few examples painted in an underglaze light cobalt-blue with only a scattering of motifs. Some of the more densely painted wares have slightly raised white motifs of flowers and dragons (Fig. 226) carved on

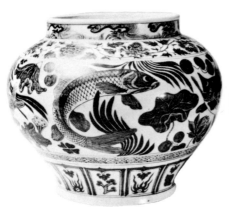

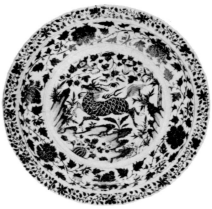

223. Blue-and-white jar with motif of fish in lotus pond. Yuan dynasty. H. 28.5 cm. Ataka Collection, Osaka.

224. Large blue-and-white plate with motif of prancing *qilin* (mythical animal). Yuan dynasty. D. 47 cm. Topkapi Saray Museum, Istanbul.

a blue-and-white painted background. This particular variation creates a very strong, vivid impression.

The raised white motif is a style that seems to have been derived from Shufu white porcelain, an official ware produced at Jingdezhen in the Yuan period. Shufu porcelains were porcelain bowls and dishes made of a fine-grained white clay and coated with a white translucent glaze. Motifs of dragons, phoenixes, and scrolls of foliage were impressed in low relief on the insides of these wares. The Chinese characters for Shufu (樞府), thought to have meant "Privy Council," or sometimes those for the felicitous term *fu lu* (福祿), meaning happiness and wealth, were scattered between the motifs. We do not know exactly when Shufu porcelain was initially produced, but among the surviving examples there is a piece stamped with a date corresponding to 1328.

Obviously, the slightly raised white motifs on the blue-and-white ware are a decorative style adapted from the earlier Shufu ware. There may have been an intermediate step in this process of adaptation, however. Some Shufu bowls and dishes are completely coated with a cobalt-blue glaze (Pl. 35). Since the glaze coating the raised motifs is thinner than that coating the surrounding area, the motifs appear as whitish patterns on a blue ground. The effect was further enhanced by consciously neglecting to glaze the raised motifs so that they would remain white to contrast with the blue ground. Another variation was to paint a fine design in blue around the raised white motifs.

Several important discoveries were made in connection with this at excavation sites in Baoding, Hebei. Blue-and-white wares with openwork designs,

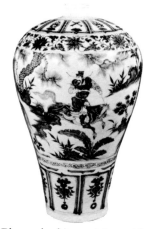

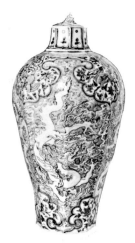

225. Blue-and-white *meiping* with motif of figure on horseback. Yuan dynasty. H. 44.1 cm. Nanjing Museum.

226. Blue-and-white *meiping* with carved dragon motif on blue-and-white background. Yuan dynasty. H. 51.5 cm. Palace Museum, Peking.

two copies of Shufu white porcelain, a pouring bowl with motifs painted in gold on an indigo ground, a blue-and-white pear-shaped ewer, and a pair of blue-and-white faceted *meiping*-style vases with raised white dragon motifs (Fig. 226) were unearthed. Regrettably, none of these can be accurately dated, but judging from the style of an openwork vase and the Shufu porcelain copies, their production can be placed at sometime around 1330. It is therefore likely that the technique of a carved motif in white on a blue-and-white ground was already well known and in use before the development of Zhizheng-style blue-and-white ware. This means it was in use right from the early stages of blue-and-white ware production.

The Zhizheng Style

Jingdezhen blue-and-white ware is thought to have made its first appearance sometime in the 1310s and developed rapidly into the so-called Zhizheng style during and somewhat previous to the Zhizheng era (1341–67) of the Yuan period. The Zhizheng style was destined to last only through the 1350s, however, for the country was soon thrown into upheaval as the Yuan gave way to the Ming dynasty. The Jingdezhen kilns would not have been immune and probably suffered. Zhizheng ware was only allowed to evolve and attain perfection within a rather limited period of time, much like the situation that confronted Tang three-color ware.

The most obvious characteristic of the Zhizheng style is its large size. Most are plates, generally about fifty centimeters in diameter with flat rims. Oc-

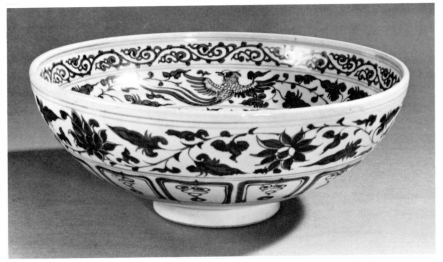

227. Large blue-and-white bowl with phoenix and peony-scroll motifs. Yuan dynasty. D. 30.2 cm. Idemitsu Art Gallery, Tokyo.

casionally a plate is seen with a foliate edge. These plates provide a flat, broad area suitable for painting. The foot of this type of plate is usually wide and low. The inside and the rim of the foot-ring are unglazed, exposing red scorched clay with black iron spots. Other shapes include large bowls similar to the plates but deeper and a variation of bowl without a rim. Other bowls have an inverted rim (Fig. 227) or are supported on a high foot.

Large jars and vases are also common among Zhizheng wares. The Baoding-type jar with its wide mouth (Pl. 36) was popular, as were jars of even more swollen shape. Occasionally, we find large high-shouldered jars with a cover and lugs (Fig. 228). Some of the most unusual and exquisite Zhizheng pieces are several large gourd-shaped vases with eight-faceted sides (Fig. 222) belonging to the Kikusui Handicraft Museum in Yamagata and the Topkapi Palace Museum in Istanbul. Other shapes that were produced on a large scale include slender-necked vases with handles, like the ones mentioned earlier dated "eleventh year of Zhizheng," rectangular flask vases (Pl. 37), and *meiping* vases.

The extreme size of the Zhizheng blue-and-white ware alone is enough to tell us that these wares were produced not to satisfy Chinese tastes but to meet a growing demand from West Asia and the Near East. This influenced not only the size of the wares but their mode of decoration as well. The basic Zhizheng design consists of a West-Asian-style arabesque. It is a pattern of flowers and foliage intricately drawn and endlessly repeating and doubling back on itself so as to cover nearly the whole surface of the white vessel. This is a typical example of the avoidance of white space that is so characteristic of West Asian

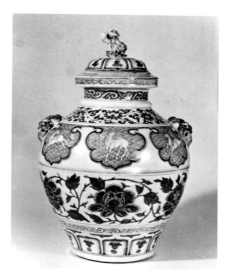

228. Blue-and-white jar with animal-mask lugs. Yuan dynasty. H. 40.5 cm. Private collection.

styles. The Chinese potters transformed this design into a flexible composition that never seems frivolous or crowded. The vigorous quality imparted by the Chinese craftsmen to an essentially foreign design is especially praiseworthy.

The Hongwu Style

The unsettled state caused by the transition from the Yuan to the Ming dynasty in the middle of the fourteenth century was probably what brought about the decline of the Jingdezhen kilns. But these kilns did not remain in a depressed condition for long. Pottery production was resumed in the middle of the Hongwu reign era (1368–98), shortly after the Ming dynasty was firmly established. The ware produced at this time is quite different in decorative style from Zhizheng ware.

The characteristic Ming blue-and-white ware did not appear until the Yongle reign era (1403–24), after the Hongwu era, when the official kilns in Jingdezhen became active under stable conditions. Sandwiched as it is between this Yongle style and the preceding Zhizheng style of blue-and-white ware, Hongwu-style ware does not stand out. It is essentially a transitional style (Fig. 229).

Compared to Zhizheng blue-and-white ware, the Hongwu wares are decorated rather crudely and without the strength of character of the older ware. There is no compactness in the flowers and foliage arabesque patterns of the Hongwu style. Compared to the vitality of the Zhizheng style it is quite lifeless.

This weakness of Hongwu decoration was in part due to the quality of the cobalt ore used for the underglaze blue painting. The wars at the end of the

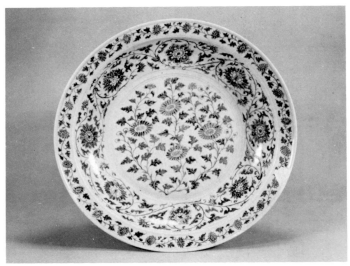

229. Large blue-and-white plate with chrysanthemum motif. Hongwu era. D. 45.8 cm. Museum of Far Eastern Antiquities, Stockholm.

Yuan period made it difficult for the Jingdezhen potters to obtain a certain kind of cobalt mixture, known as smalt, imported from West Asia. To make up for this, a low-quality domestic cobalt was mixed with the smalt. The result was a faint blackish blue that could not stand comparison with the distinctive Zhizheng blue even when the motifs were painted with the same expertise.

Underglaze Red Ware

As the quality of blue-and-white ware declined, an underglaze red ware, painted with copper oxide, began to be produced (Pl. 38, Fig. 230). This ware was simply a variation of the blue-and-white ware. Instead of painting a ware with cobalt and then coating it with a transparent glaze, the ware was painted with a copper oxide and then coated with the overglaze. The result is underglaze red ware as opposed to underglaze blue ware.

Copper oxide, however, is unstable, volatile, and difficult to handle. Because of this, it was rarely used at first, but as blue-and-white ware declined in the Hongwu era, the Jingdezhen potters tried harder to succeed with the underglaze red ware, for copper oxide was plentiful whereas high-quality cobalt was not. It is very difficult to obtain exactly the desired shade of red with copper oxide. If the overglaze coating is too thin, the copper oxide is apt to volatilize in a reduction firing and lose its red color. On the other hand, if the coating is too thick, the copper oxide may darken to an almost black shade. This is why there is so much variation among the surviving examples of underglaze red ware. On some pieces the motifs are a yellowish red, on others there is hardly any

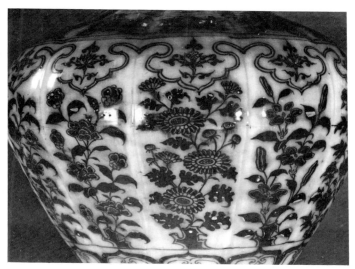

230. Large porcelain jar with floral motif in underglaze red. Hongwu era. H. 50.9 cm. Umezawa Memorial Gallery, Tokyo.

trace of red at all, or they are a blackish purple and blurred. It would be some time before the Chinese potters would be able to perfect this extremely delicate glazing technique and achieve a beautiful, stable, copper-red color.

25

Yongle and Xuande Wares

The Jingdezhen porcelains are representative of the main current of Ming, and later, Qing, ceramics. There were, of course, other types of ware being produced at the same time: three-color ware, *fahua* ware, Yixing ware, Dehua white porcelain, celadon ware produced on the southeast coast, and Guangdong mottled glazed ware. The Jingdezhen wares were the only ones, however, to show a steady development and to be produced in large numbers.

Jingdezhen wares in a definitely Ming style did not appear until the Yongle era. It is at this time that there is a discernable shift from the West Asian mode so popular at the end of the Yuan period to a more distinctly Chinese style.

Establishment of the Official Kilns

The prime factor behind this shift was the establishment of official kilns in Jingdezhen around the end of the fourteenth century. These official kilns produced excellent wares. No amount of time or expense was spared in their production, for the potters were free to concentrate their efforts solely on official wares. This inevitably led to an improvement in all the other Jingdezhen wares. The wares of the official kilns were made to appeal to the sophisticated tastes of the emperor and his court. Since their tastes were those traditional to the Han people, founders of the Ming dynasty, Yongle wares showed a natural tendency toward shapes and designs that differed considerably from those of the preceding era. The considerable number of white porcelains produced by the official kilns of the Yongle era are evidence of this shift in taste.

Song official wares had been predominantly celadons; and the Yuan official

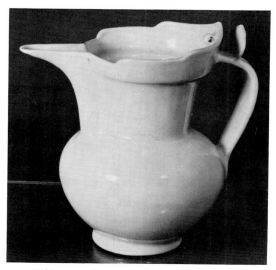

231. White porcelain jug of monk's hat shape with *anhua* decoration. Yongle era. H. 19 cm. Museum of Far Eastern Antiquities, Stockholm.

wares, white porcelains. The Han people of the Ming could have chosen the beautiful blue-and-white ware of their time for the official ware, but the somber, monochromatic white porcelain probably seemed more appropriate for ritual use simply because of its long tradition (Fig. 231).

Recent excavations of early Ming-dynasty tombs have unearthed a great deal of white porcelain and celadon ware but very little blue-and-white ware. This seems to support the theory that white porcelain was more highly prized than the blue-and-white ware. These same white porcelains bear an inscription reading Neifu, or Imperial Household. Though we tend to assume that blue-and-white and polychrome enameled wares predominated during the Ming dynasty, it is clearly evident that the Han people much preferred the more somber and dignified white porcelains. Nevertheless, a demand for the decorative blue-and-white ware did develop gradually. Most of the surviving pieces of Yongle ware are blue-and-white. There are even a few rare specimens of underglaze red ware.

Features of Yongle Ware

One of the obvious characteristics of Yongle ware is its shape. Though large vessels in the West Asian style, popular since the Zhizheng era, still predominated, such complicated shapes as jars and vases with lugs gradually disappeared in the Yongle era to be replaced by more simply shaped white porcelain and blue-and-white wares. These wares include a variety of small and medium-sized vessels used by the Han people in their daily lives.

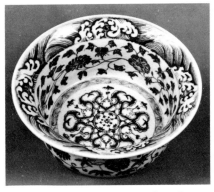

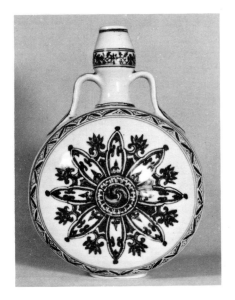

232. Blue-and-white basin with arabesque
motif. Yongle era. D. 26.6 cm. Private
collection.

233. Blue-and-white flask with arabesque
motif. Yongle era. D. 29.8 cm. Private
collection.

Vessels that preserved traditional shapes were often decorated with motifs of
new design. Sometimes shapes were slightly modified. We find a traditional
gourd-shaped vase that has been flattened into a flask (Fig. 233). Other examples
of wares representing the transition from West Asian to Chinese styles include
sensanpin-style ewers, *xi* (basins) decorated with arabesque motifs (Fig. 232),
jugs shaped like a monk's hat (Fig. 231), and *kendi,* a type of water vessel.

The high-quality smalt was once again obtainable and further refined to pro-
duce even brighter underglaze blue motifs. Both the clay and overglaze of
these wares were improved until the final product was considerably different
from the rather dark blue-and-white ware of the Zhizheng era.

There was a corresponding refinement in painting techniques, and motifs
became more sophisticated in keeping with the high quality of the materials
used. The motifs of this period have a musical tempo: water plants quiver in a
running stream (Fig. 234), and vines and floral scrolls undulate in a rhythmic
pattern across the surface of a vessel. Large areas of blank white ground are
reserved to better set off these motifs. Motifs in the sophisticated literati style
increase. There are large plates decorated with a painting of trees and rocks
surrounded by grasses (Fig. 235) and vases on which are depicted birds perched
on fruit trees. These types of painted decoration marked the end of the popu-
larity of the West Asian styles of the Zhizheng era.

Features of Xuande Ware

The Xuande era followed the Yongle era for a brief ten years. Though this reign

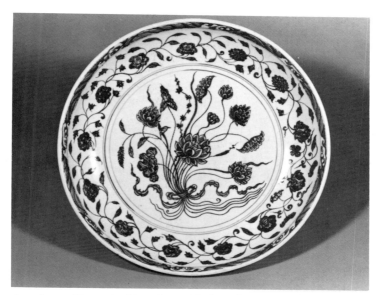

234. Large blue-and-white plate with lotus-flower motif. Yongle era.
D. 40.7 cm. Private collection.

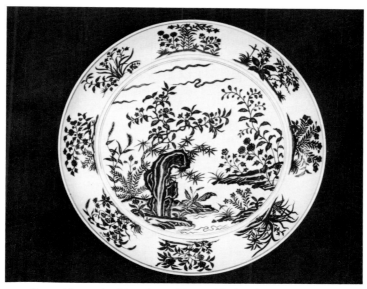

235. Large blue-and-white plate with motif of rock and grasses. Yongle
era. D. 67.6 cm. Idemitsu Art Gallery, Tokyo.

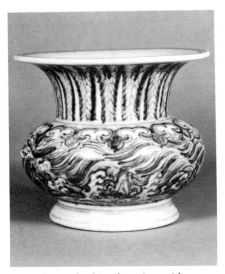

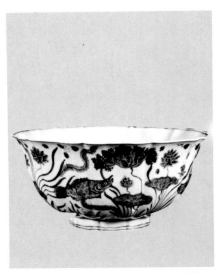

236. Blue-and-white leys jar with wave motif. Xuande reign mark and era. H. 15.5 cm. Private collection.

237. Blue-and-white bowl with foliate mouth. Xuande reign mark and era. D. 22.5 cm. Private collection.

era was short, the official kilns were more active than at any previous time, perhaps a reflection of the stable society of that period.

For the first time, the products of the official kilns were inscribed with the reign name, Xuande, thereby allowing us to date them. A six-character inscription (大明宣德年製), meaning "produced in the Xuande era of the Ming dynasty," is not what distinguishes the Xuande ware from the preceding Yongle ware, however. Xuande ware has a certain grandeur. This could be seen as a reaction to the more refined sophistication of the Yongle ware, but in any case the two wares are of the same quality and both represent a move toward a distinctive Chinese style.

Most Xuande vessel shapes are derived from those of the Yongle ware, but some other new variations have also been found: shallow bowls with wide, conical lids, lidded stem-cups, and leys jars (Fig. 236). Other unique shapes include fine, delicate stem-cups and bowls with foliate lips and ribbed sides (Fig. 237). The refinement expressed in these wares is carried over to some very small objects such as writing tools (Pl. 39). Certain stocky wares with thick walls (Fig. 238) seem out of place, but the medium-sized bowls with wide, flat rims that are executed in this style were probably meant for ceremonial use, for though their exteriors are painted with underglaze blue motifs their interiors are plain white.

The Xuande potters had a different approach to the problem of reserving white space in the decoration of their ware. Instead of aiming for the airiness of the Yongle style of painting, the Xuande potters confined their motifs to care-

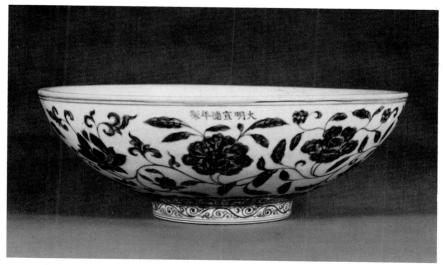

238. Blue-and-white bowl with peony-scroll motif. Xuande reign mark and era. D. 26.8 cm. Private collection.

fully outlined areas or in several bands, leaving the intermediary space white (Fig. 239). They painted their motifs with a blue smalt to which a small amount of domestic cobalt had been added. The result was a blackish tint that may have seemed to enhance the refined quality of the paintings.

The white background served to show off the white clay body as well as to enhance the blue painted motifs. The Xuande potters were justly proud of the beauty of their white ware. The clay was white, but the factor that made the white ground so unique was the presence of extremely fine bubbles in the overglaze. The result was a finely pitted, creamy white surface. The overall effect was very much like that of an orange skin. The surface of this Xuande ware has a matte-like, delicate finish. By leaving large areas of white on their ware, the Xuande potters may have been trying to emphasize the unique quality of the surface.

The inscriptions of reign marks, mentioned earlier, were painted with underglaze cobalt, generally in the center of the foot or the inside bottom of vessels. The six characters were inscribed in two vertical lines of three characters from right to left and enclosed by a double ring. Usually, the characters were executed in a fluent, formal style. On some wares with particularly wide or unglazed bottoms, the characters are in a single line reading from right to left, just below the mouth. In these cases, there are no encircling rings.

Underglaze Red Wares

We have concentrated on blue-and-white ware, but both the Yongle and

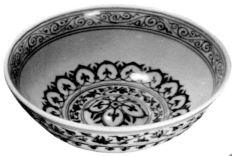

239. Blue-and-white bowl with convex inside bottom. Xuande reign mark and era. D. 15.2 cm. Private collection.

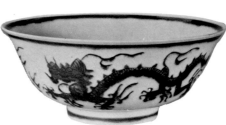

240. Porcelain bowl with dragon motif in underglaze red. Xuande reign mark and era. D. 20.9 cm. Private collection.

Xuande potters produced other types of ware, though not in such large quantities. The plain white porcelain produced in the Yongle era has already been mentioned. Underglaze red ware was also produced around the same time. We assume that this ware was a successor to the Hongwu tradition and was meant to be an improvement. The result, however, of the repeated attempts at improvement was the development of a completely new style of ware.

The Zhizheng and Hongwu underglaze red wares had motifs delineated in red, but the Yongle, and later, Xuande, underglaze red wares are decorated with a very different technique. The desired motif, a dragon, for example, was first lightly incised into the clay surface of a vessel. This technique is called *anhua,* or "secret decoration." Then the area of the motif was painted over with a red glaze (Fig. 240). The glaze accumulated along the incised lines, causing such details as the eyes and the mouth to appear to have been rendered in a darker red. This new technique of glaze application helped to solve the problem of the red glaze that too easily volatilized and disappeared when fired. By filling in the whole area of a motif with the red glaze, instead of simply outlining it, the glaze became relatively stable, and the red color remained.

This technique probably evolved from an earlier technique used in the latter part of the fourteenth century. Shufu ware of that time has a copper-red coating over the whole surface of a vessel with low-relief impressed motifs. Wares coated in this fashion were not successfully fired until the Xuande era, when a brilliant red color was at last achieved. In the Xuande era, bowls and stem-cups were sometimes decorated with silhouette patterns of fish or

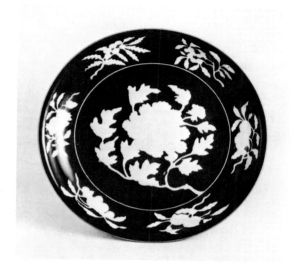

241. Large porcelain plate with white peony motif on indigo blue. Xuande reign mark and era. D. 38.5 cm. Ataka Collection, Osaka.

peaches painted in underglaze copper red on a pure white porcelain surface.

There is another ware that was produced at this time, using an indigo-blue glaze, that resembles the underglaze red ware. This indigo-blue glaze had been in use since the end of the Yuan dynasty. It was easily obtained by replacing the underglaze copper red with cobalt to achieve the indigo-blue color.

The Xuande and Yongle potters often used this cobalt in their work. One variation that was produced was a ware with white motifs in low relief on an indigo-blue ground (Fig. 241). The white motifs were drawn with a feldspar solution squeezed out of a tube, and fine details were added by incising lines with a gimlet. Both the feldspar and the glaze were of the same quality, which meant there was no fear of peeling after a vessel was fired.

26

Chenghua Ware

In the last chapter, we have covered the development of Jingdezhen wares, principally the blue-and-white wares, produced from the middle of the Yuan dynasty through the beginning of the Ming dynasty. By looking at these wares, we have been able to trace the evolution of styles from the grandeur of the Zhizheng, through the fluidity of the Hongwu and Yongle, to the maturity of the Xuande blue-and-white ware. The Ming dynasty continued for another two hundred years, but there was no further improvement upon blue-and-white ware after the initial three stages in the first three reign eras of the early Ming. The wares that were produced in later reign eras, such as the Chenghua, Zhengde, and Jiajing, each have individual characteristics, but these later blue-and-white wares were little more than minor variations on an already firmly established decorative style.

Thirty-Year Hiatus

In most Chinese ceramics history texts, Chenghua ware is introduced immediately after Xuande ware. It is seldom explained, however, that there were three reign eras after the Xuande era during which nothing of note seems to have been produced. None of the wares in existence today bear the reign marks of these three eras: the Zhengtong, Jingtai, and Tianshun. Reign marks were in common use by the Xuande era, so any wares produced during the above three reign eras should have borne one of these reign marks.

One of the explanations for the lack of such wares is that the official kilns were forced to close down during this period because of political unrest. The

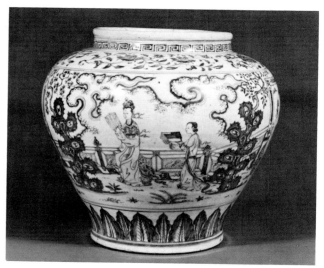

242. Blue-and-white jar with motif of woman and scrolling clouds. Ming dynasty. H. 35.8 cm. Private collection.

Zhengtong emperor had been captured by Mongolian forces, and plotting by court eunuchs had plunged the country into a politically unstable condition. The available historical records do state that the official kilns decreased production during this time, but there is no record of the kilns' being closed down altogether.

A certain amount of porcelain must have been produced, but for some unknown reason they were not marked with a reign name. There are quite a few specimens of blue-and-white ware, known to have been produced in the early Ming dynasty, that do not bear reign marks. The style of painting on these wares precludes their having been made in the Yongle era, and yet they do not have the delicacy of the later Chenghua ware. The conclusion is that these particular unmarked pieces, *meiping* vessels and jars in the *undō-de* style (a Japanese term referring to a type of decoration portraying figures in a pavilion with scrolled clouds and mountains in the background; Fig. 242), may be products of the missing three reign eras.

There is also the possibility that wares produced during these three reign eras may have been inscribed with the Xuande reign mark and have thus been classified as Xuande-era products.

Chenghua Porcelain

No other ware has been as shrouded in misinformation and misunderstanding as Chenghua porcelain. Many of the porcelain wares produced in the late Ming and Qing dynasties, as well as in Japan immediately after the Edo period, were

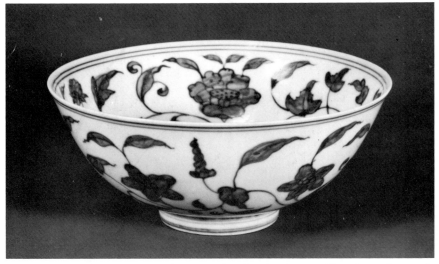

243. Blue-and-white bowl with floral motif. Palace-bowl type, Chenghua reign mark and era. D. 15.3 cm. Private collection.

inscribed with six characters meaning, "made in the Chenghua era of the Ming dynasty." This inscription was an attempt to copy the famous Chenghua porcelains, but it has also served to cause much confusion about which porcelains are genuine Chenghua wares and which are not.

Despite the high esteem for the Chenghua name, there are actually very few pieces still in existence that are definitely known to be Chenghua porcelains. The high quality and scarcity of this ware accounts for the increasing value placed upon it. Why Chenghua ware is so scarce is still one of the mysteries of Chinese ceramics history.

All the known examples of Chenghua ware are small. The blue-and-white Chenghua bowls, often referred to as palace bowls (Fig. 243) in North America and Europe, and the wine cups, commonly known as chicken cups, are so small they can be easily held in a cupped hand. Chenghua vases and jars, which are much scarcer, seldom exceed twenty centimeters in height. The small size of Chenghua ware seems to relate directly to the extremely delicate decorative styles of both the blue-and-white and enameled wares.

Blue-and-White Ware

The blue painted motifs on Chenghua porcelains are extremely delicate (Pl. 40). Floral scrolls and fruits with twining floral sprays remained popular, but the lines are not as undulating as before and seem to be little more than a device to connect the flowers and leaves in the motif. The whole motif is executed in a very fine line, faintly drawn and filled in with a faint wash.

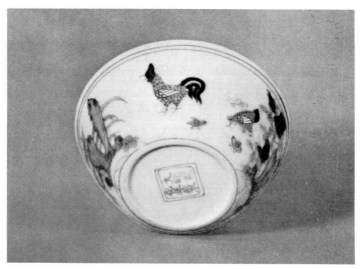

244. *Doucai* enameled chicken cup. Chenghua reign mark and era. D. 8.2 cm. Palace Museum, Peking.

The Chenghua motifs are neither as fluid as the Yongle motifs, nor as grand as those seen on Xuande ware. What these wares do have is an appealing elegance enhanced by an abundance of blank space. In addition, Chenghua porcelains are thinly constructed and carefully finished to give a delicate effect.

Doucai *Enameled Ware*

Overglaze enameled ware painted with more than two colors first appeared in the Chenghua era. As previously described, the earliest overglaze enameled ware was produced at the Cizhou kilns during the Jin period. These wares, however, are not regarded as true overglaze enameled wares since they were not white porcelains, but stoneware with a white slip coating. There are some examples that were produced in the early Ming period on which overglaze red enamel was combined with a blue-and-white ground. It is generally believed, however, that the red enamel on this ware was applied in lieu of underglaze copper red. It is not considered a true overglaze enameled ware. Chenghua overglaze enameled ware is therefore considered to be the first polychrome enameled ware. This enameled ware is more commonly known as *doucai*, a name referring to the pea-green color of the enamel most often used.

There are several other characteristics that distinguish *doucai* enameled ware. In producing this ware, an outline in a pale underglaze blue was sketched onto the unglazed surface of a vessel; the whole was coated with a transparent over-glaze and then fired until the vessel was firmly contracted. Later the motif outline was filled in with overglaze enamels baked onto the ware at a much

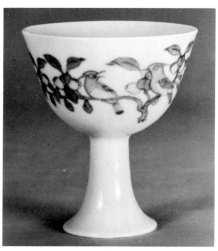

245. *Doucai* enameled stem-cup with bird design. Chenghua reign mark and era. H. 7.6 cm. Private collection.

lower temperature than the first firing. Enameled wares that do not have this underglaze blue outlining are not considered to be *doucai* ware.

Another distinctive characteristic of *doucai* ware is that the enamels used, except red, have a high transparency and glitter. In connection with this, it should be noted that another kind of enameled ware that began to be produced during the Hongzhi era is generally called *wucai,* or five-color, ware. This ware is distinguished from *doucai* ware in that it has neither the outlines in underglaze blue nor the high transparency of *doucai* enamels.

Doucai enameled wares were usually decorated with light-green, yellow, purple, and red enamels. Red was used sparingly to create an exquisitely elegant effect. In this respect, *doucai* ware again differs considerably from *wucai* polychrome enameled ware. *Doucai* shapes include small vases with gently rounded shoulders and shallow mouths (Pl. 43), chicken cups (Fig. 244), small stem-cups (Fig. 245), and palace bowls. Decorative motifs are restricted to floral sprays and scrolls, rosette-like flowers, landscape scenes, and chickens, considered to be an auspicious emblem and the source of the name chicken cup.

These *doucai* enameled wares bear the inscription of the Chenghua reign mark in six characters on the base, inscribed in underglaze blue. On the chicken cups, this inscription is set inside a double square. The inscription is executed in the printed style with the character strokes slanting to the right, an affected style that appears at first glance to be simply poor calligraphy. *Doucai* production declined after the Chenghua era but was revived later in the Yongzheng era of the Qing dynasty.

27

Hongzhi and Zhengde Wares

The Successors of Chenghua Ware

Hongzhi and Zhengde wares are considered to be the successors to the Cheng-hua style. These wares were made of the same materials as the earlier Chenghua ware and exhibit the same fragility and refinement of execution.

Few pieces remain bearing the Hongzhi reign mark. This seems to indicate that the official kilns were in a period of stagnation at the time. These Hongzhi pieces include dishes and bowls, none of which are unique or distinctive in shape.

In contrast to this, Zhengde ware appears in a wide variety of shapes. There are *zun*-shaped vases, ewers, various covered boxes, brush rests, and hat stands. Neither Zhengde nor Hongzhi wares include the large vessels characteristic of the early Ming dynasty.

The motifs are fairly uniform. A common one is of flying dragons chasing flaming pearls (Fig. 246) with a background of clouds and waves. Floral scrolls and sprays, fruit, and the "three friends" (pine, bamboo, and plum) continued to be popular but are conventionally executed. The most distinctive designs to be found on Zhengde wares are those based on Islamic motifs (Figs. 247–48). These include, of course, the arabesque motifs that had been in use since the end of the Yuan dynasty, but most of the Zhengde Islamic motifs were direct adaptations of Islamic symbols. One of these consists of decoratively arranged Arabic letters, a motif often found on Persian pottery. These Arabic letters are sacred quotes from the Koran inscribed within circles or squares and sur-

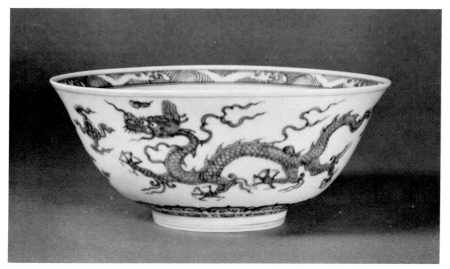

246. Blue-and-white bowl with dragon motif. Hongzhi reign mark and era. D. 18 cm. Umezawa Memorial Gallery, Tokyo.

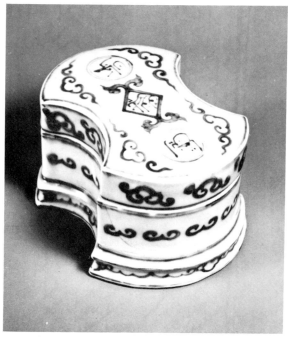

247. Blue-and-white weight-shaped covered box. Zheng-de reign mark and era. L. 15.3 cm. Private collection.

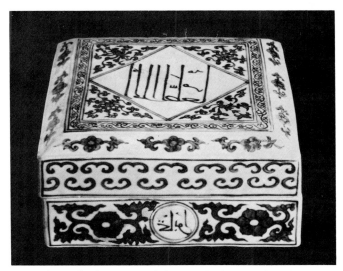

248. Blue-and-white covered box with design of Kufic letters. Zhengde reign mark and era. Museum of Far Eastern Antiquities, Stockholm.

rounded by either the traditional scroll motifs or stylized cloud motifs. Relations between China and the Islamic countries were particularly close around this time. The prevalence of Islamic motifs was probably due to the growing demand for such wares from these countries.

Some new techniques and designs were developed in the Hongzhi and Zhengde eras. One was the use of underglaze brown made from an iron pigment instead of the cobalt that had been traditionally in use for blue-and-white ware. The results are not particularly noteworthy, which probably explains why so few of these underglaze brown wares remain today. *Doucai*-style enameled ware was also produced during these two reign eras, but it cannot be compared to the elegance of the Chenghua *doucai* ware.

Wucai enameled ware displayed much more development at this time, but examples of it are rare (Fig. 249). The overglaze enamels used include red, green, brown, and a turquoise blue. The motifs were of simple flowers and fish. The composition of these motifs and their execution was still immature, but the style was increasing in popularity.

Green-Painted White Porcelain

A unique green enameled ware with a white ground was another product of these two reign eras. Only dishes and bowls were executed in this style, and the motif, without exception, was of flying dragons (Fig. 250). The overglazing technique used to make this ware was unusual and complicated.

After the bowl or dish had been formed, the flying dragon motif was incised

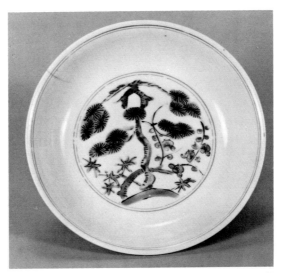

249. *Wucai* enameled plate with "Three Friends" motif. Hongzhi reign mark and era. D. 15.5 cm. Private collection.

into the ware and covered with wax. The vessel was then completely coated with a glaze and fired. The wax melted in the firing, leaving the dragon motif exposed. This reserved portion was later painted over with a green enamel, and the vessel was refired at a low temperature. The question remains of why such a troublesome wax-resist method was used.

There are two possible reasons. One reason is that if the green enamel had been applied in the usual way, over a glaze coating, it would have resulted in a very light color, which would not have created a contrast with the white ground of the vessel. The second reason is that the red tint of the biscuit helped to give the green enamel a deeper tone. Etching the motif into the clay and later coating the unglazed portion with a thick layer of enamel ensured a dark-green color that would contrast nicely with the white ground.

Production of this type of green enameled ware first began in the Chenghua era and reached its peak in the Hongzhi and Zhengde eras. The use of green enamel makes this an enameled ware, but the unique way in which the enamel was applied distinguishes this ware from other enameled wares such as *doucai* and *wucai* wares. The green-on-white design created a contrast similar to blue-and-white ware and underglaze red ware. The development of this ware is another indication of the changing tastes of the Chinese from the Chenghua era in the mid-Ming period to the Zhengde era.

Chenghua *doucai* ware and the early *wucai* ware, produced in the Hongzhi and Zhengde eras, have already been discussed. There are few examples of these two types of enameled ware in existence today. Their scarcity may indicate

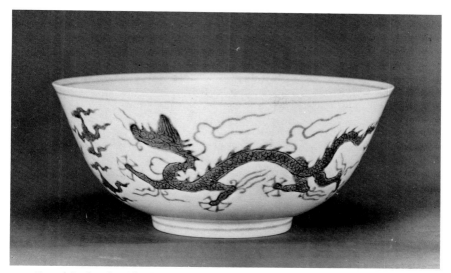

250. Porcelain bowl with dragon motif in green enamel on white ground. Hongzhi reign mark and era. D. 19.9 cm. Private collection.

that they were not so popular with the Chinese people of those times. The blue-and-white, underglaze red, and green-painted white wares seem to have been more popular. A taste for the brighter polychrome enameled wares had yet to develop.

Blue-Painted Yellow Porcelain

In the period of time between the Chenghua and the Hongzhi and Zhengde eras, a blue-painted yellow ware was produced (Pl. 41, Fig. 251). These were blue-and-white wares, fired once, painted over with a yellow glaze, and then refired at a low temperature. The yellow glaze was used only to fill in the white ground, and motifs were executed in underglaze blue. As a result, this particular ware is not classified with the other overglaze enameled wares but rather with the wares that contrast two colors. These would include the conventional blue-and-white wares and the underglaze red ware. The only difference is that the white ground was replaced with a yellow ground. The blue of blue-painted yellow ware is especially deep. A stronger coating of the underglaze blue was intentionally applied for a better contrast with the yellow ground.

A variation of this ware, a green enamel on a yellow ground, appeared in the Chenghua era. The motif was left on biscuit clay with wax resist and then painted over with a green enamel. The finished white porcelain ground was first painted over with yellow before the enamel was applied, and the ware was then fired again at a low temperature. The glassy green motif on the smooth

251. Blue-and-white plate with yellow ground. Zheng-
de reign mark and era. D. 25.3 cm. Private collection.

yellow ground creates a brilliant effect. This development of a green-on-yellow
ware represents a step toward the colorful world of polychrome ware.

The Hongzhi reign marks were executed in a style similar to the earlier
Chenghua reign marks, but sometimes the Zhengde reign marks consist of
only four characters, omitting the usual "Da Ming" (the great Ming). A few
of these reign marks were inscribed with overglaze red enamel.

28

Jiajing, Longqing, and Wanli Wares

The wares produced in the Jingdezhen official kilns from the Jiajing to the Wanli era differ considerably from their predecessors. One difference was that a greater quantity was produced. The other was the use of Mohammedan blue in place of smalt. The newly imported cobalt ore had a distinctive quality that is easily recognized. Another factor that distinguishes these periods of production is that enameled wares, including *wucai* ware, flourished. With the fall of the Wanli emperor in 1620, the country was thrown into turmoil, and porcelain production at the official kilns declined drastically.

The forty-five years of the Jiajing era were peaceful. Porcelain production was actively promoted in the official kilns. Previous to the Jiajing era, a court eunuch had been customarily appointed as the superintendent of the official kilns. But as the appointment process became more and more corrupt, the system was changed. In the ninth year of the Jiajing era (1530), a local government official was assigned to replace the eunuch then in charge of the official kilns. The result was greatly improved working conditions in the kilns. Production was divided into twenty-three separate processes, and six to seven kilns were built to fire the different types of porcelain separately. It is said that the official kilns alone numbered fifty-eight at this time. There were, in addition, at least twenty other unofficial kilns. There were more kilns than at any other time during the Ming dynasty. The yearly output of wares must have been in the tens of thousands.

The wares of all three eras are similar enough that they can be described together. The porcelain clay used was the high-quality *macang* kaolin clay,

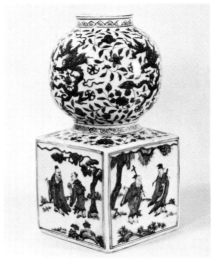

252. Blue-and-white rectangular covered box with Kufic letters. Jiajing reign mark and era. H. 9.1 cm. Private collection.

253. Blue-and-white vase with figure motif. Jiajing reign mark and era. H. 31.8 cm. Private collection.

noted for its perfect whiteness and fine texture. The wares of these three eras were not as finely formed, however, as their predecessors. The foot, in particular, was only roughly trimmed with no attempt made to smooth the edges. This may have been the result of the newly adopted mass-production system.

The overglaze used to coat the blue-and-white and enameled wares produced during these three eras was probably the same type of ash glaze as had been used previously. It consisted of a feldspar solution made of petuntse, a white China stone, mixed with fern ash and burnt lime. The ash in this overglaze may not have been refined as thoroughly as in the past. This would account for the blue tint of the overglaze when the vessels were fired in a reduction kiln. Only *wucai* enameled wares were coated with an overglaze with a greater amount of petuntse feldspar for a translucent, milky white effect. This was done purposely so that the overglaze enamels would stand out.

The situation described above—mass production, cruder forms, and the two overglazes, blue-tinted and milky white—remained relatively unchanged through the Longqing and the first half of the Wanli eras. This can be accounted for by the relatively stable political and social conditions of those times.

The Longqing emperor's reign lasted only six years, during which time the official kilns were fired only once, in the fifth year of the reign (1571). There is thus little point in trying to distinguish a Longqing style. The wares of this era are better classified as a simple extension of the Jiajing style. The same holds true for the first half of the Wanli era.

While wares produced during the second half of the Wanli era are easily

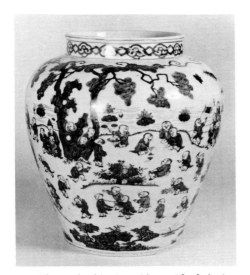

254. Blue-and-white jar with motif of playing boys. Jiajing reign mark and era. H. 31.2 cm. Private collection.

255. Blue-and-white vase with four animal-mask lugs. Wanli reign mark and era. H. 32 cm. Private collection.

distinguished from the highly ornate wares of the preceding Jiajing era, those of the first half, both blue-and-white and *wucai* enameled wares, closely resemble Jiajing wares in quality and style (Pl. 45). There are two major reasons for this consistency: one was that stable conditions still continued; the second was that comparatively few wares were actually produced, and the kilns were thus fired infrequently. These are the same reasons why there are so few early Wanli-era wares remaining today.

The court treasury suddenly became parsimonious in the twenty-fourth or twenty-fifth year of the Wanli era (1596 or 1597). China had become deeply embroiled in Korea's war against Japan. This, plus the constant effort to fend off the Manchurian forces of Nurhaci, had caused China's war expenses to escalate. In addition, a tremendous amount of money was wasted in the rebuilding of the imperial palace and the construction of other imperial residences. The official kilns therefore received less money, and it is no wonder they were obliged to produce inferior wares.

The Jingdezhen kilns were burdened with heavy taxes and an exorbitant demand for porcelains. The number of wares that were poorly formed, had peeling glazes due to poorly matched clay and glazes, and were decorated with carelessly painted motifs increased. There are some people, especially in Japan, who nevertheless claim to find a certain beauty in these wares.

Blue-and-White Ware

Blue-and-white wares were by far the most numerous of the Jingdezhen wares

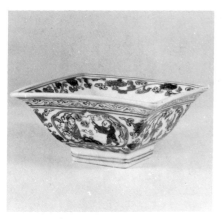

256. Square *wucai* enameled plate with design of butterflies and flowers. Jiajing reign mark and era. W. 17.8 cm. Private collection.

257. Porcelain *wucai* enameled bowl with figure motif. Jiajing reign mark and era. W. 11.5 cm. Private collection.

of the Jiajing, Longqing, and Wanli eras. These wares were painted with a new type of underglaze blue made of a cobalt known as Mohammedan blue. The smalt that had been in use previously had produced a deep, dark blue. The new cobalt produced a bright, violet blue. The motifs of the earlier blue-and-white wares had a shadowy blue tone that resulted from impurities in the smalt. In contrast, the Mohammedan-blue motifs that began to appear in the Jiajing era were extremely bright. This, coupled with the glossy, highly transparent overglaze, tended to create a rather overcrowded effect (Fig. 253).

Motifs increased in complexity from the Jiajing through the Wanli era, but some of the earlier Jiajing blue-and-white wares do show generous amounts of white space. Some of these earlier motifs are executed in a classical style that was probably an attempt to revive the early Ming-dynasty styles. Others bear Arabic motifs that were popular in the Zhengde era (Fig. 252). These earlier Jiajing blue-and-white motifs were apparently painted in Mohammedan blue mixed with domestic cobalt. The overall effect was to create a softened, muted tone.

These classical wares with their abundance of white space gradually gave way to a more elaborate style in which the whole surface of a vessel was covered with motifs. This overpainting seems to indicate an avoidance of blank space (Fig. 254). By the latter half of the Wanli era the motifs on some wares were so tightly crowded that it is difficult to distinguish individual patterns (Fig. 255). A similar trend developed with the *wucai* ware.

These complicated motifs were probably an outgrowth of a decorating

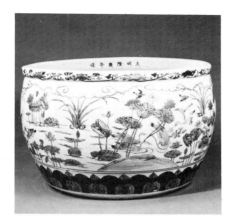

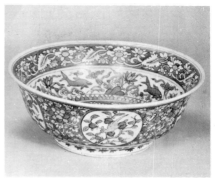

258. Large *wucai* enameled basin with design of waterfowl in lotus pond. Long-qing reign mark and era. D. 53 cm. Hatakeyama Museum, Tokyo.

259. *Ko aka-e* enameled bowl with design of fish in lotus pond. Zhengde reign mark and era. D. 28.5 cm. Private collection.

method that enclosed motifs within panels defined by repeated minute patterns (Figs. 256–57). The minute patterns packed into the background served to accentuate the main motifs inside the panels. As the amount of finely patterned background area increased, the result was busy, overcrowded decoration.

It is difficult to pinpoint the reason for the growing popularity of this type of decoration. However, it is most commonly found on wares known in Japan as *ko aka-e* (Figs. 259, 270) and *kinran-de* (Pl. 44), which were being produced by the unofficial kilns. The official kilns no longer dominated popular tastes and were gradually obliged to follow the modes set by the unofficial kilns, which were producing wares for the common people.

Characteristic Shapes

The blue-and-white, *wucai* enameled, and other wares produced during the three reign eras of the Jiajing, Longqing, and Wanli show no distinctive changes in the shapes of their bowls, cups, vases, and *meiping* except for a few variations of molded and faceted wares.

There is one type of vessel, a large-mouthed jar, that is worthy of some note. This type of jar was most commonly used as a container for goldfish and aquatic plants and was often decorated with water-related motifs such as ducks in a lotus pond and fish and waterweeds (Fig. 258). Many of these jars are extremely large, often more than a meter in diameter at the mouth, and were produced in great quantities. The development of these jars was one of the causes of the decline of the official kilns.

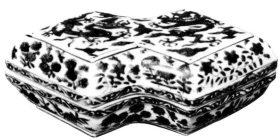

260. Blue-and-white covered box in double-diamond shape with dragon and flower-spray motifs. Longqing reign mark and era. L. 19.8 cm. Private collection.

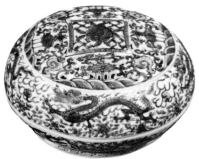

261. Blue-and-white covered box with openwork. Wanli reign mark and era. D. 21.3 cm. Private collection.

The few new shapes that appeared at this time were copies of traditional bronze shapes such as the *zun, gu* (wine cup), *lian, ding,* and *jue.* A type of ewer with a pear-shaped body, handle, and spout, which had first appeared in the Yuan dynasty, was revived in the Jiajing era and given the name *sensanpin* in Japan. These ewers were produced in large numbers by the unofficial kilns, though some are found among official ware. Unlike their predecessors, the sides are flat.

Covered boxes, which had begun to be popular in the Zhengde era, flourished in the Jiajing era. Their shapes varied widely. Some are cylindrical, others round, still others square or rectangular. Some of these boxes have elaborate octagonal and foliate shapes. There is one box in the form of a measuring weight and another of two joined diamonds (Fig. 260). Some doughnut-shaped covered boxes are unusually large. A few large covered boxes were produced in the Wanli era and most likely used as containers for food. The cover of this type of large box is decorated with openwork motifs (Fig. 261). The inside is divided into several partitions. These boxes are reminiscent of the Yue covered boxes that had been so popular in the Five Dynasties period.

Polychrome Wares

The polychrome wares, including *wucai* enameled ware, are particularly representative of the type of ware that was most popular from the Jiajing through the Wanli era. There are polychrome wares that predate the Jiajing wares. *Doucai* and *wucai* wares had been produced in the Chenghua and Hongzhi

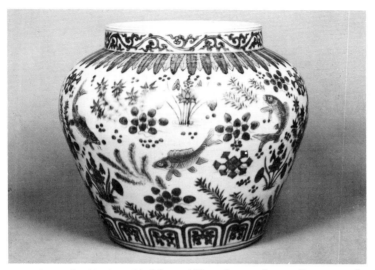

262. Blue-and-white jar with fish motif in red enamel on yellow ground. Jiajing reign mark and era. H. 30.6 cm. Private collection.

eras, and green and yellow enameled ware had been produced in the Chenghua era. These wares were still largely experimental, however, and did not attain wide popularity. But this situation changed completely in the Jiajing era.

A wide variety of polychrome wares appeared in rapid succession during the Jiajing era and quickly developed a maturity that met with great public favor. The first type of polychrome ware produced by the official kilns was probably a blue-and-white ware with overglaze decoration in red enamel. Another ware that took this one step further featured motifs of lotuses and waterweeds painted in underglaze blue, superimposed with fish, which were first painted with a yellow enamel and then with a second coating of red enamel (Fig. 262). It was natural for this ware to develop into a typical *wucai* ware with the addition of yellow, green, and turquoise blue.

By the time the official kilns began to produce polychrome ware, *ko aka-e* and *kinran-de* wares produced by the unofficial kilns had already attained popularity. The trend toward a bright polychrome porcelain finally freed the official kilns from the rigid ties of tradition.

Differences Between Official and Unofficial Wucai

The *wucai* enameled wares of the official and unofficial kilns were very different. The *ko aka-e* and *kinran-de* produced by the unofficial kilns consisted, as a rule, of decorative motifs painted in overglaze enamels on a glazed, plain surface. Nearly all of the official *wucai* ware has underglaze blue motifs in addition to the overglaze enamel decoration.

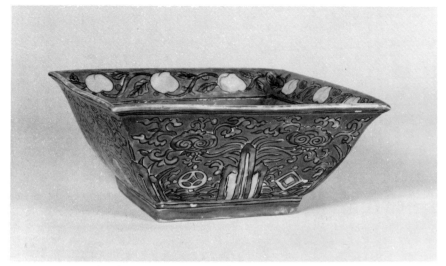

263. Square porcelain bowl with auspicious design in yellow and green enamels on red ground. *Cacai* type, Jiajing reign mark and era. W. 17.6 cm. Idemitsu Art Gallery, Tokyo.

The overglaze for the blue-and-white ware produced by the official kilns was a highly transparent ash glaze that made the underglaze blue motifs stand out clearly. This glaze, with its fine glossiness and its subtle bluish tint, was another distinctive feature of the *wucai* enameled ware produced by the official kilns.

The glaze on the *wucai* ware produced by the unofficial kilns is a translucent milky white, quite different from the transparent ash glaze used by the official kilns. The milky white effect was created by adding a large amount of feldspar to a transparent ash-glaze base. This served to accentuate the brilliant colors of the overglaze enamels. The milky white glaze does not have the bluish tint of the blue-and-white overglaze described above, nor is it as glossy.

Cacai *Enameled Ware*

Another rather unusual type of polychrome ware known as *cacai*, literally miscellaneous colors, was also produced during the Jiajing era (Fig. 263). *Cacai* ware is distinguished by its colored background, instead of the white background of the overglaze enameled wares mentioned earlier. One early example is a piece produced in the Chenghua era decorated in a green enamel on a yellow ground. Other color combinations include a yellow motif on a red ground and a red motif on a green ground.

In most cases the motif was painted onto the overglaze first, and then the background color was filled in. Another type of *cacai* was first completely coated with the motif color, and then the background was laid in with another ena-

264. Pair of porcelain bowls with design of figure under pine tree in green enamel on yellow ground. Jiajing reign mark and era. D. 16.6 cm. Ataka Collection, Osaka.

mel. This left the motifs in the first color. The most common examples of this type are red-and-yellow wares. The vessel was first coated with the yellow, and then the background was coated again with the red, leaving the yellow motif. The yellow under the red helped to create an attractive bright red tone (Fig. 265).

A ware known as *fahua* (Pl. 26, Figs. 267–68) provided the strongest stimulus behind the development of *cacai* ware. *Fahua* was a type of ceramic cloisonné on which motifs were outlined with fine threads of white slip on biscuit. The colored glazes were applied within the white slip outlines, which prevented the different colors from running into each other. The most commonly employed colors included indigo, purple, yellow, white, and turquoise blue. The juxta-position of these heavy, thick glazes created a very strong effect. *Fahua* ware will be described in more detail in the next chapter. It is only necessary here to note that *fahua* ware was the main inspiration behind the development of *cacai* ware.

In the Wanli era, popular tastes turned toward overdecorated wares, and the *cacai* wares became even more popular than before. *Cacai* developed from the simple two-color ware and the subsequent three-color ware. There were two distinct styles. One, known as overglaze enameled *sancai* (three-color) ware, generally consisted of a dominant yellow background that had been painted over a glazed and fired white porcelain body. Purple or green motifs were added later (Fig. 264, 266). The second style, known as *susancai* (enamel-on-biscuit), consisted of a direct application of *sancai* enamels onto a biscuited

265. Porcelain covered jar with dragon-and-cloud motif in yellow and red enamels. *Cacai* type, Jiajing reign mark and era. H. 17.4 cm. Musée Guimet, Paris.

266. Porcelain *zun*-shaped vase with design of figure and landscape in purple on yellow ground. Wanli reign mark and era. H. 26.8 cm. Yamato Bunkakan, Nara.

surface. Both types served as predecessors for the black and yellow hawthorn wares (Pl. 27) that were produced in the Kangxi era of the later Qing dynasty.

29

Various Types of Ming Unofficial Wares

The first official kilns are assumed to have been the ones established in Jing-dezhen around the end of the fourteenth century. Before this time all ceramic ware had been produced by independent, unofficial kilns. The only exception was the Shufu white porcelain produced by order of the government offices in the Yuan dynasty.

The unofficial kilns continued to prosper even after the official kilns had been established. Some blue-and-white ware in the Yongle and Xuande styles, but without the appropriate reign mark and of a somewhat lower quality, were probably products of the unofficial kilns. Wares such as *ko aka-e, kinran-de,* and *fuyō-de* have ensured the unofficial kilns a place in Chinese ceramics history. These wares have a unique character that is quite different from the wares of the official kilns.

Fahua *Wares*

The *fahua* wares, briefly described in the last chapter, had considerable influence on the ceramics of the Ming dynasty. Some of their more common shapes include jars, vases, and bowls (Pl. 26, Figs. 267–68). The name *fahua* is derived from the way in which these wares were decorated with motifs (*hua*) clearly delineated by thin threads of trailed white slip known as *fa,* or "boundary," in Chinese.

This decorative technique was probably first suggested by a cloisonné enameling technique common in the Jingtai and Tianshun eras. *Fahua* ware is traditionally said to have been produced in kilns located in Puzhou, Pingyang,

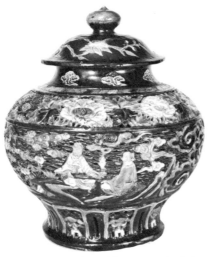

267. Stoneware jar with openwork design of figures among clouds. *Fahua* type, Ming dynasty. H. 47.5 cm. Private collection.

268. Small stoneware jar with floral scroll design. *Fahua* type, Ming dynasty. H. 6.6 cm. Private collection.

and Huozhou in Shanxi at the end of the Yuan dynasty, but this has yet to be proven.

There are two types of *fahua* ware. One has an earthenware body and the other is a hard stoneware. The earthenware type was often decorated with generous sprays of crudely drawn peonies done in light-colored enamels. This type of decoration is to be found exclusively on small jars (Fig. 268) and bowls. The similarity of this decorative style to that of the Cizhou ware suggests that this *fahua* ware was produced before the stoneware type.

The stoneware *fahua* were generally painted with thick, colored enamels. Motifs include such complex compositions as figures in a landscape, ducks in a lotus pond, and floral sprays and birds. Some of these motifs were combined with openwork decoration. The style of motifs is another indication that stoneware *fahua* was probably produced later than the earthenware *fahua*. In any case, both types of *fahua* were products of the fifteenth and sixteenth centuries.

The Jingdezhen potters were strongly influenced by the elaborately decorated, polychrome enameled *fahua* ware. This influence led first of all to the development of the Chenghua yellow-and-green enameled wares and later to the *sancai* and *cacai* wares (Fig. 269) of the Jiajing and Wanli eras. The Jingdezhen kilns originally produced a white porcelain ware with a vitreous glazed body. The appearance of a biscuit ware with enamel decoration, known as *susancai,* could only be explained by the influence of polychrome enameled *fahua* ware.

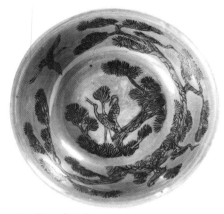

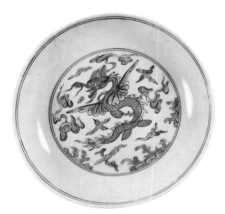

269. Porcelain bowl with design of crane and pine tree in green enamel on brownish red ground. *Cacai* type, Jiajing reign mark and era. D. 15.2 cm. Private collection.

270. *Ko aka-e* enameled plate with dragon motif. Jiajing era. D. 20.6 cm. Idemitsu Art Gallery, Tokyo.

Ko Aka-e *Ware*

It is unclear when overglaze enameling was first used at the Jingdezhen unofficial kilns, but it seems to have become very popular during the Zhengde era in the early sixteenth century. Many of these wares were manufactured for export.

The bowls, dishes, and vases produced at this time are commonly known as *ko aka-e,* or "old enameled ware" (Figs. 270–71). *Ko aka-e* is a general term used in Japan to distinguish this ware from the later *aka-e* enameled ware that was imported into Japan in the seventeenth century. Naturally, these wares do not bear reign marks since they were produced in unofficial kilns. There are some bowls inscribed in red enamel, however, that were apparently meant for presentation to the imperial court. One of these bowls is inscribed with the cyclical year name of *jiaxu* (甲戌), which would correspond to the ninth year of the Zhengde era (1514). This bowl is one of the earliest known examples of *ko aka-e* ware. Further proof of this is the similarity of this *ko aka-e* bowl to the plate illustrated in Figure 249. This plate is decorated with the "three friends" motif (pine, bamboo, and plum) and bears the Hongzhi reign mark.

Ko aka-e ware is usually predominantly red without any underglaze blue motifs. While the clay may be the same as that of the blue-and-white ware, the overglaze is of the milky white type rather than the transparent ash glaze used on the blue-and-white wares. Other colors to be found on *ko aka-e* include green and yellow. Occasionally, additions of turquoise blue and purple

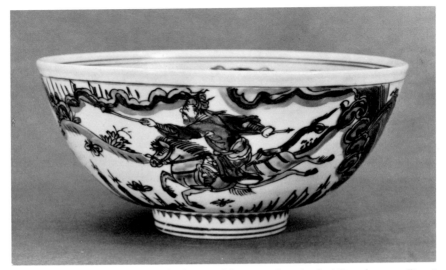

271. *Ko aka-e* enameled bowl with design of figure on horseback. Ming dynasty. D. 18 cm. Hatakeyama Museum, Tokyo.

may be seen but these are rare. The polychrome enamels and the creamy white overglaze that is left unpainted combine to give a bright, warm effect.

Major motifs include floral scrolls, ducks in a lotus pond, fish and water-weeds, peacocks and peonies, dragons, phoenixes, and human figures. The style and composition of these motifs are very often in the tradition of the early Ming blue-and-white ware. One obvious example of this carry-over of styles is the scrolled cloud border found around some of the human figure motifs.

At this early stage in its development, *ko aka-e* had not yet evolved its own original designs. Still, the use of overglaze enamels at a time when blue-and-white ware predominated was a revolutionary event in itself. *Ko aka-e* was produced mainly for export, but it still exerted a powerful influence on other ceramic wares produced for the Chinese markets. The official kilns began to produce *wucai* enameled ware in the Jiajing era.

It should be mentioned that some *ko aka-e* pieces bear Xuande and Chenghua reign marks, but these were actually produced after those reign eras.

Kinran-de *Ware*

Another enameled ware produced by the unofficial kilns of Jingdezhen is known by the Japanese name of *kinran-de*. This ware flourished in the Jiajing era a little after *ko aka-e* had appeared. The major difference between *kinran-de* and *ko aka-e* is that the former consisted generally of a combination of colored enamels and underglaze blue motifs. The overglaze was the transparent type

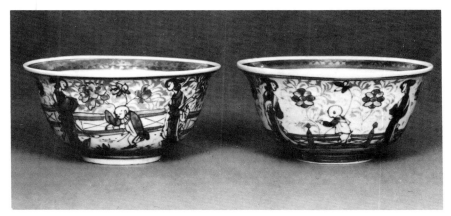

272. Pair of porcelain bowls with design of court lady and boy in underglaze blue and enamels. *Kinran-de* type, Ming dynasty. D. 12.2 cm. Private collection.

with a faint blue tint, used on blue-and-white ware (Fig. 272). Some *kinran-de* ware without underglaze blue motifs also used this type of overglaze, which is quite different from the translucent, milky white glaze of *ko aka-e*.

The name *kinran-de* is a reference to the lavish gold decoration resembling gold brocade that is found on this ware. There are a few, very rare, examples of *kinran-de* pieces decorated only in gold on the white porcelain body. Most *kinran-de* ware has a gold motif applied on a ground first painted with a colored enamel. This style seems much more effective than the plain gold on white. The gold was not used for such scenic motifs as ducks in a lotus pond or dragons and clouds. Gold was more often used in floral scrolls centered around peonies and Indian lotuses. In such cases, the enamel application was generally limited to fine repeated patterns such as checks and sectioned diamonds.

The use of gold and colored enamels makes *kinran-de* ware appear gaudy at first glance, but upon closer inspection it can be seen that the motifs are relatively simple compositions. *Kinran-de* is quite different in decorative style from the blue-and-white ware and other enameled wares produced around the same time by both the official and unofficial kilns.

Kinran-de shapes include several that were not seen previously. There are *kinran-de* bottles, similar to the pear-shaped bottles with trumpet-shaped mouths set on a slender neck from which the trumpet portion appears to have been abruptly cut off. Another variation of this type of bottle is a gourd-shaped bottle with either a plain or a faceted body.

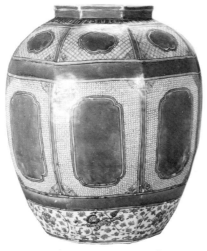

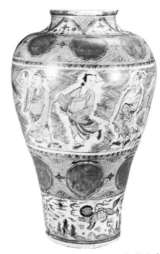

273. Porcelain hexagonal jar with geometric pattern in enamels and gold. *Kinran-de* type, Ming dynasty. H. 62.2 cm. Hakutsuru Art Museum, Kobe.

274. Large porcelain vase with "Eight Immortals" design in enamels. *Kinran-de* type, Ming dynasty. H. 53.5 cm. Hakutsuru Art Museum, Kobe.

There are *kinran-de* vases with lids in the early Ming style, but there are also other vases with plump bodies, gently sloping shoulders, and low, wide mouths. Some of these have faceted bodies as well (Fig. 273). A *sensanpin*-style ewer that had been popular ever since the Yuan dynasty, but which had declined somewhat in the Chenghua era, was revived with a few alterations and decorated in the *kinran-de* style (Pl. 44). The round body was flattened into a flask shape, and a high foot was added.

Bowls, the most numerous of *kinran-de* wares, were fashioned in a new style in which the lip did not flare out. It is evident that the *kinran-de* potters were willing to experiment with every possible style. The many variations of shape were to have a strong influence upon other wares produced in the official and unofficial kilns at that time and later.

The distinguishing feature of *kinran-de* ware is the fussy decorative technique of tiny patterns packed into the background surrounding panels of outlined motifs with very little blank space (Fig. 274). This decorative technique had considerable influence on Jiajing and Wanli blue-and-white and other enameled wares produced by both the official and the unofficial kilns.

30

Late Ming and Early Qing
Unofficial Kilns

Production at the Jingdezhen kilns was cut back drastically after the death of the Wanli emperor. It was almost as if the kilns had never been commissioned to produce wares for the imperial court. The position of superintendent of the kilns was abolished. The potters, released from a demanding schedule and severe restrictions, were now able to attempt commercial production. No longer were they required to make their wares according to rigid specifications, nor did they have to work overtime to meet impossibly high quotas. The result was a wide variety of wares including Tenkei, Nankin *aka-e, fuyō-de,* and Shonzui wares.

All of these wares produced from the late Ming through the early Qing dynasty are referred to in Europe and North America as transitional wares. They are characterized by unusual features setting them apart from other wares executed in more traditional styles.

One exception is a certain ware, very few specimens of which exist today, executed in the former official-ware style and inscribed with the reign marks of the Tianqi and Chongzhen eras (Fig. 275). The scarcity of this ware suggests it was specially manufactured for some unknown purpose. Despite its similarity to the former official ware and its careful execution of form and decorative motifs, this ware is only a copy made in an attempt to revive the traditional style of the former official wares. It is an exception, out of harmony with its time.

Tenkei Blue-and-White Ware

The transitional wares are extremely varied, and it is difficult to pinpoint one

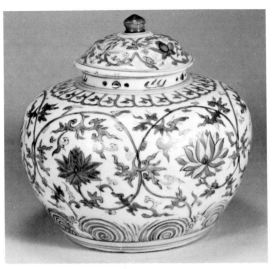

275. *Wucai* enameled covered jar with floral scroll motif. Tianqi reign mark and era. H. 19.6 cm. Private collection.

common feature, but perhaps it is their spontaneity that ties them together. They seem to reflect the liberated spirit of the potters who fashioned them.

The blue-and-white ware known in Japan as Tenkei ware is the most representative of this spirit. Its name derives from the Japanese pronunciation of the Tianqi era in the late Ming dynasty, when it was first produced. The name distinguishes this ware from later Qing blue-and-white ware imported into Japan in the eighteenth century. Tenkei ware is also known in Japan as *ko sometsuke,* or "old blue-and-white" (Fig. 276). Tenkei enameled porcelain, or Tenkei *aka-e,* is a variation of Tenkei blue-and-white ware to which overglaze enamels are added.

Tenkei blue-and-white ware included small and medium-sized plates and bowls and a few vases. Other forms include *mukōzuke* (side dish), serving dish with handle, *mizusashi* (water jar), and *yutō* (a type of ewer); all were made in accordance with specific orders from Japan for tea-ceremony utensils.

Tenkei blue-and-white ware is roughly formed. It was apparently thrown at high speed and made in large quantities. Common motifs are landscapes (Figs. 277–78), birds and flowers, and human figures. These motifs are executed with an exuberance that speaks of the pleasure the potter had in painting them, rather than refined skill. Most are copies of paintings of the Dong Qichang school of painting popular at the time and are pictorial compositions. There are no repeated patterns. These pictorial motifs anticipate the exquisite paintings found on early Qing blue-and-white ware.

A peculiar feature, found on many Tenkei blue-and-white wares, is the

276. Tenkei blue-and-white flask with design of fish and net. Late Ming dynasty. H. 16.8 cm. Tokyo National Museum.

277. Tenkei blue-and-white bowl with landscape motif. Late Ming dynasty. D. 14 cm. Private collection.

278. Tenkei blue-and-white square plate with landscape motif. Late Ming dynasty. W. 17.4 cm. Private collection.

279. Tenkei blue-and-white water jar with grapevine motif. Late Ming dynasty. D. 25 cm. Private collection.

ragged-looking rim referred to in Japan as *mushikui,* or "insect nibbles." This is caused by the flaking of the glaze along the rim of some vessels, especially bowls, when the glaze and clay have differing rates of contraction in the firing process. As the ware is fired, the clay shrinks away from the glaze, leaving pockets of glaze that flake off easily. This apparent flaw, coupled with the lively execution of the painted motifs, actually creates an overall effect that is quite pleasing.

Though many Tenkei blue-and-white wares are ordinary bowls and dishes (Figs. 277–78), certain pieces were produced for special orders from Japan for tea-ceremony utensils. Because no Tenkei blue-and-white wares exist in China today, it has been widely assumed that these wares were produced solely for export. However, it is more likely that the ordinary bowls and dishes were actually made for use as everyday ware in China. Since they were not considered to be special, they were probably easily broken and discarded, which would account for none being found in China today. In Japan, on the other hand, even these everyday wares were highly esteemed and treasured along with the tea-ceremony utensils.

The Tenkei blue-and-white tea-ceremony utensils (Fig. 279) and tableware (Fig. 280) ordered from Japan display a variety of uniquely Japanese designs that do not reflect Chinese tastes in either shape or decoration. These pieces were manufactured in accordance with wooden models and illustrations brought over from Japan where the tea ceremony was flourishing under Furuta Oribe, the great tea master.

281.. Blue-and-white plate with design of flowers in basket. *Fuyō-de* type, Late Ming dynasty. D. 51.5 cm. Private collection.

280. Tenkei blue-and-white plate with design of arhat. Late Ming dynasty. L. 34.7 cm. Private collection.

One common feature of these wares is their thick construction. Porcelains manufactured in Jingdezhen up to that time were generally extremely thin and made of fine kaolin clay. The Tenkei wares, however, were thickly made. One reason for this might be that they were made according to specifications given by Japanese who were only familiar with stoneware and its thick construction.

In Europe, on the other hand, Jingdezhen porcelains were highly prized for their delicate, thin construction and the regularity of their motifs. Examples of Tenkei blue-and-white ware are therefore extremely rare in Europe.

One variation of Tenkei blue-and-white ware is a painted porcelain with red, green, and yellow overglaze enamels applied over the blue-and-white base. These are generally referred to in Japan as Tenkei *aka-e,* or Tenkei enameled ware, but, again, none are to be found in Europe. The finer *fuyō-de* and Nankin *aka-e* seem to have had more appeal for European tastes.

Fuyō-de *Ware*

Tenkei blue-and-white ware may have suited Japanese tastes, but *fuyō-de* blue-and-white, produced by other kilns in the Jingdezhen area, appealed to the taste of the peoples of Southeast Asia, West Asia, and Europe. *Fuyō-de* is more commonly known in Europe by the name of kraak ware. The Japanese name is derived from the characteristic decoration common to this type of ware. Most often seen on dishes and large plates, this decoration consists of a central circular area surrounded by radiating panels divided into small panels.

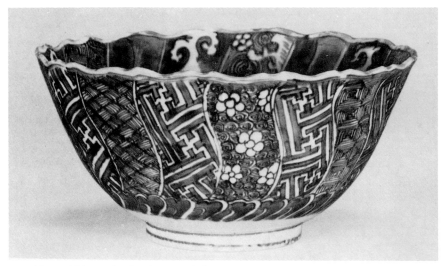

282. Shonzui blue-and-white bowl with foliate rim. Late Ming dynasty. D. 20 cm. Private collection.

The overall effect closely resembles the petals of a kind of rose mallow called *fuyō* in Japanese, hence the name *fuyō-de* for wares decorated in this manner, *de* meaning style (Fig. 281).

Fuyō-de seems to have first appeared in the Wanli era. We know this because *fuyō-de*-type decoration appears on some of the official wares of the Jiajing and Wanli eras, as well as on *ko aka-e* and *kinran-de* wares. In addition, the Dutch East India Company began to import a great deal of *fuyō-de* ware from China in the Wanli era. The height of *fuyō-de* production, however, probably dates to the Tianqi and Chongzhen eras.

The distinguishing characteristic of *fuyō-de* ware is its extremely regular decoration, already described, which is in direct contrast to the spontaneous painting found on Tenkei blue-and-white ware. One example, a delicate dish decorated with orderly panels of floral motifs centered around a circular painting of a bird and flower, has an especially European flavor. This suggests that *fuyō-de* was specifically produced to appeal to European tastes. Records show that a great deal of this ware was exported to Europe, where it was tremendously popular. *Fuyō-de* dishes even figure in many of the paintings by contemporary northern European artists, which is another indication of their popularity.

Despite its apparent resemblance to European designs, however, the origins of this ware actually trace back to Islamic designs. Persian kilns producing low-fired pottery began manufacturing brilliantly colored glazed wares in the ninth century. A polychrome ware, painted with an exquisite revolving motif

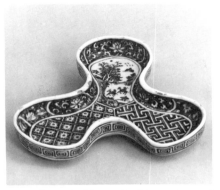

284. Shonzui blue-and-white plate of irregular shape. Late Ming dynasty. L. 21 cm. Private collection.

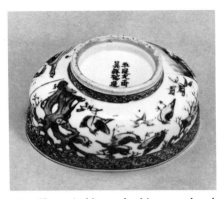

283. Shonzui blue-and-white tea bowl with oval mouth. Late Ming dynasty. D. 12.6 cm. Fujita Art Museum, Osaka.

in the style of Radibaldina ware, was very popular in Persia. The Izunique kilns in Turkey also began producing a similar ware at about that time. Both the Persian and Turkish styles were introduced into China together with Mohammedan blue, a cobalt ore. They were the impetus behind the development of Jingdezhen porcelains, the most typical of which was *fuyō-de* blue-and-white ware.

Major shapes to be found among *fuyō-de* wares include large and medium-size dishes, liquor bottles, and *kendi*-shaped ewers. A common type of dish is one with a scalloped rim and ribbing to match the panels of motifs arranged like flower petals. These vessels are usually of thin construction with a smooth glaze surface. Occasionally, pieces have broken *mushikui* rims.

Two types of pigments were used to paint the *fuyō-de* designs: a Chinese cobalt and Mohammedan blue. The Mohammedan-blue pigment produced a more brilliant color and is usually found on the superior *fuyō-de* wares.

Shonzui Ware

Shonzui blue-and-white ware is fine-quality porcelain that reflects Japanese taste as dictated by the aesthetics of the tea ceremony. Some of the tea-ceremony utensils that have been handed down from generation to generation are decorated with exquisite paintings. Known as Shonzui ware, these pieces include incense boxes, tea bowls, *mizusashi* (water jars; Pl. 42), sakè bottles, dishes, and bowls (Figs. 282–85).

After much debate, it has been concluded that these particular pieces must have been produced under the direction of a Jingdezhen potter known as Wu

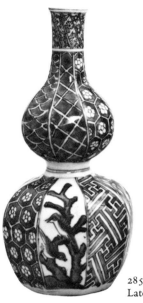

286. Porcelain plate with motif of birds and peony in underglaze blue and enamels. *Iro-e* Shonzui type, Late Ming dynasty. D. 26.5 cm. Private collection.

285. Shonzui blue-and-white gourd-shaped sakè bottle. Late Ming dynasty. H. 21.5 cm. Private collection.

Xiangrui, who was active from the middle of the Chongzhen era of the Ming dynasty to the Shunzhi era of the Qing dynasty. He probably had these wares made to fill orders from Japanese tea masters who were followers of Kobori Enshū, a famous tea master.

Some of the pieces bear the inscription Wuliang Dafu Wu Xiangrui *zao*, "made by Wu Xiangrui [also known as] Wuliang Dafu" (Fig. 283), and are regarded as having been made at a studio directed by Wu Xiangrui himself. His name is used to refer to all wares resembling the style of these few authentic pieces. The Chinese reading of the characters for the potter's given name is Xiangrui, but this ware is known by the Japanese reading Shonzui.

Shonzui ware resembles Tenkei blue-and-white in that both wares were produced for the Japanese market. The similarities of shape and decoration between the two wares represent one aspect in the development of Wanli and Tenkei blue-and-white ware. Closer inspection, however, reveals that the Shonzui ware has an exquisite sophistication that contrasts directly with the uninhibited spontaneity of Tenkei blue-and-white. This can also be seen as a reflection of the difference in taste between the tea masters Enshū and Oribe.

The clay and glaze of Shonzui ware has been refined to the point where it resembles jade. The Shonzui potters seem to have paid particular attention to producing a beautiful blue for their designs. One scholar even suggests that lapis lazuli from Afghanistan was mixed with the Mohammedan blue pigment.

Most Shonzui wares are very carefully formed, and quite a few have rather thick walls. The Japanese patrons, unfamiliar with the delicate thinness most

287. Square Nankin *aka-e* enameled plate with paired phoenix design. Shunzhi era. W. 19.6 cm. Tokyo National Museum.

appropriate for porcelain, probably specified a thick construction. Some earlier pieces of Shonzui ware display the *mushikui* rim often found on Tenkei blue-and-white, but this flaw was soon corrected, for it is not to be found on later pieces. As an added precaution, an iron-oxide slip was applied along the mouth of some vessels, resulting in a rust-red rim known as *kuchibeni*. Such attention to detail shows how much care was taken in the production of Shonzui ware. The rust-red rim of some of the Shonzui pieces, and a purely decorative variation consisting of a thin rust-red ring around the body of a vessel, add very elegant touches to this blue-and-white ware.

The principal designs on Shonzui wares are landscapes, human figures, and bird and flower motifs. The secondary motifs are more extraordinary. They include repeated patterns of diaper quatrefoil motifs, checks, bisected diamonds, basket weaves, zigzag lines and tortoise-shell motifs. These patterns, similar to those found on early examples of Japanese Kyō ware (*Kyō-yaki*), reflect a strange combination of both Chinese and Japanese styles (Fig. 285). This is the most distinguishing feature of Shonzui ware.

Iro-e, or enameled, Shonzui is a variation of Shonzui ware with decoration in overglaze colored enamels on the blue-and-white ware (Fig. 286). Though these pieces were probably made at the same time and by the same kilns producing ordinary Shonzui ware, there are few specimens to be found today. Copies, however, distinguished by the lighter blue of the underglaze motifs and produced by subsidiary kilns, are to be found in unexpected quantities. The underglaze blue motifs and overglaze enamels produce a brilliant and

288. Nankin *aka-e* enameled bowl with floral spray motif. Early Qing dynasty. Ethnological Museum, Groningen.

well-harmonized combination that suggests an interesting relationship to the Kutani and Arita enameled wares of Japan in both motifs and techniques.

Nankin Aka-e *Ware*

Nankin *aka-e* ware bears motifs painted predominantly with red, green, and yellow enamels, with additions of turquoise blue, purple, and black on a milky white surface. The mouth rim of Nankin *aka-e* ware often has the rust-red coating described earlier in relation to Shonzui ware. Some early Nankin *aka-e* pieces have underglaze blue decorations as well (Fig. 287), but these should really be classified as Shonzui ware, since Nankin *aka-e* generally does not have any underglaze blue decoration. The term Nankin *aka-e* comes from the Japanese pronunciation of the city of Nanjing, which had become the name closely associated with China during the Edo period.

The delicate and fine formation of many Nankin *aka-e* pieces and the numerous Nankin *aka-e* dishes with foliate rims and ribbing (Pl. 48, Figs. 288–89) indicate a close relationship to *fuyō-de* ware. There are, however, two features that make Nankin *aka-e* ware different: the milky white overglaze and a type of decoration that is quite different from the regular motifs found on *fuyō-de* ware. Nankin *aka-e* motifs are executed in the pictorial style. Though this suggests a similarity with Tenkei blue-and-white, the Nankin *aka-e* motifs are more neatly and delicately executed. The overall composition and choice of colors also seem to reflect a careful consideration. The Kakiemon ware of Japan, a successor to Nankin *aka-e,* still shows this decorative effect.

289. Nankin *aka-e* enameled plate with birds-and-rockery motif. Early Qing dynasty. Private collection.

Apparently, Nankin *aka-e* was equally popular both in Japan, where Tenkei and Shonzui blue-and-white were so loved, and in Europe, where *fuyō-de* ware was preferred. Hence there are numerous examples of Nankin *aka-e* in both Japan and Europe that have survived to this day. In Japan, however, this ware was eventually displaced by a more Japanized version produced by the Arita and Kutani kilns. In Europe, on the other hand, the popularity of Nankin *aka-e* ware grew. Some of the pieces of Nankin *aka-e* ware to be found in Europe are in a conspicuously European style, as designed for that market, and are not to be found in Japan (Fig. 288).

All of the above-mentioned wares produced by the unofficial Jingdezhen kilns tend to be regarded as products of the late Ming dynasty because they were believed to have been produced during the Tianqi and Chongzhen eras. It would be more accurate to regard these wares as transitional pieces belonging to the time span between the late Ming and early Qing periods.

Produced as these wares were in the Jingdezhen area, it would seem only natural that they should reflect some of the tradition behind most of the wares produced in that region. And yet these wares display too many unique features to tie them closely to traditional styles, which has led to their separate classification as a special group designed primarily for export.

As the *fuyō-de,* Shonzui, and Nankin *aka-e* wares developed, they were influenced by Japanese and European tastes and by each other as they eventually evolved into the blue-and-white and enameled porcelains of the Kangxi reign era of the Qing dynasty.

31

The Revival of Official Kilns
in the Qing Dynasty

The Chongzhen reign era, the last of the Ming dynasty, ended in its seventeenth year to be replaced by the Shunzhi reign era (1644), the first of the new Qing dynasty. This does not mean, of course, that there was a sudden appearance of typical Qing-style wares. The Jingdezhen region must have been affected by the disturbances accompanying the change in dynasties. It is unlikely that ceramic production would have undergone any major development for several years before and after the dynastic change.

The Jingdezhen kilns apparently did not regain their former pace of production until the eighth year of the Shunzhi period (1651). Historical records state that in this year the governor of Jiangxi commissioned bowls to be painted with dragon motifs, which he presented to the imperial court. This seems to indicate that the Jingdezhen kilns had sufficiently revived to produce ware worthy of presentation (Figs. 290–91).

Though the Jingdezhen kilns were producing porcelains for official use, it was not until the nineteenth year of the Kangxi era (1680) that they were formally designated official kilns. Three years later, in the twenty-second year of the Kangxi era (1683), Zang Yingxuan and Che Erde, high-grade ceramics technicians and designers, were assigned to supervise the kilns. Zang Yingxuan in particular had an extraordinary supervisory talent. This is known since major pieces of Kangxi official ware are referred to in several different historical records as Zang *yao* ware.

The Qing official kilns represent the consummation in Chinese ceramics production. Superior wares of the same basic quality were continuously pro-

duced during the three reign eras of the Qing dynasty. These wares are generally known by the reign names of Kangxi (also known as Zang *yao* ware), Yongzheng, and Qianlong wares. The official wares of the last two periods were produced under the talented supervision of Nian Xiyao and Tang Ying. A description of the materials used to produce these wares will proceed a discussion of the wares themselves.

Clay

The Qing official wares were made of a mixture of kaolin and petuntse, a China stone. The name of kaolin is derived from the mountain of this name near the Panyuan River, east of Jingdezhen, where this porcelain clay was first discovered. Kaolin is now a general term commonly used to refer to porcelain clay. Kaolin is composed of decayed quartz trachyte containing fine silica particles. It is pure white and has a high melting point. Since kaolin used alone is infusible, it is mixed with petuntse so that it can be fired in the kiln. Petuntse (*baidunzi*) is a powder made of a finely ground feldspathic stone known as *qimen* stone, or China stone.

The kaolin clay does not require special preparation before it is mixed with the petuntse powder. The ratio of kaolin to petuntse varies according to the period in which a ware was produced. In the Kangxi era, only a small amount of petuntse was mixed with the kaolin, but by the late Yongzheng and Qianlong eras, the ratio was reversed.

Kangxi porcelain ware has a smooth white surface that still retains a somewhat clayish quality. The porcelain wares produced from the late Yongzheng era have a vitreous, glasslike quality. The lack of plasticity of the Yongzheng porcelain clay with its high petuntse content made it difficult to throw on the wheel

Glaze

The glaze used on Qing official wares was based on petuntse mixed with ash. The ash was made from burnt lime and ferns piled in alternate layers and burned several times. The ash that resulted was dissolved in water. After adding a small amount of plaster (one percent of ash), the solution was strained and mixed with a slip made of petuntse powder and plaster to make a fine ash glaze. The calcium phosphate contained in the fern ash gives this overglaze its characteristic deep brilliance. The one-to-ten ratio of the ash glaze to petuntse makes a high-quality overglaze that can withstand a high-temperature kiln. Too much ash lowers the glaze quality. The high temperatures at which Qing porcelains were fired made it necessary to include feldspar (petuntse) in both clay and glaze. At a high temperature, the feldspar in the clay and glaze combine to create a firmly contracted ware.

The Letters of Père d'Entrecolles

How is it that we are able to give such a detailed explanation of Qing clays and glazes? The answer is simple. There are records, from the late Kangxi era,

290. Blue-and-white covered box with landscape motif. Shunzhi reign mark and era. D. 6 cm. Private collection.

that give us this detailed information. Most Chinese historical records make very little mention of ceramics production, and when they do the information is generally so meager as to be useless. This is why the descriptions of ceramics production of the late Kangxi era are so valuable. They provide information on the characteristics, not only of Qing-period Jingdezhen wares, but of the earlier Ming and Yuan Jingdezhen wares as well.

These valuable records were not compiled by a Chinese but by a French Jesuit missionary, Père d'Entrecolles. This man sent two letters to Europe describing in detail the ceramics production processes he witnessed at the Jingdezhen kilns. Père d'Entrecolles, a European intellectual of the seventeenth century, was trained in scientific observation. His letters contain information that surpasses all other sources available today for the study of Chinese ceramics.

Père d'Entrecolles carefully described the fine division of labor he found in a Jingdezhen factory: "It is in these precincts that innumerable laborers live and work, each with his designated task. A piece of porcelain, before it is ready to be taken to the kiln, passes through the hands of more than twenty people, and all this without confusion. Doubtlessly the work was done much faster in such a way."

There were apparently at least thirty different steps in the process of kiln production, including grinding the clay, throwing vessels on the wheel, mixing glazes, applying decorations, and, of course, firing of the kilns. The system of division of labor guaranteed that each step was carried out by a highly skilled professional.

291. Blue-and-white bowl with motif of animals. Shunzhi reign mark and era. D. 14.9 cm. Private collection.

Directors supervised the whole process, making adjustments in production when necessary and giving advice to the craftsmen.

The Jingdezhen kilns apparently consisted of several factories, each producing a different type of ware. Overseeing the factory directors were superintendents who directed the whole complex.

The firing process employed by the Qing official kilns apparently was quite different from that used by the earlier Ming official kilns. The Qing blue-and-white and enameled wares have a relatively thin overglaze coating. They lack the warmth of the earlier Ming wares. This is probably due to different kiln construction and firing techniques. The Qing kilns were larger than their predecessors, and yet their fuel consumption was less. The firing time and cooling period were also shortened. Such economizing measures are behind the characteristic quality of the Qing-dynasty porcelains.

32

Qing Blue-and-White Ware

Early Blue-and-White Ware

It is not clear what the early Qing porcelains, produced in the middle of the Shunzhi and the first half of the Kangxi eras, were like. Official kilns were not established until the ninth year of the Kangxi era, but even then the use of reign marks was not immediately adopted. This means that there are few porcelains that can be authenticated as having been made in the beginning of the Qing dynasty. Only fragmentary evidence is available to help us trace the development of Qing porcelain. It is fairly evident, however, that the early Qing wares were probably little more than extensions of the transitional wares that appeared at the end of the Ming period.

Early Qing blue-and-white ware is believed to have derived from the Shonzui and *fuyō-de* ware of the late Ming period. Many examples of Kangxi blue-and-white wares are decorated with pictorial motifs (Figs. 292–93), which suggests that they are successors of the Shonzui and Tenkei blue-and-white styles.

The overglaze used on Kangxi ware is smooth and thin, much more refined than that used on the earlier *fuyō-de* ware. The motifs, too, are much more distinctive. There is a rare, dated piece that serves as an excellent example of Kangxi blue-and-white ware. This is an underglaze blue and red dish with a motif of human figures (Fig. 294), belonging to the Percival David Foundation, London. An inscription reading Kangxi *xinhai* (1671) appears on the base.

The inscription on this piece gives us a clue to the nature of early Qing

293. Blue-and-white plaque with motif of figures on horseback. Kangxi era. Private collection.

292. Blue-and-white rectangular decanter with motif of court ladies. Kangxi era. H. 28.5 cm. Osaka Municipal Museum of Fine Art.

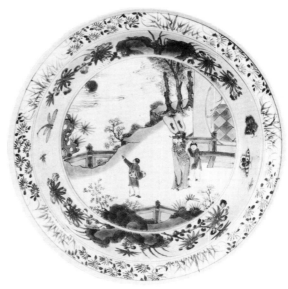

294. Two views of porcelain plate with motif of literati and attendants in underglaze blue and red. Kangxi reign mark and era. D. 35.8 cm. Percival David Foundation, London.

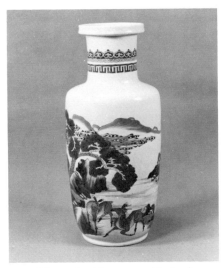

295. Blue-and-white vase with landscape motif. Kangxi era. H. 44.8 cm. Umezawa Memorial Gallery, Tokyo.

blue-and-white ware. The underglaze blue motif on this piece, of figures in a garden executed in the literati style of painting, is smooth and clear. There are many other pieces that are similar to this dish. Those bearing the reign mark for the last years of the Kangxi era also help to clarify the development of early Qing blue-and-white ware.

The smooth, clear quality of the underglaze blue motifs of Kangxi wares is the result of an excellent choice of glaze ingredients and painting technique. The underglaze blue motifs on Ming ware tend to be blurred because the cobalt melted into the overglaze in the kiln. Yongle and Chenghua blue-and-white wares are prime examples of this blurring.

The lack of blurring of the Kangxi underglaze blue is due to the thinner layer of overglaze and the superior refinement of the cobalt. Every brush stroke is clearly defined. The thin overglaze makes it more nearly colorless and transparent than other overglazes, allowing the underglaze blue motifs to be clearly visible. Since the motifs could be more sharply defined, pictorial themes became increasingly popular.

Pictorial Motifs

Symmetrical, repeated patterns were not suitable for Kangxi ware since they would appear stiff and cold under the thin overglaze. The highly refined cobalt and thin overglaze combination was better suited to pictorial motifs. Gradation of tone was possible, and the cobalt could be very effectively contrasted with the pure white ground. The lyrical quality of the landscape (Fig. 295) and

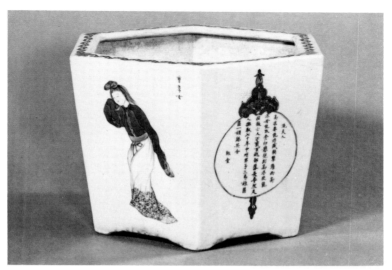

296. Blue-and-white flowerpot with motif of woman and landatory verse. Kangxi era. Private collection.

flower and bird motifs and the dramatic appeal of historical scenes served to cover up to a certain extent the actual cold sharpness of the underglaze blue.

Copybooks of popular paintings, produced in the city of Xin'an, near Jingdezhen, from the end of the Ming period, were often used by the Kangxi potters as guides for the motifs on their wares. Most of the motifs to be found on early Qing ware are derived from paintings in these copybooks. A wide range of subjects is to be found in the *Bazhong huapu,* ascribed to Dong Qichang and Chen Jiru, and the *Jieziyuan huazhuan* (*Mustard Seed Garden Painting Manual*), compiled by Wang Gai. Two other popular copybooks were the *Gengzhi tu,* compiled by Jiao Bingzhen, and the *Wushuang pu,* compiled by Jin Guliang (Fig. 296). One art critic of the Qing dynasty pointed out that the landscapes seen on Kangxi blue-and-white wares resemble those painted by Wang Shigu, the sprays of flowers on Yongzheng wares are like those painted by Yun Nantian, and the human figures on Kangxi wares are similar to those painted by Chen Hongshou, while the human figures on Daoguang ware are like those of Gai Qi.

Many examples of early Qing blue-and-white seem to uphold this critic's comparisons. Certain tall-necked blue-and-white vases, probably produced by the Qing official kilns, are painted with white plum blossoms, magnolias, and sprays of other flowers (Figs. 297–98), excellently executed with fine, skillfully rendered shading. The gradated shading creates a sense of perspective, making these paintings just as worthy of admiration as the literati paintings done on scrolls.

PICTORIAL MOTIFS · *213*

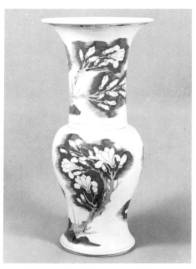

297. Blue-and-white vase with magnolia motif. Kangxi era. H. 46.7 cm. Umezawa Memorial Gallery, Tokyo.

Division of Labor

The paintings on early Qing blue-and-white ware, such as those described above, were not done by one person, but rather by several within a carefully defined system of labor division. Père d'Entrecolles describes the decorating process: "The task of painting is divided in the same workroom between a great number of laborers. One paints only the first colored circle that is seen near the edges of the porcelain; another traces the flowers, which are then painted by a third; this laborer is for the waters and mountains; that one, for the birds and other animals. Every step of the decorating process was highly specialized and the whole process carefully coordinated."

Because their work was so specialized, the craftsmen were able to concentrate on refining a single skill. One example of how far this kind of refinement could be taken is the magnolia-tree motif on a tall-necked, blue-and-white vase (Fig. 297). The motif itself is slightly raised above the surface of the vase. The area around the motif is then stained with dark cobalt, finishing the edges in light shading. A raised white motif is also used on some examples of late Yuan blue-and-white ware (Fig. 226). These motifs rise above the blue-and-white ground. For example, the large, simple flowering-tree motif on the Qing vase is accentuated by shading in bright blue along its raised white silhouette. This decorative technique demonstrates the Qing craftsman's skill.

Only a few of the Kangxi blue-and-white wares discussed here bear the Kangxi reign mark. This is because the application of reign marks was pro-

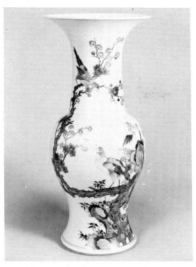

298. Blue-and-white vase with motif of birds and flowers. Kangxi era. H. 46.2 cm. Private collection.

hibited throughout much of the era, and it was not until near the end of the Kangxi era that reign marks were allowed to be used. Blue-and-white wares bearing the Kangxi reign mark continued to be scarce, however. The reign marks are more readily found on underglaze red, peach bloom, polychrome enameled, and *susancai* (enamel decoration on a biscuited surface) wares. The blue-and-white wares seem to have been regarded differently from the other wares, but it is not clear why.

Many blue-and-white dishes and vases bear other types of inscriptions on the base. Many are symbols derived from the Eight Immortals, such as leaves, flowers, fungi, *jue* vessels, calligraphy scrolls, and locks. Some of these are encircled by a double ring.

The wares produced at the end of the Shunzhi and in the beginning of the Kangxi era either bear no reign mark or are inscribed with a fake reign mark of the Chenghua era of the Ming dynasty. The symbolic marks described above do not appear until the middle of the Kangxi era when the wares were beginning to show the distinctive features of the Kangxi style. Though it is not certain what these marks represented, they probably indicate the workshop in which a vessel was produced since firing was done in cooperative kilns. Another possible explanation is that the symbols indicate the different destinations of the wares produced for export.

Yongzheng and Qianlong Blue-and-White

Qing blue-and-white ware shows no sign of development in the Yongzheng

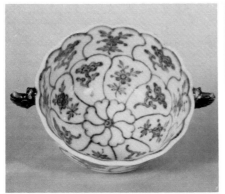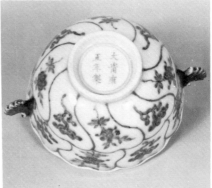

299. Two views of blue-and-white cup with design of flowers enclosed in petal-shaped outlines. Yongzheng reign mark and era. H. 4.8 cm. Private collection.

and Qianlong eras that followed the Kangxi era. Other wares went into decline after the Qianlong era, but the blue-and-white ware neither declined nor advanced. Qing blue-and-white ware seems to have reached the final stage in its development by this time. All of the conceivable variations of this ware had already been tried, and it is not surprising that *famille rose* and monochrome ware came to replace blue-and-white by the Yongzheng era.

Despite its static quality, blue-and-white ware remained popular enough that the potters in the official kilns were forced to copy classic styles after they had tried every other possible variation. These copies, bearing Yongzheng or Qianlong reign marks (Figs. 299–300), proved to be more brilliantly executed than the Ming-dynasty Yongle, Xuande, and Chenghua originals. This is not surprising since techniques had advanced considerably by the Qing dynasty. Even with such perfect execution, however, the Qing copies lack a certain indefinable quality, which clearly marks them as being copies.

There is a record of pottery-making techniques inscribed on a stone monument. It was compiled by Tang Ying, superintendent of the official kilns from the Yongzheng era through the beginning of the Qianlong era. Tang Ying made major contributions to the development of pottery-making skills far in advance of those used up to his time. The stone monument, known as the *Shiyi jilue bei,* gives an especially vivid description of how to copy Chenghua blue-and-white, a ware noted for its elegant, pale paintings, among the many techniques it enumerates.

In addition to copying classical styles, the Qing potters experimented with

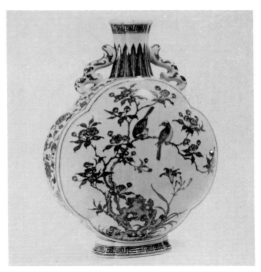

300. Blue-and-white flask with motif of birds and flowers. Qianlong reign mark and era. H. 49.3 cm. Private collection.

variations of blue-and-white ware. Among these variations is a ware with blue motifs on a yellow ground (Fig. 301), a style that had been in continuous production since the Chenghua era, and another ware decorated in the reverse manner with yellow motifs on a blue ground.

Blue-and-white wares with landscape and bird and flower motifs in the shading style of the Kangxi era, which had nearly disappeared by the Yongzheng era, reappear again in the Qianlong era. The Qianlong version of this type of ware, however, is distinguished in North America and Europe from ordinary blue-and-white ware by the term "soft paste" because of the peculiar qualities of the clay and glazes used. The ware is made in very small sizes, and specimens are extremely rare.

Underglaze Red Wares

Underglaze red wares, replacing copper for the cobalt of blue-and-white ware, had been made at the end of the Yuan dynasty and throughout the Ming dynasty, but these wares were never completely satisfactory. The copper glaze was unstable, causing the motifs to blur and to vary from nearly invisible to a blackish purple color. The Ming potters gave up trying to paint finely drawn motifs with this glaze and instead used it to paint silhouettes of peaches and fish.

With the beginning of the Qing dynasty, however, the potters at last succeeded in refining the glaze so that it could be used to paint finely delineated motifs in addition to the traditional silhouettes (Fig. 302). The copper glaze could now be used for drawing extremely thin, precise lines to create complex,

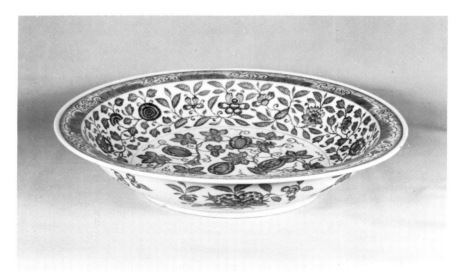

301. Large blue-and-white dish with yellow ground. Yongzheng reign mark and era. D. 45.6 cm. Private collection.

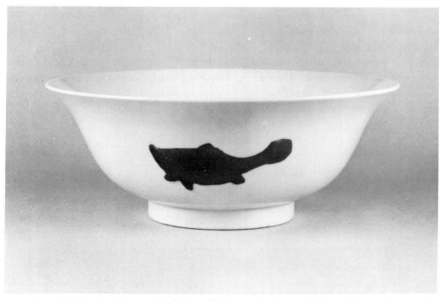

302. Porcelain bowl with motif of three fish in underglaze red. Yongzheng reign mark and era. D. 22.3 cm. Umezawa Memorial Gallery, Tokyo.

303. Porcelain bowl with "Immortals" motif
in underglaze blue and red. Kangxi reign mark
and era. D. 18.8 cm. Private collection.

sensitive motifs. Even gradation of tone was possible. The actual red color
was enhanced as well.

Later the copper and cobalt were used in combination for underglaze red
and blue motifs (Fig. 303). An early example of this combination can be seen
on the dish illustrated in Figure 294. Bearing the inscription Kangxi *xinhai*
(1671), the motif on this dish is painted mostly in underglaze blue touched with
red. The use of underglaze red was carefully studied and developed in the
extreme with the establishment of the official kilns.

33

Qing Enameled Porcelains

Qing enameled porcelains are particularly noteworthy because they include a variant ware known as *"famille rose."* The techniques used to produce this ware and the difference between it and other enameled wares will be described in detail later in this chapter.

In the West, Qing enameled wares have been traditionally classified into two types, *famille verte* or *wucai* (Pl. 47) and *famille rose* or *fencai* (Pl. 46), according to the respective dominant colors of green and rose.

The Qing *famille verte* enameled wares, which are basically the same as Ming *wucai* ware, are thought to be the successors to the Tenkei, Shonzui, and Nankin enameled wares. The Nankin wares, in particular, were made to appeal to European rather than Japanese taste, and hence their motifs and coloring are more refined and delicate. Bird and flower motifs taken from copybooks predominate. *Famille verte* enameled wares gradually developed into the official enameled ware of the Kangxi era in the Qing dynasty (Fig. 304).

Translucent White Glaze

All Qing enameled wares have certain common characteristics. The first is that both the clay body and the overglaze were much improved over those of the Ming wares. The clay body is a pure white with an overglaze coating different from that used on blue-and-white and underglaze red wares. Père d'Entrecolles wrote that this glaze was composed of "thirteen bowls of white glaze to which a bowl of liquified fern ash has been added." The two major features of this

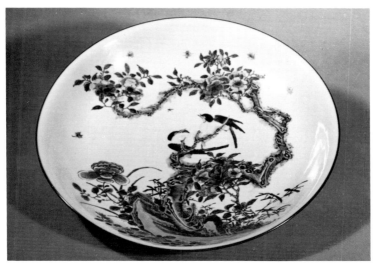

304. *Famille verte* enameled plate with motif of birds and flowers. Kangxi era. D. 18.8 cm. Private collection.

glaze are that it has a very high melting point and that its opaque quality will allow an underglaze blue motif to show through only indistinctly.

This glaze's high melting point makes it especially suitable for porcelains. Using a transparent glaze over a white clay body would naturally result in a white porcelain ware, but the vitreous quality of a transparent glaze tends to create a blue tinge. For enameled wares, a pure white background is preferable to enhance the colorfulness of the enamels. For this reason, the translucent, opaque white overglaze was preferred. Such a glaze was being used on the Nankin enameled wares of the Ming dynasty, but it was considerably refined and improved by the Qing dynasty (Fig. 305).

The Brilliant Colors of Qing Famille Verte

The second common characteristic of Qing enameled wares is finely shaded motifs. These could be painted because the enamels were so refined that there were no impurities to coagulate in unsightly patches, such as those sometimes seen on Ming enameled ware. As new ingredients were devised for the enamels, the range of usable colors was greatly broadened to heighten the effect of the motifs. For example, a red enamel made from burnt iron sulfate has greatly improved in tone by the Qing dynasty and has a much smoother texture as well. The yellow and purple enamels on Qing ware are especially fine also. A blackish brown, made from iron oxide, was used for highlighting tree bark, rocks, riverbanks, and principle components of bird and flower motifs, as well as for outlining the whole motif. *Mocai* ware exhibits the most delicate and refined

305. *Famille verte* enameled plate with motif of Immortal and deer cart. Kangxi era. Private collection.

306. *Famille verte* enameled bowl with motif of birds and grasses. Kangxi era. D. 17.4 cm. Tokyo National Museum.

307. *Famille verte* enameled bowl with motif of bird and peach tree. Kangxi reign mark and era. D. 9.2 cm. Private collection.

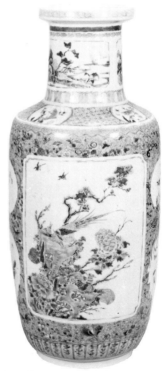

308. *Famille verte* enameled vase with motif of birds and flowers. Kangxi era. H. 46 cm. Umezawa Memorial Gallery, Tokyo.

309. *Famille verte* enameled table with plum tree on black ground. Black hawthorn type, Kangxi era. H. 10.2 cm. Private collection.

use of blackish brown. This color is used to paint all of the motifs, including the finely shaded areas, to create an overall effect resembling a Chinese ink painting.

Bird and flower motifs are the most popular subjects to be found on *famille verte* ware (Figs. 306–8), but there are occasional motifs including human figures, such as elegant young ladies, and landscape scenes. These types of pictorial motifs dominate *famille verte* ware as they did Qing blue-and-white ware. Many motifs are in the early Qing literati style, but there are others executed in Japanese and European styles.

When the importation of Jingdezhen ware to Europe ceased in the late Ming dynasty, Europe turned to Japan for its porcelains, making large purchases of Japanese Imari ware. The Europeans developed a taste for Japanese styles at this time that had to be satisfied later, when the importing of Chinese porcelains was resumed in the Kangxi era.

Hawthorn Ware

French cloisonné was imported into China early in the Qing dynasty, and attempts were made to copy the cloisonné techniques and designs using porcelain instead of metal. This type of enameled ware, known in Europe and North America as hawthorn ware, began to be produced in the Kangxi era. Hawthorn wares are distinguished by their background colors of black, green, and yellow. Referred to as black hawthorn, green hawthorn, and yellow hawthorn (Pl. 27), these wares are highly esteemed in the West. Haw-

310. *Famille verte* enameled vase with motif of bird and flowers in panels on blue ground. Kangxi era. H. 43.6 cm. Private collection.

thorn decorative motifs always include white flowering trees; hence the name of hawthorn is not precisely accurate since some of the trees are plum or peach (Fig. 309).

One variation of hawthorn ware is characterized by windowed panels arranged on the colored background. These panels were reserved in white and define the space in which motifs were applied with enamels. The background color was painted on with either a low-fire color enamel or a high-fire cobalt. On some of the latter pieces the cobalt was applied by blowing through a bamboo tube to create a pleasing mottled effect (Fig. 310).

Famille verte ware is being produced to this day and is representative of modern Chinese ceramics. The most excellent examples of this ware are those produced in the Kangxi era. But by the end of the Kangxi era, *famille rose* had come to dominate, replacing *famille verte* in the mainstream of official enameled wares. It would be more accurate to say that *famille verte* evolved into *famille rose*. In fact, *famille rose* wares incorporated enameled motifs from *famille verte* ware. The term *famille rose* refers to the predominant rose color of this ware.

Yongzheng Doucai *Wares*

The delicate *doucai* enameled wares first appeared in the Chenghua era of the Ming dynasty. Of the many types of *famille verte* ware, the *doucai* wares were the only ones to be produced in large quantities during and after the Yongzheng era.

311. *Doucai* enameled plate with motif of sea pavilion. Yongzheng reign mark and era. D. 21.3 cm. Private collection.

The Yongzheng era is a time noted for its elegant enameled wares, and the *doucai* wares produced in this period achieve a magnificence that equals and sometimes even surpasses their Chenghua predecessors.

The *doucai* wares differ from the ordinary *wucai* enameled wares in that their enamels retain a fresh, shiny quality and are extremely clear and transparent. The appeal of this ware is quite different from that of the later *famille rose* wares (Fig. 311).

Famille Rose *Ware*

Famille verte ware continued to be popular in the Kangxi era, but Père d'Entrecolles notes in his letters that a revolutionary new type of enameled ware evolved at the end of that time as a result of the adoption of European cloisonné techniques. This was the ware known today as *famille rose*.

It is usually assumed that *famille rose* began to be produced sometime in the Yongzheng era, but though this ware certainly attained its peak in the Yongzheng era, its beginnings, according to Père d'Entrecolles, can probably be traced back to the final years of the Kangxi era. Several pieces of *famille rose,* which will be described in detail later, help to support this theory.

According to Père d'Entrecolles: "Though porcelain is naturally white, and the glaze applied to it serves to augment this white even more, yet there are certain designs in favor of which one applies a particular white substance on the porcelain, which is then painted in different colors. This white is made of a powder of transparent pebbles, which calcinates in the kiln like cobalt.

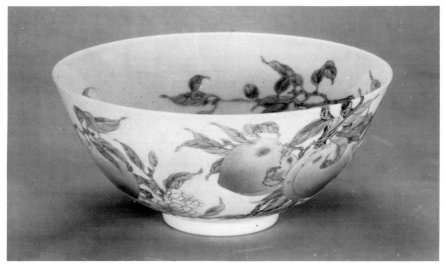

312. *Famille rose* enameled bowl with peach-tree motif. Yongzheng reign mark and era. D. 14.4 cm. Musée Guimet, Paris.

For each half ounce of this powder, one adds an ounce of pulverized lead. This also enters into the mixture of the color; for example, to make green, to an ounce of white lead and a half ounce of pebble powder, one adds three ounces of what is called *tonghuapian* (pulverized pure copper)."

Here Père d'Entrecolles mentions *famille verte* as a ware with colored enamels painted on a white porcelain body. It should be emphasized again that this white porcelain body is actually coated with an opaque white glaze. Wherever motifs that required subtle shading and gradation of tone, such as fruit and flowers, were to be painted on the ware, an additional coating of another white substance was applied over the white overglaze. His description signifies that this white substance was a lusterless white powder that served to create an absorbent surface that facilitated the painting of finely shaded areas of the motifs (Fig. 312). It is this kind of special glaze base that was used on *famille rose* ware, or *fencai* in Chinese.

Père d'Entrecolles describes the contents of this white powdered substance in the letter quoted above. The powder was apparently composed of transparent small stones, a type of quartz sand, that were ground and mixed with lead powder. This is the same as the type of white enamel used on the traditional cloisonné wares of Limoges in France.

After a white porcelain vessel was fired, motifs were painted onto the ware with colored enamels in the *famille verte* style. Later, the parts of the motifs that required more detail were decorated in a *famille rose* style.

The colored enamels painted over the white enamel base also contained

313. Two views of *famille rose* enameled teacup with motif of fruit and flowers, "I L" inscription. Kangxi era. Musée Guimet, Paris.

some of the white enamel as one of their prime ingredients. One of the advantages of this was that the colored enamels adapted well to the white enamel base. Another reason was that a wide range of subtle variations of tone could be achieved by simply altering the ratio of colored enamels to white enamel. For example, with the peach motifs we can see a gradation of color tone ranging from a faint, cream white, to a cream yellow, to orange, and finally to a deep red tone.

The Influence of European Cloisonné Techniques

The technique described above, of applying colored enamels over a white enamel base, was derived from the same type of technique used in the production of cloisonné wares in Limoges, France, and Battersea, England. *Famille rose* ware was, in other words, a type of cloisonné ware, the only difference being that the base was porcelain rather than metal.

A pair of *famille rose* cups (Fig. 313) provide clear evidence that their decorative technique was derived from Europe. These cups, now owned by the Musée Guimet in Paris, are decorated with a fruit and flower motif and inscribed with the initials "I L." These initials were the mark of Jaques Laudin I (1627–95), a maker of cloisonné ware in Limoges. The cups are apparently carefully executed copies of Laudin's work, even down to his mark, by a Jingdezhen potter.

Laudin died in the year corresponding to the thirty-fourth year of the Kangxi era. D'Entrecolles' letters and the existence of the pair of cups described above

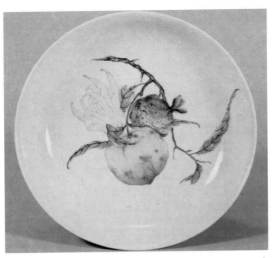

314. *Famille rose* enameled plate with fruit motif. Qianlong reign mark and era. D. 22.2 cm. Private collection.

place the earliest production of *famille rose* ware at sometime in the end of the Kangxi era. Since there are no *famille rose* wares bearing Kangxi reign marks, however, it is likely that they were not produced in the official kilns until the Yongzheng era.

Once *famille rose* wares began to be produced in the official kilns, from the Yongzheng to the Qianlong era, they underwent a great deal of refinement under the direction of the kiln superintendents Nian Xiyao and Tang Ying. One of the signs of this refinement is the restraint shown in the application of the motifs. Once the revolutionary, cloisonné-style enameling technique had been mastered, it could have been applied to excess, but it was not. The result of the restraint of the potter is quiet, blank areas on *famille rose* ware that serve to enhance the enameled motifs. The overall effect is one of restrained elegance (Fig. 314).

An Italian painter, Giuseppe Castiglione, a Jesuit missionary known in China by the name Lang Shining, resided in the imperial courts of the Yong-zheng and Qianlong emperors. The style of painting he introduced from Europe, without outlines and with a sense of perspective, was often applied to *famille rose* wares (Fig. 315).

Common *famille rose* subjects include birds and flowers, grasses and insects, and trees and rocks. There are a few landscapes and scenes with human figures, but these are relatively rare. Bird and flower motifs were apparently considered the most suitable for the *famille rose* enameling technique. A Qing-period connoisseur of *famille rose* says with admiration, "...the flower motifs

315. Double *famille rose* enameled vase with motif of Europeans. Gu Yue Xuan type, Qianlong reign mark and era. H. 21.2 cm. Eisei Bunko Foundation, Tokyo.

painted on Yongzheng ware should be regarded as being in the style of the Yun (Nantian) school. The exquisiteness of the painting without outlines should be likened to that of Xu Xi. The grasses and insect motifs are most finely executed. Their startling reality is such that one tries to brush away the flies on a vessel before realizing that they are only painted on." The surviving examples of this ware suggest that this description is not altogether exaggerated.

Gu Yue Xuan Ware

There is a distinctive type of Qing enameled ware known as Gu Yue Xuan (or Ku Yüeh Hsüan) ware. There are only a few pieces of this ware in Japan, but the Palace Museum in Taiwan and art museums in Europe and North America have a considerable number that are highly prized. Gu Yue Xuan ware is nothing more than the finest *famille rose* ware. It was specially produced for the emperor. The name Gu Yue Xuan was apparently derived from the name of a certain building in the imperial palace that may have been a secret storehouse, but this is not clear.

Gu Yue Xuan ware is the finest *famille rose* ware because every one of its components is perfect. The porcelain body, its shape, the overglaze, the colored enamels, and the choice of motifs all combine in superb harmony. The exquisite beauty of the motifs is especially astonishing. Tradition has it that after the porcelain wares were fired in the Jingdezhen official kilns they were carefully carried to the imperial palace in Peking where eminent painters of the Painting Academy school painted on the elaborate motifs. The wares were

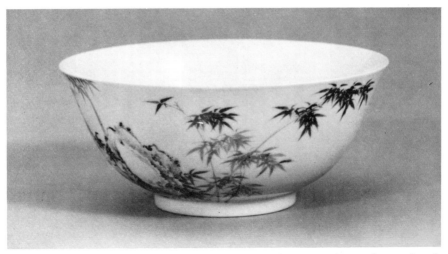

316. *Mocai* enameled bowl with motif of rock and bamboo. Yongzheng reign mark and era. D. 16.1 cm. Shanghai Museum.

then fired in a specially constructed kiln (known in Japan as a *nishiki-gama*) for fusing overglaze enamels onto the body of a ware, which was located right in the palace grounds.

Gu Yue Xuan White Overglaze

Another noteworthy feature of Gu Yue Xuan ware is its brilliant, translucent white, gemlike quality. The opaque white of the Gu Yue Xuan ware has a purity and warmth that is felt immediately when the ware is compared with other official wares.

Tang Ying, superintendent of the official kilns, records that the bodies of the superior Qianlong wares were composed almost entirely of petuntse. No kaolin seems to have been added. The lack of plasticity would have made the formation of any vessel with this feldspathic clay extremely difficult.

After a ware was formed, it was coated with a refined overglaze made of the same petuntse. Since body and overglaze were composed of the same substance, they would have fused together into one substance in the high temperatures of the kiln. The result was a ware that resembles a jewel, its glaze indistinguishable from the body. Extremely fine-quality clay and overglaze were used for Gu Yue Xuan enameled ware.

Characteristic Motifs

The primary feature, after all, of Gu Yue Xuan ware is its *famille rose*-style decoration. Most of the designs are of birds and flowers (Pl. 46), grasses and

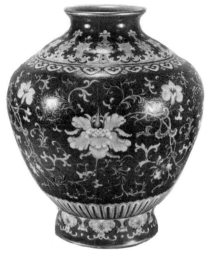

317. *Famille rose* enameled jar with motif on red ground. Qianlong reign mark and era. H. 29.6 cm. Umezawa Memorial Gallery, Tokyo.

insects, and trees and rocks, the same as those found on the ordinary *famille rose* ware. Landscapes and scenes with human figures are rare, but there are some motifs of Western people in European costume that are outstanding for their exotic eccentricity (Fig. 315). These particular motifs may have been painted by the Italian painter Castiglione.

In addition to these polychrome motifs, there is another type of peculiar motif painted in monochrome enamels. This is the *mocai* ware (Fig. 316) mentioned previously. *Mocai* wares are usually painted with landscape scenes colored in several shades of a black enamel, giving the effect of an ink painting on a scroll. There are variations on this, painted in either indigo blue or purplish red with the same tone gradation.

Another popular style consisted of *famille rose* motifs surrounded by a background filled in with regular enamels. This background decoration is especially noteworthy. Purplish red, light blue, yellow-green, and emerald-green enamels were applied and then etched with foliage and meanders using a gimlet made from a willow branch. These lines are extremely intricate and delicate (Fig. 317).

Poetry and Seals

Many Gu Yue Xuan wares bear poetic inscriptions suitable to their motifs. The poetic verses are usually couplets of five or seven characters executed in the elegant, semicursive style of the Tiexue school of Liu Yong. These poetic inscriptions usually included seals. The Gu Yue Xuan wares with motifs of Westerners are not decorated in this fashion.

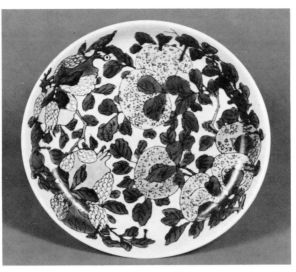

318. Three-color porcelain plate with fruit motif on biscuit. *Susancai* type, Kangxi reign mark and era. D. 25 cm. Private collection.

Reign Marks

The Gu Yue Xuan wares bear special reign marks that differ from the usual style. Usually reign marks were inscribed in an underglaze blue on the base of official wares, but the Gu Yue Xuan wares bear reign marks applied in an overglaze blue enamel, with the exception of a few pieces produced in the Yongzheng era. As a rule, the reign marks consist of four characters, *Yongzhengnian zhi* (made in the Yongzheng era) or *Qianlongnian zhi* (made in the Qianlong era), written in two lines within a double square with rounded corners. These inscriptions are applied with blue enamel and protrude slightly.

Enamel-on-Biscuit Ware

Enamel-on-biscuit ware is a polychrome ware that was produced throughout the Qing dynasty. This ware resembles *famille verte* ware with a colored background, but the motifs are painted with different colored enamels directly onto the unglazed, biscuited body of a vessel. Hence, this ware is called *susancai,* or enamel-on-biscuit ware. After the enamels were applied, the ware was refired in a medium-temperature kiln. The enamels therefore also served as an overglaze, and it is this feature that distinguishes this ware from other *famille verte* ware, which it otherwise closely resembles.

There is usually no body surface left exposed on the enamel-on-biscuit ware since the red-tinged, rough surface of the clay would be out of harmony with the enamels and would also tend to stain easily.

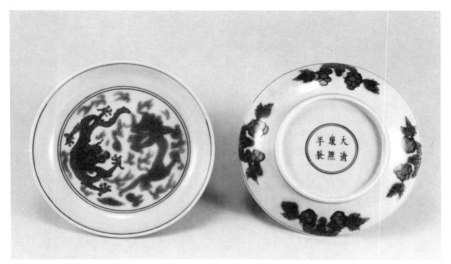

319. Two views of porcelain plate with dragon motif in green and purple on yellow ground. Kangxi reign mark and era. D. 13.4 cm. Umezawa Memorial Gallery, Tokyo.

There are, however, a few examples on which a white surface is shown with some success. There are dishes painted with fruit in green and purple on which some white ground is left (Fig. 318). It should be noted, however, that this white ground is not actually the clay body itself but a white enamel coating. The difference with the other *famille verte* wares is that the white exposed portions are actually white enamel while on most *famille verte* ware it is a white porcelain with an overglaze coating.

Some examples of the ware described above with white enameled portions are decorated with *anhua,* or "secret decoration" motifs. This very fine, elusive incised decoration causes light to be subtly reflected on the colored enamel surface of the ware, thereby increasing the iridescent quality of the lead-fluxed enamel glazes.

Enamel-on-biscuit ware is thought to have been derived from a Ming ware with green motifs on a yellow ground and from Wanli three-color ware. These wares underwent various alterations and refinements in the Qing official kilns until a unique group of enamel-on-biscuit wares was produced (Fig. 319). Though there are a variety of motifs to be found, the most common are polychrome enamel motifs on a single-color background. The motifs are usually outlined in a thin line of purplish black.

Vases and dishes are the most common shapes, but there are other more peculiar forms as well, such as small tables and sets of small dishes that fit together into a turtle-shell pattern.

34

Qing Monochrome Wares

Monochrome wares completely coated with a green or yellow low-fired glaze were common in the Qing dynasty. There are two types of this ware that represent a tradition going back to the period between the Chenghua and Wanli eras of the Ming dynasty. One has an ordinary white porcelain body, and the other, an unglazed biscuit body like that of *susancai* ware of the Wanli era.

The medium-fired light yellow wares of the Kangxi era contained antimony as a coloring agent. When a darker yellow was desired, iron oxide was added (Fig. 320). The green glazed wares also show variations of tone, but in every case this glaze was composed completely of copper oxide. Another medium-fired monochrome ware produced in the Kangxi era was an aubergine-purple ware. The color was derived from a mixture of manganese and cobalt and is of unparalleled beauty.

This purple is frequently found on *susancai* enameled ware and *famille verte* ware. However, the purple on these wares was produced differently from the medium-fired purple ware. Père d'Entrecolles states that the *susancai* and *famille verte* purple glaze consisted of a glassy blue vitriol known as "le vitriol Romain," which was made up of minute lead particles. It was a simple process to grind the blue vitriol into a powder for a glaze. In other words, the purple glaze was made from a purple glass containing manganese. This is important when one considers that artificial purple crystals were being produced with glass frit at around the same time in Guangdong.

Another Kangxi monochrome ware is noted for its brilliant turquoise-blue glaze. This glaze was made from lime and soda with the addition of copper

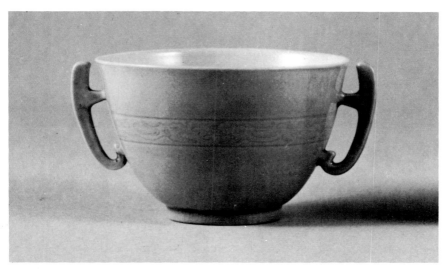

320. Porcelain cup with handles, dark yellow glaze. Kangxi reign mark and era. D. 6.3 cm. Umezawa Memorial Gallery, Tokyo.

carbonate. Another medium-fired monochrome ware had a red body with a red glaze coating composed of *bengara,* an iron oxide used primarily as an enamel. By adjusting the amount of vitreous lead flux in this glaze, it could be varied from a deep, glossy red to a matte-finish, coral red (Fig. 321).

High-Fired Glazes

There are a series of blue wares that are generally coated with a high-fired cobalt glaze, though the medium-fired turquoise glaze described above is an exception. One method of producing these high-fired blue wares was to coat them with an overglaze containing cobalt. Another method was to blow the cobalt solution onto the biscuit surface of a ware with a bamboo tube. A colorless, high-fired overglaze was applied over this to create a powder-blue ware.

Other high-fired monochrome wares include a deep, coffee-brown ware and a shiny black ware with such a high gloss that it reflects like a mirror.

Celadon glazes, the most common of the high-fired glazes, appear at the end of the Kangxi era as copies of such wares as Longchuan and Song official wares. The Nian celadons, which imitate the grayish blue of Song official ware, and *douqing* celadons (Fig. 322), with their faint blue-green coating, are especially noteworthy. There are also some light blue celadons, coated with a celadon glaze containing a small amount of cobalt, which should be praised for their fresh tone. The darker blue celadons are simply variations of this ware with more cobalt in the glaze.

There are, as well, Lujun wares made to imitate the "moon-white" blue glaze of the Jun wares of the Song dynasty. These wares might be also regarded as a refinement on the opaque, blue-mottled wares produced by the Yixing kilns in Jiangsu and by the Guangdong kilns. Some of these pieces are suffused with minute red flecks of copper.

Tea-dust glazed wares are so named because they seem to have been sprinkled with a brownish green tea powder (Fig. 323). This was a phenomenon that resulted from the gradual cooling of the iron oxide in the glaze after a reduction firing. As the vessel cooled, the minute crystals of iron in the glaze turned a yellowish green or dark greenish brown.

Copper-Red Glazes

The copper-red glazed wares of the Qing dynasty show a remarkable development. Customarily known as Lang *yao* red wares because they are believed to have been first produced under the direction of Lang Tingji, superintendent of the official kilns at the end of the Kangxi era, these wares are also known by other names that refer to their colors.

Jihong wares are of an ordinary red that is much more beautiful than that of the Ming red wares but still lacks brightness and depth. By firing this type of ware in a well-controlled kiln, a deeper red was obtained. Streaking in the glaze creates a gradation of tone from a faint red at the mouth rim of a vessel down to heavy purplish black drops of glaze at the vessel's base. This ware, known as *sang de boeuf,* or ox blood, in the West, is held in high esteem

321. Left: porcelain vase with coral-red glaze. Yongzheng reign mark and era. H. 29 cm. Private collection.

322. Right: porcelain gourd-shaped vase with *douqing* glaze. Qianlong reign mark and era. H. 22.1 cm. Private collection.

323. Stoneware vase with dragon-head handles, tea-dust glaze. Yongzheng reign mark and era. H. 51.5 cm. Idemitsu Art Gallery, Tokyo.

for its great beauty. In rare instances, glaze quality, firing, and cooling combined perfectly to produce a magnificent ruby-red ware. This red glaze in particular seems to have captured the love of Westerners.

Père d'Entrecolles speaks of the rarity of such pieces: "If, after the firing, the red emerges pure and brilliant, without the least blemish appearing, then the perfection of the art has been attained."

The general instability of copper-red glazes and their tendency to volatilize has already been mentioned. This is why the Lang *yao* red glazes do not attain a brilliant red tone. To create a refined, brilliant red tone, the pure copper in the glaze has to turn into extremely minute colloidal particles that are evenly distributed in layers over the whole glaze surface of a vessel. In order for this to happen, the kiln fire must be controlled carefully so that an oxidizing atmosphere is created at the last moment after the vessels have first been fired in a reduction kiln. It is also necessary to add just the right amounts of iron, tin, and lead to the glaze to help produce the colloidal effect by pulverizing the copper particles.

According to Père d'Entrecolles: "This red in the glaze is made of granulated red copper and a powder of a certain stone or pebble that is tinged with red; a Christian doctor told me that this stone is a kind of alum used in medicine; it is ground in a mortar, adding the urine of a young man and the oil of *baiyou* (white glaze), but I have not been able to discover the quantity of these ingredients, and those who have the secret are careful not to divulge it."

Père d'Entrecolles notes here that the copper particles were sometimes

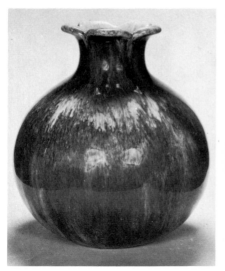 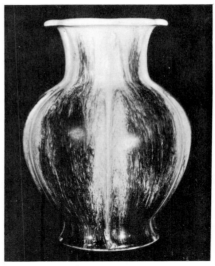

324. Stoneware pomegranate-shaped vase, streaked red glaze. Yongzheng reign mark and era. H. 18 cm. Private collection.

325. Stoneware vase, copper-red glaze mottled with blue. Qianlong reign mark and era. H. 19.7 cm. Private collection.

obtained in the process of refining low-grade silver and may have therefore contained small amounts of silver as well as lead. In any case, it is clear that many methods were devised to expedite the colloidal effect. Despite their efforts, however, the potters had difficulty for quite a long time before finally achieving the desired effect. When they did meet with success, they kept the recipe for the glaze a well-guarded secret.

Père d'Entrecolles notes that these red glazed wares did not produce a clear ringing sound when tapped with the fingers. His own theory was that these wares were not made from pure petuntse but with kaolin mixed with loess, which was refined in the same manner as petuntse.

"It is likely that such an earth is more appropriate for receiving this sort of color." Père d'Entrecolles's display of foresight here is astonishing. As he notes, a buff or grayish white clay body would better serve to create a deep red color than would a pure white clay body. A pure white body tends to rob the glazes with which it is coated of their subtle depth of tone. We can see this with Longquan celadon. Its pale gray body has a far deeper glaze tone than does the Nabeshima celadon of Japan with its white porcelain body.

All of the red glazed wares described above have peculiar thin runny streaks (Figs. 324–25). These streaks are caused by the copper oxide particles rising to the surface of the glaze and streaking as the glaze melts in the firing process. This is the same kind of phenomenon as that seen on hare's fur *temmoku* ware and the bluish white mottled glaze on Jun ware. These thin streaks also serve to enhance the depth of the glaze.

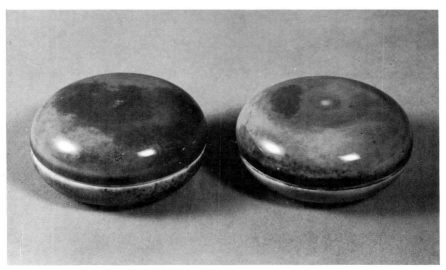

326. Pair of porcelain covered boxes with peach-bloom glaze. Kangxi reign mark and era. D. 7.2 cm. Eisei Bunko Foundation, Tokyo.

Peach-Bloom Ware

There is another type of red glaze that was produced differently from the red glazed wares mentioned so far. On this ware, the copper-red glaze was blown onto the surface of the vessel using a bamboo tube. This ware is well known throughout the world as peach-bloom ware (Figs. 326–27). A variant of this ware is known as apple-green ware because of its beautiful green color, which is caused by the transmutation of the copper-red glaze when it is fired.

The blowing on of the glaze for this ware was a necessary prerequisite for its marvelous glaze tone. Ordinary copper-red glazed wares were only coated once with one type of glaze. But by using a blowing technique, several thin layers of different types of glaze could be applied to produce a deeper glaze tone. A copper glaze, the primary coloring agent, which was composed of different types of glaze containing tin and iron to aid in the colloidal effect of the copper, was applied repeatedly in differing amounts with each application.

Careful control was required in the firing process of this ware. One technique was to create occasionally an oxidation atmosphere in a reduction kiln by introducing air into the kiln. It is not strange that Père d'Entrecolles should exclaim in admiration: "This sort of porcelain is still more expensive and rarer than the preceding one (Lang *yao* type) because the execution is more difficult if one wants to preserve all the requisite proportions."

The peach-bloom ware that was produced in this manner is covered with purple, orange, yellow, and green speckled areas that create an overall

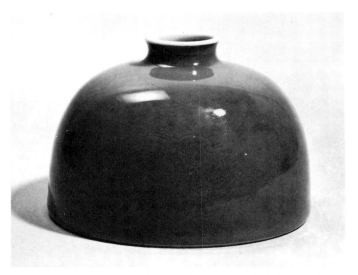

327. Porcelain vase, peach-bloom glaze over incised dragon design. Kangxi reign mark and era. D. 12.4 cm. Umezawa Memorial Gallery, Tokyo.

hazy red tone. The careful control required in the firing process and the mixing of the glaze to produce this fantastic color is clearly the ultimate application of human knowledge in the production of an exquisite ware.

Peach-bloom and apple-green wares have a white porcelain body that is different from the more commonly known *sang de boeuf* ware. This white porcelain body was probably found to be more suitable for enhancing the delicate, elusive glaze tones of peach-bloom and apple-green wares.

The *sang de boeuf* ware produced in the Kangxi era does not bear reign marks, but the peach-bloom wares are inscribed with six-character reign marks in underglaze blue. This suggest that *sang de boeuf* ware was produced before the peach-bloom ware, which probably first appeared at the end of the Kangxi era when the use of reign marks was at last allowed.

All of the existing red glazed wares that bear reign marks are believed to have been produced during or after the Yongzheng era.

The makers of Qing porcelains took the final step, bringing them to the apex of porcelain production in the first half of the Qianlong era. *Mille fleurs* ware, densely painted with a *famille rose* motif on a *famille rose* enameled background, was produced at this time (Fig. 328). Another superior ware that resembled *mille fleurs* ware was a true copy of cloisonné ware.

The practice of copying and reproducing the techniques used on other materials with clay was developed to such an extent that archaic bronzes were faithfully reproduced right down to the effect of rust, wooden vessels were carefully copied to include the wood grain, and lacquer wares were so well

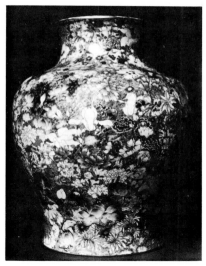

328. *Famille rose* enameled jar. *Mille fleurs* type, Qianlong reign mark and era. Musée Guimet, Paris.

reproduced in clay as to be indistinguishable from the originals. Natural objects were often reproduced in the same manner, for example, ceramic striped stones and ceramic coral. This mania for reproducing everything in clay in the Qianlong era seems to indicate that the continual probing and exploration of the possibilities of man-made reproductions had finally reached its limit.

As the emperor's power waned in the latter part of the Qianlong era, the Qing ceramics, especially those sponsored by the court, declined in creative development. Against the background of a long and illustrious tradition, however, Chinese ceramics has continued to be held in high esteem throughout the world.

APPENDIX

Chinese Characters for
Proper Names and Technical Terms

This appendix lists the Chinese characters that are transliterated in the text, together with their *pinyin* and Wade-Giles readings. Common geographical and historical names are not included. Chinese characters for major kiln sites are listed with the map of kiln sites on the foldout.

PINYIN	WADE-GILES	CHINESE CHARACTERS
baidunzi (petuntse)	*pai-tun-tzu*	白不子
Banpo	Pan-p'o	半坡
Banshan	Pan-shan	半山
Baoding	Pao-ting	保定
Bazhong huapu	*Pa-chung hua-p'u*	八種畫譜
Boshanlu	Po-shan-lu	博山爐
Cha Jing	*Ch'a Ching*	茶經
Changsha	Ch'ang-sha	長沙
Chengziyai	Ch'eng-tzu-yai	城子崖
Chu	Ch'u	楚
chunyu	*ch'un-yü*	錞于
Dantu	Tan-t'u	丹徒
ding	*ting*	鼎
Dingjiashan	Ting-chia-shan	丁家山
Dingxian	Ting-hsien	定縣

dou	tou	豆
doucai	tou-ts'ai	豆彩
douqing	tou-ch'ing	豆青
Erligang	Erh-li-kang	二里岡
fahua	fa-hua	法花
fang	fang	鈁
fencai	fen-ts'ai	粉彩
Fengcheng	Feng-ch'eng	豐城
fu	fu	鍑
Fuliang	Fou-liang	浮梁
gaolin (kaolin)	kao-lin	高嶺
gu	ku	觚
Gu Yue Xuan	Ku Yüeh Hsüan	古月軒
gui	kuei	簋
he	ho	盉
Hongzhou yao	Hung-chou-yao	洪州窯
hu	hu	壺
Huai (River)	Huai	淮河
Huangdao yao	Huang-tao-yao	黃道窯
Huozhou	Huo-chou	霍州
Hutian	Hu-t'ien	湖田
jian	chien	鑑
Jiancicun	Chien-tz'u-ts'un	澗磁村
Jian'ou	Chien-ou	建甌
Jiaotan guan yao	Chiao-t'an kuan-yao	郊壇官窯
Jiaxian	Chia-hsien	郟縣
Jieziyuan huazhuan	Chieh-tzu-yüan hua-chuan	芥子園畫傳
Jincun	Chin-ts'un	金村
Jingxian	Ching-hsien	景縣
Jinhua	Chin-hua	進化
Jiujiang	Chiu-chiang	九江
jue	chüeh	爵
Lang yao	Lang-yao	郎窯
lei	lei	罍
li	li	鬲
lian	lien	奩
Liangzhu	Liang-chu	良渚
Linru	Lin-ju	臨汝
Liquan	Li-ch'üan	禮泉
Longshan	Lung-shan	龍山
Luoyang	Lo-yang	落陽
Lu Yu	Lu Yü	陸羽
macang (clay)	ma-ts'ang	蔴倉土
Majiayao	Ma-chia-yao	馬家窯
meiping	mei-p'ing	梅瓶

Miaodigou	Miao-ti-kou	廟底溝
mingqi	*ming-ch'i*	明器
mocai	*mo-ts'ai*	墨彩
Nanchang	Nan-ch'ang	南昌
Neifu	Nei-fu	內府
Neiqiu	Nei-ch'iu	內邱
Nian *yao*	Nien-*yao*	年窯
pan	*p'an*	盤
Pingyang	P'ing-yang	平陽
pou	*p'ou*	瓿
Puducun	P'u-tu-ts'un	普渡村
Puyang	P'u-yang	濮陽
Puzhou	P'u-chou	蒲州
qimen (stone)	*ch'i-men*	祁門石
qingbai (ware)	*ch'ing-pai*	青白磁
Quyang	Ch'ü-yang	曲陽
Ru *guan yao*	Ju *kuan yao*	汝官磁
Shangdong	Shang-tung	上董
Shanxian	Shan-hsien	陝縣
Shaogou	Shao-kou	燒溝
Shaoxing	Shao-hsing	紹興
Shouxian	Shou-hsien	壽縣
Shufu	Shu-fu	樞府
Shuiji	Shui-chi	水吉
susancai	*su-san-ts'ai*	素三彩
Susong	Su-sung	宿松
Tang Ying	T'ang Ying	唐英
Tiejianglu	T'ieh-chiang-lu	鐵匠爐
Tongchuan	T'ung-ch'uan	銅川
tuluping	*t'u-lu-p'ing*	吐魯瓶
Tunqi	T'un-hsi	屯溪
Wajiaping	Wa-chia-p'ing	瓦家坪
Wu-Yue	Wu-Yüeh	吳越
wucai	*wu-ts'ai*	五彩
Wuchang	Wu-ch'ang	武昌
xi	*hsi*	洗
Xiangyin *yao*	Hsiang-yin *yao*	湘陰窯
Xiaoshan	Hsiao-shan	蕭山
Xinyang	Hsin-yang	信陽
Xiuneisi *guan yao*	Hsiu-nei-ssu *kuan-yao*	修內司官窯
Yangshao	Yang-shao	仰韶
yi	*i*	匜
Yidu	I-tu	益都
yingqing	*ying-ch'ing*	影青
Yizheng	I-cheng	儀征

you	*yu*	卣
Yueyang	Yüeh-yang	岳陽
Yuxian	Yü-hsien	禹縣
Yuyao	Yü-yao	餘姚
zacai	*tsa-ts'ai*	雜彩
Zang *yao*	Tsang-*yao*	臧窯
Zhengzhou	Cheng-chou	鄭州
Zhenjiang	Chen-chiang	鎮江
zhong	*chung*	鍾
zun	*tsun*	尊

Bibliography

ENGLISH SOURCES

Ayers, John. *The Baur Collection: Chinese Ceramics,* vol. 1. Geneva: Collection Baur, 1974.

Garner, Harry. *Tang Ceramics and Glass.* London: Transactions of the Oriental Ceramic Society, 1955.

———. *Oriental Blue and White.* London: Praeger, 1971.

Gray, Basil. *Early Chinese Pottery and Porcelain.* London: Faber and Faber, 1953.

Jenyns, R. Soame. *Ming Pottery and Porcelain.* London: Faber and Faber, 1951.

Joseph, Adrian. *Ming Porcelains, Their Origin and Development.* London: Bibelot Publishers Limited, 1971.

Medley, Margaret. *The Chinese Potter.* Oxford: Phaidon, 1976.

———. *Yuan Porcelain and Stoneware.* London: Faber and Faber, 1974.

Percival David Foundation of Chinese Art, ed. *Illustrated Catalogue of Celadon Wares.* London, 1977.

———. *Illustrated Catalogue of Ming and Qing Monochrome.* London, 1973.

———. *Illustrated Catalogue of Ming Polychrome Wares.* London, 1978.

———. *Illustrated Catalogue of Qing Enamelled Ware.* London, 1973.

———. *Illustrated Catalogue of Underglaze Blue and Copper Red.* London, 1976.

Pope, John. *Chinese Porcelains from the Ardebil Shrine.* Washington: Freer Gallery of Art, 1956.

———. *Fourteenth Century Blue and White in the Topkapu Serayi Muzesi, Istanbul.* Washington: Freer Gallery of Art, 1952.

Watson, William. *Chinese Ceramics from Neolithic to Tang*. London: Transactions of the Oriental Ceramic Society, 1971.

Wirgin, Jan. *Sung Ceramic Designs*. Stockholm: Museum of Far Eastern Antiquities, 1970.

JAPANESE AND CHINESE SOURCES

Chūgoku tōji (Topkapi Saray Collection). Tokyo: Heibonsha, 1974.

d'Entrecolles, Père. *Chūgoku tōji kembunroku*. Translated by Taichirō Kobayashi. Tokyo: Zenkoku Shobō, 1946.

Feng Xianming. "Xin Zhongguo taoci kaogu de zhuyao shouhuo." *Wenwu*, no. 7 (1973).

Hasebe, Gakuji. *Shōrai bijutsu: tōgei*. Genshoku Nihon no bijutsu, vol. 30. Tokyo: Shōgakukan, 1972.

———. "Jū seiki no Chūgoku tōji." *Tōkyō Hakubutsukan Kiyō*, vol. 3 (1968).

——— et al. *Tōyō ko tōji*, vols. 1, 2. Tokyo: Mainichi Shimbunsha, 1971.

Kokyū hakubutsu-in. Tokyo: Kōdansha, 1975.

Koyama, Fujio. *Chūgoku meitō hyakusen*. Tokyo: Nihon Keizai Shimbunsha, 1960.

———. *Chūgoku no tōji*. Koyama Fujio chosakushū, vol. 1. Tokyo Asahi Shimbunsha, 1965.

———. *Chūgoku tōji*. Idemitsu Bijutsukan sensho, vol. 2. Tokyo: Heibonsha, 1970.

———. *Tōyō ko tōji*. Tokyo: Bijutsu Shuppansha, 1954.

——— et al. *Tōgei*. Tōyō bijutsu, vol. 4. Tokyo: Asahi Shimbunsha, 1967.

Okazaki, Takashi et al. *Chūgoku Bijutsu*, no. 1. Sekai bijutsu taikei, vol. 8. Tokyo: Kōdansha, 1963.

———. *Tōzai kōshō no kōkogaku*. Tokyo: Heibonsha, 1973.

Okuda, Seiichi et al. *Chūgoku no tōji*. Tokyo: Tōto Bunka Shuppanbu, 1955.

Osaka Shiritsu Bijutsukan, ed. *Kan-dai no bijutsu*. Tokyo: Heibonsha, 1976.

———. *Rikuchō no bijutsu*. Tokyo: Heibonsha, 1977.

———. *Sō Gen no bijutsu*. Tokyo: Heibonsha, 1980.

———. *Zui Tō no bijutsu*. Tokyo: Heibonsha, 1978.

Mayuyama, Yasuhiko. *Chūgoku bumbutsu kembun*. Tokyo: Mayuyama Ryūsendō, 1973.

Mikami, Tsugio. *Tōji no michi*. Tokyo: Iwanami Shoten, 1969.

Naitō, Tadashi. *Ko tōji no kagaku*. Tokyo: Yūzankaku, 1969.

Nihon shutsudo no Chūgoku tōjiten zuroku. Tokyo: Tokyo Kokuritsu Hakubutsukan, 1975.

Satō, Masahiko. *Chūgoku no tōjiki*. Tokyo: Sekai Bunkasha, 1977.

Sekai kōkogaku taikei, Higashi Ajia, vols. 1–3. Tokyo: Heibonsha, 1958–62.

Sekai tōji zenshū, vols. 8–12. Tokyo: Kawade Shobō, 1954–57.

Sekai tōji zenshū, vols. 10–14. Tokyo: Shōgakukan, 1976–81.

Shanhai Hakubutsukan. Tokyo: Heibonsha, 1976.

Shin Chūgoku no kōko shūkaku. Translated by Yūzo Sugimura. Tokyo: Bijutsu Shuppansha, 1963.

Shin Chūgoku no shutsudo bumbutsu, Japanese edition. Peking: Gaibun Shuppansha, 1972.

Tōji taikei, vols. 33–46. Tokyo: Heibonsha, 1972–78.

Tōki kōza, vols. 5–7, 12. Tokyo: Yūzankaku, 1971–75.

Tōki zenshū, vols. 9–16, 25–27. Tokyo: Heibonsha, 1957–63.

Tōyō tōji, vols. 1–6. Tokyo: Tōyō Tōji Gakkai, 1974–79.

Tōyō tōji taikan, vols. 1–12. Tokyo: Kōdansha, 1974–77.

Wenhua dageming qijian chutu wenwu. Peking: Wenwu Chubanshe, 1972.

Index

amphora with dragon-head handles, 55, 74, 78, 80

anhua ("secret decoration"), 167, 233

animal-shaped wares, 38–40

apple-green ware, 239–40

applied molded decoration, 28, 46, 57–58, 88, 143, 149

Arita enameled ware, 204–205

ash-glazed ware, 14–18, 19–22, 25, 29, 33; fern ash, 35, 47, 180, 207; straw ash, 47, 89, 117, 137

Banshan painted pottery, 5

beaded decoration, 149–50

bianhu, see pilgrim flask

black Ding ware, 97, 130

black glazed ware, 48–49, 59, 77

black pottery, 6–10

black slip, 107

black ware, 48–49, 74–78, 117, 126; with mottling, 77–78

blue-and-white ware, 139, 145, 146, 150–58, 168, 170–71, 181–83, 210–17

blue-painted yellow ware, 177–78

"Boshanlu" censer, 29, 54, 58

bronze culture, 8

bronze vessels, 9–10, 12–13, 29, 39

brown glazed ware, 25–32, 56–59

cacai enameled ware, 186–87, 190

carved decoration, 83, 85, 93, 100–101, 122, 123

celadon ware, 15, 33–35, 44; northern, 98–101; southern, 86–89; with iron spots, 42, 145; *see also* Jun celadon, Longquan celadon, Ru celadon, Southern Song official celadon

Cha Jing, see *The Classic of Tea*

Changsha kilns, 86–87, 145

Chaozhou kilns, 122

Chenghua ware, 168–72, 173

chicken cup, 170–72

chicken-head ewer, 37–38, 40, 48

chicken-head jar, 46

China stone, 120, 124

chunyu, 20

The "weathermark" identifies this book as a production of John Weatherhill, Inc., publishers of fine books on Asia and the Pacific. Book design and typography: Miriam F. Yamaguchi and Meredith Weatherby. Layout of illustrations: Yoshihiro Murata. Composition and printing of the text, engraving and printing of the plates in four-color and monochrome offset, and binding: Korea Textbook Company, Inc. The typeface used is Monotype Bembo.